Art and Architecture
A Place Between

For Beth and Alan

Art and Architecture
A Place Between

JANE RENDELL

I.B. TAURIS
LONDON · NEW YORK

Reprinted in 2008 by I.B.Tauris & Co Ltd
6 Salem Road, London W2 4BU
175 Fifth Avenue, New York NY 10010
www.ibtauris.com

In the United States of America and Canada distributed by
Palgrave Macmillan, a division of St Martin's Press
175 Fifth Avenue, New York NY 10010

First published in 2006 by I.B.Tauris & Co Ltd

ISBN-10: 1 84511 222 9
ISBN-13: 978 1 84511 222 6

A full CIP record for this book is available from the British Library
A full CIP record for this book is available from the Library of Congress

Library of Congress catalog card: available

Printed and bound in Great Britain by TJ International Ltd, Padstow, Cornwall from
camera-ready copy edited and supplied by the author

Contents

List of Figures

Section 2: Chapter 1

Section 2: Chapter 2

Section 2: Chapter 3

Section 3: Chapter 1

Section 3: Chapter 2

Section 3: Chapter 3

Acknowledgements

When Malcolm Miles first asked me to contribute to an MA directed by Faye Carey called 'The Theory and Practice of Public Art and Design' at Chelsea College of Art and Design in London, the term 'public art' was new to me. Over the next few years I learnt that public art was an interdisciplinary practice that refused to settle as simply art or design. If design, and I include architecture here as one design discipline, can be considered a form of practice that is usually conducted in response to a brief or a set of requirements, and if fine art is defined by its independence from such controls, then public art, in drawing on both approaches, constructs a series of differing responses to sites, forming a continuum of practice located in a place between art and design. If designers are expected to provide a solution to a problem, albeit a creative one within a given set of parameters, and artists are encouraged to rethink the terms of engagement, then public art practice, by operating in a place between, is well positioned to address the procedures of both art and architecture.

'You cannot design art,' one of my colleagues once warned a student studying public art and design. One of the more serious failings of so-called public art has been to do precisely this, to produce public spaces and objects that provide solutions – answers rather than questions. If there is such a practice as public art, and that in itself is debatable as will be discussed in this book, then I argue that public art should be engaged in the production of restless objects and spaces, ones that provoke us, that refuse to give up their meanings easily but instead demand that we question the world around us.

Teaching public art suggested to me different ways in which theoretical ideas could inform studio practice. In architectural design education there is great pressure to design buildings within the terms the architectural profession sets. Unlike history, commonly believed to provide a non-threatening and benign contextual backdrop, theory is often understood in direct opposition to design, at best as an abstract subject with no practical use, at worst as the source of difficult and distracting political questions. When I left Chelsea to return to architecture, to the University of Nottingham, the point in the process of teaching architectural design where it seemed possible to make a connection between theory and practice seemed to be located in the construction and critique of the design brief. Here, conceptual thinking and theoretical ideas provided more than a context for design; they allowed the invention of imaginative yet critical narratives to form the conceptual basis to an architectural design project. Following my time at Nottingham, at the Bartlett School of Architecture, UCL, my interests in the production of art and architecture have further evolved into a pedagogical and research programme of 'site-writing', where modes of working adopted from the design studio and fine art practice spatialize writing processes, resulting in creative propositions in textual form that critique and respond to specific sites.

This short autobiographical tour serves to acknowledge the important role teaching has played in my exploration of the relationship between art and architecture and the colleagues and students who have inspired this book. My thanks go to my teachers, both students and colleagues, on the BA and MA in Public Art and Design at Chelsea School of Art and Design, especially to Faye Carey, Julia Dwyre, Sophie Horton and Sue Ridge. Thank you too to all those at the University of Nottingham who during my time there were prepared to take a risk, step outside what might be thought of as 'architecture', and to try something a little bit different and see where it might take them. At the Bartlett School of Architecture, UCL, I consider myself very lucky to have taught with such stimulating colleagues as Iain Borden, Davide Deriu, Adrian Forty, Dan Gretton, Felipe Hernandez, Jonathan Hill, Lorens Holm, Sarah Jackson, Brigid McLeer, James Marriott, Barbara Penner, Peg Rawes, Katie Lloyd Thomas and Jane Trowell, who together have provided a place to think and write history and theory in many different ways. Thank you also to my students at the Bartlett, who have been open enough to allow the course of their research to change through their engagement at an early stage with some of the ideas in this book. Rex Henry and I shared a mutual interest in the 'spatial arts' through our collaboration on the *Public Art Journal*. So thank you to Rex and to the other contributors to 'A Place Between', a publication that served as a seedbed for this book in many ways.

My understanding of the relationship between theory and practice, art and architecture, has developed through many discussions over the past few years. I would like to thank all those who have contributed thoughts and works to the various lecture programmes I have organized in different institutions, as well as those who, in asking me to write and talk about my own research, have inadvertently provided a place for thinking and writing parts of this book. I am especially grateful to the following people for the conversations we have had and continue to have about art and architecture: Kathy Battista, Ana Betancour, David Blamey, Katrin Böhm, Alex Coles, David Connearn, Matthew Cornford, Alexia Defert, Penny Florence, Stephen Greenberg, Katja Grillner, Peter Hasdell, Roger Hawkins, Hilde Heynen, Janet Hodgson, Sue Hubbard, Brendan Jackson, Sharon Kivland, Brandon LaBelle, Miche Fabre Lewin, Marsha Meskimmon, Malcolm Miles, Sharon Morris, Rosa Nguyen, Mario Petrucci, Steve Pile, Shelley Sacks, Clive Sall, Sally Tallant, Pamela Wells and Jules Wright.

At different stages of the research, a number of people have been generous enough to give their time to discuss various aspects of their work; thank you especially to Adam Chodsko, Lynne Cooke of the Dia Art Foundation, New York, USA, Tom Eccles of the Public Art Fund, New York, USA, Deborah Kermode of the Ikon Gallery, Birmingham, UK, and Sandra Percival of Public Art Development Trust, UK. I am very grateful too to all those who have kindly given permission to publish images of their work, and to Sue Hubbard and Mario Petrucci for allowing me to publish excerpts of their poems. I would also like to thank UCL, which generously funded a two-month sabbatical, providing me with dedicated time to focus on finishing the manuscript, and the Architecture Research Fund of the Bartlett School of Architecture, which provided the significant financial support needed to produce the book.

Because these ideas sit precariously between theory and practice, art and architecture, they have taken a long time to enter the world as a book, far longer than I ever intended or expected. I therefore wish to say a special thank you to Susan Lawson for providing a home for my work at I.B.Tauris and for her careful reading of the manuscript in the final stages, to Nick Beech for his excellent help in obtaining images, to Stuart Munro for his wonderful work in designing the book, and to Jason and Selina Cohen, Wendy Toole, Carolann Martin, Elizabeth Munns and Stuart Weir for their thorough and highly professional assistance in copy-editing, proof-reading, indexing, page-layout and production. Finally my thanks go to David Cross for his longstanding patience with this project, for critical commentary and intellectual inspiration, but most importantly for emotional sustenance.

Introduction

A Place Between

For some years now I have been positioned between art and architecture, theory and practice, exploring the patterning of intersections across this pair of two-way relationships. In *Art and Architecture* I trace the multiple dynamics of this ongoing investigation and, in so doing, draw on a range of theoretical ideas from a number of disciplines to examine artworks and architectural projects. It is neither desirable nor possible to sketch out an inclusive picture of contemporary art and architecture. To do so one would have to operate without any selection criteria. Such an approach would run against the grain of this project, which, at its core, is concerned with a specific kind of practice, one that is both critical and spatial, and that I call 'critical spatial practice'. In art such work has been variously described as contextual practice, site-specific art and public art; in architecture it has been described as conceptual design and urban intervention. To encounter such modes of practice, in *Art and Architecture* I visit works produced by galleries that operate 'outside' their physical limits, commissioning agencies and independent curators who support and develop 'site-specific' work and artists, architects and collaborative groups that produce various kinds of critical projects from performance art to urban design.

In the last ten years or so a number of academic disciplines – geography, anthropology, cultural studies, history, art and architectural theory, to name but a few – have been drawn into debates on 'the city'. Such discussions on the urban condition have produced an interdisciplinary terrain of 'spatial

theory' that has reformulated the ways in which space is understood and practised. Rather than attempt to summarize the work of such influential spatial thinkers as Rosi Braidotti, Walter Benjamin, Michel de Certeau, Luce Irigaray, Doreen Massey and Edward Soja, in *Art and Architecture* I focus my attention on particular aspects of their writings. I do so to provide starting points for considering the relationship between art and architecture with reference to several different theoretical themes.

Theoretical ideas have suggested the conceptual framework for *Art and Architecture*. My readings of the works of postmodern geographer Soja, in particular his concept of trialectical as opposed to dialectical thinking, borrowed from the philosopher Henri Lefebvre, have informed this book's tripartite structure.[1] I have drawn on Soja's triad of space, time and social being to provide this book's three sections, each one emphasizing a different aspect of 'a place between' art and architecture: specifically, the spatial, the temporal and the social.

The focus in Section 1: 'Between Here and There' is on the spatial. In it I deal with how the terms site, place and space have been defined in relation to one another in recent theoretical debates. Through the chapters in this section I go on to investigate three particular spatial issues: first, the relationship between site, non-site and off-site as locations for art and architectural practice; second, commissioning work outside galleries where curation over an 'expanded field' engages debates across the disciplines of art, design and architecture; and third, how art, as a form of critical spatial practice, holds a special potential for transforming places into spaces of social critique.[2] In Section 2: 'Between Now and Then', I shift the scale from a broad terrain to examine particular works as new interventions into existing contexts, highlighting the importance of the temporal dimension of 'a place between', specifically, the relation of past and present in allegorical, montage and dialectical constructions and the time of viewing and experiencing art and architecture. Finally, in Section 3: 'Between One and Another', I turn the emphasis to the social to look at the relationships people create in the production and occupation of art and architecture and consider 'work' less as a set of 'things' or 'objects' than as a series of exchanges that take place between people through such processes as collaboration, social sculpture and walking.

Having laid down the structure for this book in a synchronic fashion, it became apparent to me that it was impossible to talk of work made in the present without reference to either the past or the future. For this reason, I take each section backwards to locate it in a broader historical trajectory, but also forward to speculate on future possibilities. Looking backwards, I make connections with the work of minimal, conceptual, land and performance artists of the 1960s and 1970s, whose work has in

many cases been informed by an interest in architecture and public space. Such projects play an important role in providing a historical perspective on our current condition in terms of both art and architectural discourse and wider critical, cultural and spatial debates. The contemporary projects I focus on engage with the trajectories set up by the earlier works, and have been in the main produced by artists operating outside galleries, materially and ideologically. In this book I do not deal equally with art and architecture. Since my interest is in practices that are critical and spatial, I have discovered that such work tends to occur more often in the domain of art, yet it offers architecture a chance to reflect on its own modes of operation. Sometimes I can point towards certain kinds of architectural projects already occurring but in other cases I can only speculate.[3] Looking forward then, I argue that discussion around these artworks gestures towards future possibilities for architecture.

Between Art and Architecture: Public Art

Art and architecture have an ongoing attraction to one another. When I first came into contact with the discourse on public art, it changed my understanding of this relationship. At this particular cultural moment in advanced capitalist countries, an interest in the 'other', whether the feminine, the subaltern, the unconscious, the margin, the between or any other 'other', is manifest and could be characterized as a fascination with who, where or what we are 'not'. Architecture's curiosity about contemporary art is in no small way connected with the perception of art as a potentially subversive activity relatively free from economic pressures and social demands while art's current interest in architectural sites and processes may be related to architecture's so-called purposefulness, its cultural and functional role, as well as the control and power understood to be integral to the identity of the architect. Artists value architecture for its social function, whereas architects value art as an unfettered form of creativity. For example, architect Maya Lin, best known for her public artworks, has described her experience of the division of art and architecture like this: 'I always sense that the fine arts department thought we were somehow compromising art because we built things for people as opposed to being pure and doing it for yourself.'[4]

Art and architecture are frequently differentiated in terms of their relationship to 'function'. Unlike architecture, art may not be functional in traditional terms, for example in responding to social needs, giving shelter when it rains or providing a room in which to perform open-heart surgery,

but we could say that art is functional in providing certain kinds of tools for self-reflection, critical thinking and social change. Art offers a place and occasion for new kinds of relationship 'to function' between people. If we consider this expanded version of the term function in relation to architecture, we realize that architecture is seldom given the opportunity to have no function or to consider the construction of critical concepts as its most important purpose.

When art is located outside the gallery, the parameters that define it are called into question and all sorts of new possibilities for thinking about the relationship between art and architecture are opened up. Art has to engage with the kinds of restraints and controls to which only architecture is usually subject. In many public projects, art is expected to take on 'functions' in the way that architecture does, for example to alleviate social problems, comply with health and safety requirements, or be accessible to diverse audiences and groups of users. But in other sites and situations art can adopt the critical functions outlined above and works can be positioned in ways that make it possible to question the terms of engagement of the projects themselves. This type of public art practice is critically engaged; it works in relation to dominant ideologies yet at the same time questions them; and it explores the operations of particular disciplinary procedures – art and architecture – while also drawing attention to wider social and political problems. It might best be called critical spatial practice.

In the late 1980s it appeared that artists in Canada and on the west coast of the USA were leading the way in public art. They were developing practices out of a community base, which rather than avoid the distinctions between different modes of art, worked to extend and critique them. Artist Suzanne Lacy coined the term 'new genre public art' to describe what she saw as a new trajectory where public art could include conceptual and critical work with a focus on collaboration, interaction, process and context.[5] Also published in 1995, the various essays in art critic Nina Felshin's edited collection *But is it Art? The Spirit of Art as Activism* pointed to the potential of socially engaged public art practice as a tool for political critique, while writer Tom Finkelpearl describes this period as a time in which artists, administrators and communities 'reinvented the field of public art'.[6]

Now, ten years on, it is disappointing to note that the potential of public art, pointed to in the 1990s, has not really developed in North America in the way we might have hoped. In New York today, for example, it seems that a very clear division exists between the 'fine' art celebrated in the gallery districts of SoHo, Chelsea and more recently Williamsburg and Brooklyn, and the 'public' art found in the outside spaces of the city. Few galleries wish to move outside their own economic circuits and frames

of reference; however, there are changes in the commissioning of public art, which indicate a move from object-based to process-based work and towards a more critical mode of practice.

In the UK, despite the noticeable increase in the funding of so-called public art projects, the category of 'public art' has come to be considered a problematic or 'contested' practice.[7] In *Art, Space and the City*, cultural theorist Malcolm Miles describes two of the main pitfalls of public art: its use as wallpaper to cover over social conflict and tensions and as a monument to promote the aspirations of corporate sponsors and dominant ideologies.[8] Many so-called 'fine' artists have been particularly scathing about public art, including those whose careers have been built around a sustained critique of the gallery system. For example, the artist Chris Burden has remarked: 'I just make art. Public art is something else, I'm not sure it's art. I think it's about a social agenda.'[9]

By linking 'social' to an 'agenda', a distinction is at play that associates the social aspect of public art with a deterministic approach and, by implication, fine art with freedom. However, in extending their field of practice outside the gallery, some 'fine artists' have encountered the criticism that their work is overly concerned with personal interests or the ongoing debates of the art world and is not attentive enough to the specific concerns of a particular site and audience. Perhaps because of these problems, terms such as site-specific or contextual art have been used more recently to describe art outside galleries. I will, however, continue to use the term for a while longer here since the tensions at play in discussions around public art allow us to examine the ideologies at work in maintaining distinctions between public and private space.

The category 'public art' usually refers to a certain kind of artwork, a large sculpture placed in an external site; the word 'art' describes the object and 'public' the site in which the art is placed and/or the audience or the body of people 'for' whom the art is intended.[10] At the start of her essay 'Agoraphobia', art theorist Rosalyn Deutsch asks, 'What does it mean for space to be public? The space of a city, building, exhibition, institution or work of art?'[11] The boundaries drawn around notions of private and public are not neutral or descriptive lines, but contours that are culturally constructed, change historically and denote specific value systems. The terms appear as social and spatial metaphors in geography, anthropology and sociology, as terms of ownership in economics, and as political spheres in political philosophy and law. Public and private, and the variations between these two terms, mean different things to different people – protected isolation or unwelcome containment, intrusion or invitation, exclusion or segregation. And as the privatization of public

space increasingly occurs in all directions – extending outwards to all regions of the globe and inwards to hidden reaches of the mind – we need to define carefully how we use the terms.

In the Western democratic tradition, 'public' stands for all that is good, for democracy, accessibility, participation and egalitarianism set against the private world of ownership and elitism. But if public space relies on democracy and vice versa, what kind of democracy are we talking about? Democratic public space is frequently endowed with unified properties, but one of the problems of aiming for a homogenous public is the avoidance of difference. Philosopher Chantal Mouffe has argued instead for radical democracy, a form of democracy that is able to embrace conflict and passion.[12] For those who support the public realm, 'privatization' is associated with the replacement of public places by a series of private places with exclusive rules governing entry and use. But if we take instead a liberal-rights-based perspective, then privacy is understood to provide positive qualities, such as the right to be alone, to confidentiality and the safeguarding of individuality.[13] For those who support the private realm, public spaces are seen as potentially threatening, either as places of state coercion or sites of dissidence in need of regulation.

The terms 'public' and 'private' do not exist then as mutually exclusive categories; rather, their relationship is dependent and open to change. For example, public art located outside the private institution of the art gallery may still be inside the corporate world of private property and finance, and further still inside the private world of the fine art network.[14] In the long term it probably does make sense to abandon the term 'public art' simply because its use requires so many justifications and explanations. Here, in *Art and Architecture*, I suggest a new term, 'critical spatial practice', which allows us to describe work that transgresses the limits of art and architecture and engages with both the social and the aesthetic, the public and the private. This term draws attention not only to the importance of the critical, but also to the spatial, indicating the interest in exploring the specifically spatial aspects of interdisciplinary processes or practices that operate between art and architecture.

Between Theory and Practice: Critical Spatial Practice

In the late 1970s artist and theorist Victor Burgin argued that art theory was at an end because it was 'identical with the "objectives of *theories of representation*"'.[15] Burgin was suggesting that because social and cultural theories of representation already focused on questions of concern to

artists, there was no need for a theoretical discourse that dealt only with art. In a more recent collection of essays debating the 'point of theory' in literary criticism, literary critic Brian McHale's position suggests the opposite tendency with reference to contemporary literary criticism. McHale bemoans the preponderance of generalized theoretical texts, and laments the loss of a theory specifically derived from a study of literature, a theory that lies between the general and the specific.[16]

This ability and desire to differentiate between certain kinds of theory and assess their relative merits appears to be missing in architectural debates on theory. In recent collections of architectural theory from the USA, no attempt is made to distinguish between theories that have been generated out of their own disciplines and those that have come from elsewhere. In the introduction to one of these collections, *Theorizing a New Agenda for Architecture*, Kate Nesbitt does choose to separate architecture theory from criticism and history,[17] while in another, *Architecture Theory since 1968*, K. Michael Hays sees architecture theory as a form of mediation between architectural form and social context.[18] Remaining under-discussed are the differences between theories, their aims and objectives, the ways in which they represent (usually implicitly) varying models of knowledge, their disciplinary origin, and what relationships they are able to construct with specific kinds of objects. In the UK there has also been a lack of distinction made between particular kinds of theoretical positions, and here too those in architecture talk of 'theory' in general rather than distinguishing between critical theories and architectural theories. The difference is that in the UK the tendency has been to favour critical theory. For example, the essays architectural theorist Neil Leach brought together in his edited collection *Rethinking Architecture* specifically turn to critical theory rather than architectural theory as a way of engaging with architecture. The authors of the essays in *InterSections: Architectural History and Critical Theory*, a book I edited with Iain Borden, examine the relationship between architectural history and critical theory, demonstrating different modes of writing theorized histories, bringing to the surface questions of critical methodology.[19]

To negotiate the relationship that theory has to practice and vice versa is no easy task, but as a contemporary critic I take this to be my role. The term 'theory' is often understood to refer to modes of enquiry in science through either induction, the inference of scientific laws or theories from observational evidence, or deduction, a process of reasoning from the general overarching theory to the particular. Critical theory is a phrase that refers to the work of a group of theorists and philosophers called the Frankfurt School operating in the early twentieth century. The group includes Theodor Adorno, Jurgen Habermas, Max Horkheimer, Herbert

Marcuse and Walter Benjamin; and their writings are connected by their interest in the ideas of the philosopher G. W. F. Hegel, the political economist Karl Marx, and the psychoanalyst Sigmund Freud. Taken together, their work could be characterized as a rethinking or development of Marxist ideas in relation to the shifts in society, culture and economy that took place in the early decades of the twentieth century. Critical theories are forms of knowledge, but according to Raymond Guess, in *The Idea of Critical Theory*, they differ from theories in the natural sciences because they are 'reflective' rather than 'objectifying' – they take into account their own procedures and methods. Critical theories also have a particular set of aims in that they seek to enlighten and emancipate their readers by providing a critique of normative attitudes. Critical theories aim neither to prove a hypothesis nor to prescribe a particular methodology or solution to a problem; instead, in a myriad of ways critical theorists offer self-reflective modes of thought that seek to change the world, or at least the world in which the inequalities of market capitalism, as well as patriarchal and colonial (or post-colonial) interests, continue to dominate. 'A critical theory, then, is a reflective theory which gives agents a kind of knowledge inherently productive of enlightenment and emancipation.'[20]

I extend the term 'critical theory' in this book to include the work of later theorists, poststructuralists, feminists and others whose thinking is also self-critical and desirous of social change. For me, this kind of theoretical work provides a chance not only to reflect on existing conditions but also to imagine something different – to transform rather than describe.[21] More importantly, in *Art and Architecture* I explore the spatial aspects of different kinds of critical theory and the relationship between these theories and art and architectural practice. These explorations range from debates about space, place and site in cultural geography and art theory (Section 1: 'Between Here and There'), to discussions on juxtaposition, disintegration and melancholy in allegorical, montage and dialectical techniques in the work of Benjamin (Section 2: 'Between Now and Then'), to examinations of the spatial construction of subjectivity in feminist and psychoanalytic theory (Section 3: 'Between One and Another').

It is easy to generalize the relationship between theory and practice and perhaps a little dangerous. Each historical moment offers a particular set of conditions and, depending on their own life story, each person takes a different approach. I trained and worked first as an architect and practitioner and later as a historian and theorist. This influences the place I occupy between theory and practice. I say this because although I started out chronologically as a practitioner, for me the relationship between the two 'starts' with theory. Reading critical theory is what

opened up my world and allowed me to see things differently. Theoretical debates changed the ways in which I understood architectural practice, expanding my expectations of what architecture could do. But it took me a much longer time to realize that theoretical concepts could not provide the 'answer' to critical practice, that the relationship between theory and practice was not one of continuity.[22]

Critical theory is instructive in offering many different ways of operating between 'two'. The philosophy of deconstruction developed by Jacques Derrida has allowed us to critique binary thinking and understand how the hierarchical relationship often assigned to two terms in a pair is not natural or pregiven but a social construction that can change according to how we are positioned. In a binary model, everything that one is, the other cannot be, thus limiting the possibility of thinking of two terms together. Such a model operates hierarchically, where one of the two terms is placed in a dominant position. Derrida's project aims to expose the ways in which binary systems allow things to be only 'like' or 'not like' the dominant category and replaces such prevailing intellectual norms with new formulations.[23] The radical move deconstruction offers is to think 'both/and' rather than 'either/or', putting deferrals and differences into play and suggesting instead 'undecidability' and slippage.[24] Feminist theorist Diane Elam has observed that Derrida's understanding of 'undecidability' is not indeterminate but rather a 'determinate oscillation between possibilities' and argues that by refusing to choose between one and another such a position offers a political potential.[25]

Broadly speaking, my approach in this book takes up certain tenets of deconstruction to destabilize binary assumptions that are often made about the relationship between art and architecture, private and public and theory and practice. First, I refuse to think of either term in the pair as dominant. Second, I consider how one term in the pair operates through the categories (such as function mentioned above) normally used to define the other. And third, I invent or discover new terms, like critical spatial practice, which operate simultaneously as both and neither of the binary terms, including the two, yet exceeding their scope.[26]

My process also connects with a fascinating conversation between philosophers Gilles Deleuze and Michel Foucault that took place in 1972. Here Deleuze reveals quite directly, though certainly abstractly, how he comprehends a 'new relation between theory and practice'. Rather than understanding practice as an application of theory or as the inspiration for theory, Deleuze suggests that these 'new relationships appear more fragmentary and partial',[27] and discusses their relationship in terms of what he calls 'relays': 'Practice is a set of relays from one theoretical

point to another, and theory is a relay from one practice to another. No theory can develop without eventually encountering a wall, and practice is necessary for piercing this wall.'[28]

I would certainly agree with Deleuze that the relationship between theory and practice is fragmentary and partial; I enjoy his concept of a relay whereby one discourse forms a link or passage between aspects of the other – theories travel between practices and practices travel between theories. However, although the notion of relays at first appears symmetrical, it turns out not to be, for the suggestion that theory needs practice to develop is not accompanied by its reversal. This may be because, for Deleuze, theory is 'not for itself'. 'A theory is exactly like a box of tools. ... It must be useful. It must function. And not for itself. If no one uses it, beginning with the theoretician himself (who then ceases to be a theoretician), then the theory is worthless or the moment is inappropriate.'[29]

It is this useful aspect of theory that interests me: theory needs to be used. I am also interested in Deleuze's suggestion that theory is 'local and related to a limited field' and should be 'applied' in a more distant 'sphere'.[30] Yet, although I would agree that theory needs to travel far afield, I prefer to think of theories throwing trajectories, or suggesting paths out into practice, rather than being used as 'tools' of 'application'. It is the proactive and inventive aspect to Deleuze, his thinking about what theory can do, that holds appeal for me, but so too does its corollary, what practice can do for theory. My position is probably at its closest to Deleuze's when he says that in its encounter with 'obstacles, walls and blockages' theory requires transformation into another discourse to 'eventually pass to a different domain'.[31] It is this possibility of transformation – the potential for change that each may offer the other – that interests me here in *Art and Architecture*.

In *The Point of Theory*, art historian Mieke Bal and Inge E. Boer argue that theory is a way of 'thinking through the relations between areas' and 'a way of interacting with objects':[32]

> *'Theory' only makes sense as an attitude; otherwise the generalization of the very concept of 'theory' is pointless. Part of that attitude is the endorsement of interdisciplinarity, of the need to think through the relations between areas where a specific theory can be productive, and of the need to think philosophically about even the most practical theoretical concepts, so-called 'tools'.[33]*

If Bal and Boer are correct, and I believe they are, in suggesting that the productive use of theory takes place in an interdisciplinary terrain, it is worth spending a few moments outlining what might be meant by the term 'interdisciplinary'. In both academic and arts-based contexts, the term

interdisciplinarity is often used interchangeably with multidisciplinarity and collaboration, but I understand the terms to mean quite different things. In my view, multidisciplinarity implies that a number of disciplines are present but that each maintains its own distinct identity and way of doing things, whereas in interdisciplinarity individuals move between and across disciplines and in so doing question the ways in which they work. In collaboration, the emphasis is less on disciplinary distinctions and more on how individuals work together towards end points decided through mutual consent.

In exploring questions of method or process that discussions of interdisciplinarity and the relationship between theory and practice inevitably bring to the fore, critical theorist Julia Kristeva has argued for the construction of 'a diagonal axis':

> *Interdisciplinarity is always a site where expressions of resistance are latent. Many academics are locked within the specificity of their field: that is a fact ... the first obstacle is often linked to individual competence, coupled with a tendency to jealously protect one's own domain. Specialists are often too protective of their own prerogatives, do not actually work with other colleagues, and therefore do not teach their students to construct a diagonal axis in their methodology.[34]*

Engaging with this diagonal axis demands that we call into question what we normally take for granted, that we question our methodologies, the ways we do things, and our terminologies, what we call what we do. The construction of 'a diagonal axis' is necessarily, then, a difficult business. When Kristeva talks of 'expressions of resistance', she is referring to the problems we encounter when we question the disciplines with which we identify. It is precisely for this reason that, despite being a passionate advocate of interdisciplinarity in current art, architectural practice and academic debate, I also remain sceptical because real engagement in interdisciplinary work is not simply procedural but demanding emotionally as well as intellectually and politically, demanding because this way of working requires us to be critical of what we do and open to change.

In *Art and Architecture* I operate across this interdisciplinary terrain, seeking to make a new kind of relationship between theory, specifically critical theories that are spatial, and art and architectural practice. If theory has often been used in certain kinds of architectural discourse as a way of post-rationalizing practice by drawing out general 'rules' and describing these as theories for 'how to do it', offering a 'recipe' for how to design, this is certainly not my intention here. The theoretical ideas I introduce at the start of each section have not been used to generate

any of the works I go on to describe. I am not interested in using theory as a general model against which to 'test' the specifics of practice, or in another version of this method, to use practice to illustrate theoretical concepts. There is a strong tendency for theorists interested in art and architectural practice to choose to explore works they feel exemplify a theoretical position, but this is not the 'point' of theory for me.

Rather than use theory to explain practice or practice to justify theory, the point of theory in *Art and Architecture* is to articulate practices that operate between art and architecture; by discussing spatial concepts in theoretical writings I open up a place between art and architecture that allows works to be explored in relation to one another as forms of critical spatial practice. I introduce theoretical concerns at the beginning of each section in order to set a scene, to frame a debate, to raise particular questions or issues that are then further explored through practice. The thematics raised by the theories have allowed me to select a particular range of artworks and architectural projects to investigate in each of the three sections. My aim is not to 'answer' any of the questions raised theoretically, but to see how those same questions operate materially through close examinations of certain arrangements of critical spatial practice. Here, in what I have called 'a place between', discussions of theoretical ideas can draw attention to particular forms of practice and then, moving back in the other direction, these works, and the connections and differences between them brought to the fore by considering them as forms of critical spatial practice, in turn ask questions of the concepts. So, if theoretical ideas have informed my choice of artworks and architectural projects and suggested to me new ways of thinking about them, it is also the case that the works themselves take the theoretical ideas in new and unexpected directions. And to draw this set of introductory ideas into a summarizing question: if critical spatial practice provides such a rich terrain for exploring the relationship between theory and practice as well as art and architecture, how to write 'a place between'?

Section 1

Between Here and There

Introduction

Space, Place and Site

In producing artworks outside the gallery, new forms of curating have increasingly emphasized the importance of multiple sites. The three chapters in Section 1 relate current discussions of off-site curating and site-specific art to the critical debates on site that emerged in connection with minimalist and land art in the late 1960s and theories of space and place in contemporary cultural geography.

A recent interest in 'site-specific' art has developed an understanding of site beyond its location as the position of the work and instead in relation to performance and ethnography. Nick Kaye has made a strong argument for site as a performed place, while authors in Alex Coles's edited collection position site within an ethnographic perspective that includes the research processes of fieldwork as well as the artist as a contemporary ethnographer.[1] These new understandings do not define sites in terms of geometry but in relation to the cultural and spatial practices that produce them, including the actions of those who investigate them. Indeed, self-critique, along with culture, context, alterity and interdisciplinarity, have been noted as aspects of anthropological research to impact on fine art practice.[2]

In *One Place after Another*, art critic Miwon Kwon notes that site-specificity has been 'embraced as an automatic signifier of "criticality"' in current art practice and goes on to argue that in fact there is a lack of

criticality in much site-specific work and that while site-specific practice has a radical potential it is always open to co-option by institutional and market forces.[3]

The title of her book sounds a warning of 'undifferentiated serialization', one of the dangers associated with taking one site after another without examining the differences between them.[4] Kwon points to Homi Bhabha's concept of 'relational specificity' as a way of emphasizing the importance of thinking about the particularity of the relationships between objects, people and spaces positioned. Akin to James Clifford's notion of site as a mobile place, located between fixed points, Bhabha's concept suggests an understanding of site that is specific but also relational.[5]

Robert Smithson's dialectic of 'site' (non-gallery) and 'non-site' (gallery), developed in the 1960s and early 1970s, could be described as the first exploration of relational sites through art practice. In Chapter 1: 'Site, Non-Site, Off-Site' I examine the current interest in locating work outside the physical confines of the gallery in relation to Smithson's dialectic. Dia Center for the Arts, located at 548 West 22nd Street in Chelsea, New York City, part of a much larger network of artworks sited across the city and the USA, is taken as a point of departure. In the chapter I also look at the UK, where programmes of spatial dispersal in recent curatorial practice have located art outside the gallery in multiple sites, citywide or even countrywide. Many contemporary galleries have adopted the term 'off-site' to describe the commissioning and curatorship of works situated outside the physical confines of the gallery where, in a strange reversal of Smithson's concept, the gallery is the 'site'.

If the relation of artworks organized through space in Chapter 1 could be described as a dispersion from an originating point, in Chapter 2: 'The Expanded Field' there is no reference to the central, if absent, site of the gallery. In Chapter 2 I examine projects like *In the Midst of Things* (1999) in Bournville where the decision to locate a number of specially commissioned artworks across a specific territory is the strategic and conceptual decision of independent curators. This kind of work has a history that can be connected to the ongoing projects at Munster and Documenta at Kassel where artworks are curated throughout the city. In Chapter 2, although the works are positioned in different locations and produced over varying lengths of time, the overall spatial pattern emerges at once.

This simultaneous production of artworks across multiple sites takes up Rosalind Krauss's notion of an 'expanded field' first introduced in 1979 to describe the work of artists producing interventions into the landscape.[6] When Krauss expanded the term sculpture in relation to architecture and landscape, she did so by examining individual artworks. Contemporary practice seems to raise new questions about terminology and method. Is

the expanded field best understood in terms of site, place or space? Can the processes of art, architecture and landscape design be better described in an interdisciplinary way as critical spatial practices?

In the 1970s one of the main projects for cultural geographers was the 'reassertion of space in critical social theory', the subtitle of Edward Soja's *Postmodern Geographies* of 1989.[7] In Marxist thought, time as history had been taken to be the active entity in shaping social production; space was merely the site in which social relations took place. Through the dialectical processes of historical materialism, change happened over time, not through space. Geographers such as David Harvey, Doreen Massey and Edward Soja argued for the importance of space in producing social relationships and in so doing turned to the work of French philosopher Henri Lefebvre.[8]

In *The Production of Space* Lefebvre argued that space was produced through three interrelated modes – spatial practices, representations of space and spaces of representation – a trialectical model that many cultural geographers, as well as art and architectural historians, have subsequently adopted as a theoretical framework within which to critique spatial and visual culture. At the start of *The Production of Space*, Lefebvre notes that one of the key problems with studies of space is that spatial practice is understood as the 'projection' of the social onto the spatial field. Lefebvre suggests instead that this relation is two way, that space also has an impact on the social: 'Space and the political organization of space express social relationships but also react back upon them.'[9]

Soja describes this concept of Lefebvre's as the 'fundamental notion of the socio-spatial dialectic: that social and spatial relations are dialectically inter-reactive, interdependent; that social relations of production are both space forming and space contingent'.[10] It is not then simply that space is socially produced, but also that social relations are spatially produced. Throughout the 1990s, feminist geographers like Liz Bondi, Doreen Massey, Linda McDowell and Gillian Rose played a key role in extending and developing much of this work, arguing for attention to gender as well as class in the production of space.[11] Massey and Rose, as well as Rosalyn Deutsche, provided insightful critiques of the writings of Harvey and Soja, pointing out that it was not enough to add gender as one of the categories of social relations, but that gender difference is a specific kind of difference and, as such, produces and is produced by very particular kinds of space.[12]

The 'turn' to spatial theory in the late 1980s and early 1990s highlighted the importance of space rather than time in the postmodern period. Academics from all kinds of disciplines, from art history to cultural studies, turned to geography for a rigorous and theoretically informed

analysis of the relationship between spatial and social relations, and of place and identity. Published in 1993, Michael Keith and Steve Pile's edited collection of essays, *Place and the Politics of Identity*, marked the moment in the debate when identity and place became central to discussions of space.[13] By interrogating the reciprocity of the relation between the politics of place and the place of politics, the introduction and many of the essays in the collection highlighted an interest in 'unfixing' place. 'A different sense of place is being theorized, no longer passive, no longer fixed, no longer undialectical – because disruptive features interrupt any tendency to see once more open space as the passive receptacle for any social process that cares to fill it – but, still, in a very real sense about location and locatedness.'[14]

A number of artists whose work dealt with issues of identity and place entered the frame of reference here. However, although several authors in the edited volume referred to art practice, the artworks that were selected for discussion operated as illustrations of theoretical discussions or as articulations of certain political positions rather than developments and critiques of debates on place, identity and visual culture.

By 2002 the time had come to reflect on the 'geographic turn'. In *Thinking Space*, a collection of essays again edited by two male geographers, this time Mike Crang and Nigel Thrift, the authors reviewed the 'seminal' theorists whose 'spatial thinking' had influenced geographers.[15] They identify a number of new themes in spatial thinking such as experience and travel, trace and deferral, mobility, practice and performance – themes that could be said also to describe the focus of much recent art theory and practice, marking a new intersection between art and geography around spatial practice.[16]

In his highly influential text *The Practice of Everyday Life*, anthropologist Michel de Certeau develops an understanding of place and space that is connected to linguistic practice.[17] Drawing on Ferdinand de Saussure's notions of langue and parole, in which langue is the complex of rules and conventions that constitute a language and parole the practice of speech, for de Certeau 'space is a practised place'.[18] While de Certeau's understanding of space as being socially produced and experienced resonates with the work of cultural geographers, his arguments on 'place' seem to be more problematic. In arguing for space as dynamic and constituted through practice, place somehow becomes fixed and passive in his writings; indeed at one point he compares place with a 'tomb'. It is worth quoting de Certeau's distinction here at length:[19]

> *At the outset, I shall make a distinction between space (espace) and place (lieu) that delimits a field. A place (lieu) is the order (of whatever kind) in accord*

with which elements are distributed in relationships of coexistence. It thus excludes the possibility of two things being in the same location (place). The law of the 'proper' rules in the place: the elements taken into consideration are beside one another, each situated in its own 'proper' and distinct location, a location it defines. A place is thus an instantaneous configuration of positions. It implies an indication of stability.

A space exists when one takes into consideration vectors of direction, velocities, and time variables. Thus space is composed of intersections of mobile elements. It is in a sense actuated by the ensemble of movements deployed within it. Space occurs as the effect produced by the operations that orient it, situate it, temporalize it, and make it function in a polyvalent unity of conflictual programmes or contractual proximities. On this view, in relation to place, space is like the word when it is spoken, that is when it is caught in the ambiguity of an actualization ... situated as the act of a present (or of a time ...[20]

In Chapter 3: 'Space as Practised Place' I look at site-specific art in relation to de Certeau's notion of 'space as a practised place' and argue that in 'practising' specific places certain artworks produce critical spaces. I examine the work of commissioning agencies like Artangel who work with selected artists to make artworks in unexpected places in the city. The spatial pattern produced can be considered a constellation. A little like a view of the night sky, in which each one of the many stars we can see has a different life span, when viewed as a constellation over time the different locations for artworks past or present are positioned in relation to one another, each bringing its own history, with the possibility of a new 'star' appearing at any time.

Such a view fits in very well with the work of Massey who, like many of the authors in Keith and Pile's *Place and the Politics of Identity*, argues in favour of understanding place as 'unfixed, contested and multiple'. For Massey, although a place may comprise one articulation of the spatial or one particular moment in a network of social relations, each point of view is contingent on and subject to change.[21] Harvey has also highlighted how the specific qualities of individual places can have certain pitfalls within the context of the expansion of postmodern global capitalism: 'the less important the spatial barriers, the greater the sensitivity of capital to the variations of place within space, and the greater the incentive for places to be differentiated in ways attractive to capital'.[22] From an anthropological perspective, Marc Augé's concept of 'non-place' has been highly influential in critiquing the cultural significance of the specificity of place. His examination of places of transition, such as airports, has

provided an account of places that are unfixed in terms of the activities associated with them and the locational significance ascribed to them.[23]

As an intellectual tool, the 'unfixing' of place operates as a critique of writings in recent human geography and architectural theory that have emphasized the special qualities of particular places as if they are somehow pregiven and not open to change or connected to wider conditions. This work, including Yi-Tu Tuan's notion of topophilia and Gaston Bachelard's concept of topoanalysis, has been invaluable in emphasizing a humane, imaginative and sensual understanding of place.[24] Yet, the focus on 'genius loci', in architecture in particular, has had essentializing tendencies.[25] Harvey and Massey, as well as Kwon and others, stress the importance of understanding the specifics of particular sites and places but only in relational terms as parts of larger networks, systems and processes, physically and ideologically. However, it is interesting to note how in the work of the theorists briefly discussed, the desire to 'unfix' one term, be it space, place or site, usually involves the 'fixing' of another term. In the following three chapters I attempt to use all three terms as different processes involved in critical spatial practice: space in connection to social relations, place as a single articulation of the spatial and site as a performed place. I reserve use of the term location to define the physical position of an art or architectural work.

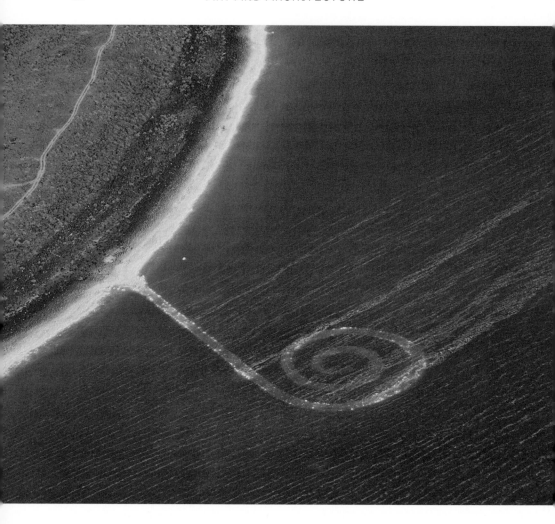

2
Robert Smithson,
'Spiral Jetty' (1970)
Salt Lake, Utah.
Photograph: Cornford & Cross (2002).

Chapter 1

Site, Non-Site, Off-Site

I was sort of interested in the dialogue between the indoor and the outdoor and … I developed a method or a dialectic that involved what I call site and non-site … (it's a back and forth rhythm that moves between indoors and outdoors).[1]

Robert Smithson's 'Spiral Jetty' (1970) was the focus of a conference held at Tate Britain in London in 2001. One of the key issues that emerged from the papers and subsequent discussions was our 'distance' today from works of land art produced in the 1960s and 1970s, both historically and physically. It was suggested that this very remoteness has allowed the work to resonate in more speculative ways, that indeed the imagination of the audience might today be the most potent place land art occupies (fig. 2: opposite page).[2]

'Spiral Jetty', located on the Great Salt Lake in Utah, is an enormous coil that reaches into the lake counter-clockwise. Some 1500 feet long and 15 feet wide where it joins the shore, the jetty is made of 6650 tons of black basalt rocks and earth taken from the site.[3] As part of his desire to 'return to the origins of material' held in the site, along with other so-called land artists such as Michael Heizer, Nancy Holt, Walter de Maria, Mary Miss, Robert Morris and Dennis Oppenheim, Smithson intervened in the landscape on a huge scale, often moving massive quantities of natural material.[4] For a long time, 'Spiral Jetty' was discussed in terms of its impressive size and also, having been submerged by the lake for a long

period, its visibility. Smithson's death in a plane accident in 1973 while surveying the site of another piece of work, 'Amarillo Ramp' (1973), lends 'Spiral Jetty' a heroic quality. Stimulated largely by the film Holt and Smithson made of its construction, more recent criticism has focused on the performative aspects of the work, while artist Tacita Dean's journey to locate the artwork, 'Trying to find the Spiral Jetty' (1997), locates 'Spiral Jetty' as a site of pilgrimage.

In 1965–6 Smithson worked as a consultant artist for an architectural firm called TAMS on designs for Dallas Forth Worth Airport. The project alerted him to ways of working outside the gallery, to consider how works might be viewed from the air and to think about how to communicate aspects of exterior works to passengers in the terminal building. This latter aspect he termed the 'non-site'.[5]

> *I was sort of interested in the dialogue between the indoor and the outdoor and on my own, after getting involved in it this way, I developed a method or a dialectic that involved what I call site and non-site ... so I decided that I would set limits in terms of this dialogue (it's a back and forth rhythm that moves between indoors and outdoors).[6]*

Through his interest in entropy, ready-mades and the monumental forms of industrial architecture, Smithson had been exploring specific sites since 1965.[7] His first non-site was made in relation to Pine Barrens, New Jersey, 'A Nonsite (an indoor earthwork)'.[8] Later retitled 'A Nonsite, Pine Barrens, New Jersey' (1969), this work consisted of bins filled with sand taken from the runways of a little-used wilderness airfield laid out in a hexagonal pattern in the gallery with a photostat map and a text that read:

> *31 subdivisions based on a hexagonal 'airfield' in the Woodmansie Quadrangle – New Jersey (Topographic) map. Each subdivision of the Nonsite contains sand from the site shown on the map. Tours between the Nonsite and site are possible. The red dot on the map is the place where the sand was collected.[9]*

Over the same time period artist Dennis Oppenheim had also been developing an interest in site. In 'Site markers with information' (1967), Oppenheim marked sites with aluminium posts, which he photographed and described in writing.[10]

> *The site markers effectively clouded the traditional distinctions between the artwork and the utilitarian object, and between the art context and the outside world.[11]*

Smithson saw a number of differences between his own and Oppenheim's approaches to 'the dialectic between the outdoors and the gallery':

> *I think that what Dennis is doing is taking a site from one part of the world and transferring the data about it to another site, which I would call a dis-location. … Where I differ from Dennis is that I'm dealing with an exterior and an interior situation as opposed to two exterior situations. … I like the artificial limits that the gallery presents. I would say my art exists in two realms – in my outdoor sites which can be visited only and which have no objects imposed on them, and indoors, where objects do exist.[12]*

The most comprehensive description of Smithson's concept of the dialectical relationship between site and non-site can be found in his 1972 essay on 'Spiral Jetty'. Here he lists the qualities of sites and non-sites. According to Smithson, sites have 'open limits', 'outer coordinates', and include processes of subtraction or the removal of material, combining a physical place with 'indeterminate certainty'. Non-sites, on the other hand, have closed limits, inner coordinates and 'contained information'; they include processes of addition, combining abstraction or 'no place' with a 'determinate certainty'.[13] Although Smithson stressed the relational or dialectical aspect of site and non-site, by sometimes using the term 'non' with a hyphen and sometimes without, the implication is that site is assigned the more privileged position in the relationship.

Inseparable from its context, much land art was intended as a critique of the gallery system and the role of art as commodity. However, resisting the site of the gallery by physically locating work outside does not necessarily involve operating outside the institution of the gallery, economically and culturally. Indeed, many works of land art would not exist without the funding of private patrons.[14] Although land art is often cited as a precedent for public art today, the artists of the 1960s and 1970s did not always aim to make their work accessible. Many works of land art are positioned in remote sites, resulting in audiences of dedicated specialists. Walter de Maria, for example, claimed that 'isolation is the essence of land art', and tightly controlled the photographic documentation of his work and the conditions under which it was to be viewed.[15] The statement below by Robert Morris establishes land art as a paradoxical precedent for the rationale of accessibility that accompanies the 'off-site' programmes of many contemporary galleries:

> *It would not be accurate to designate privately funded early works of Smithson or Heizer or de Maria in remote parts of the desert as public art. The only public access to such works is photographic.[16]*

The Dia Art Foundation has an exhibition programme at the Dia Center for the Arts in a four-storey renovated warehouse at 548 West 22nd Street in Chelsea, New York, but this gallery space is only one of a much larger collection of exhibition venues and artworks sited in other parts of the city and state, as well as diverse locations in far-flung corners of the USA. From its early days the Dia Art Foundation supported projects that because of their nature and scale required unusual locations.[17] For example, one of de Maria's sculptures initially supported and maintained by the Dia Art Foundation is to be found in the high desert of southwestern New Mexico. 'The Lightning Field' (1971–7) consists of 400 stainless steel poles situated in a rectangular grid measuring one mile by one kilometre. To experience the work, you must book in advance to stay in a residence at the site, which takes a maximum of six visitors, and visit at a time of year when lightning is expected. The artist describes how the work is to be viewed:

> The land is not the setting for the work but part of the work. A simple walk around the perimeter of the poles takes approximately two hours. Because the sky–ground relationship is central to the work, viewing 'The Lightning Field' from the air is of no value. It is intended the work be viewed alone, or in the company of a very small group of people, over at least a 24-hour period.[18]

In SoHo, the art district of New York that preceded Chelsea in the history of gentrification, two other works by de Maria – 'The Broken Kilometer' (1979) and 'The New York Earth Room' (1977) – were originally commissioned and continue to be supported by the Dia Art Foundation. At 393 West Broadway, on a polished wooden floor between the grids of iron columns, de Maria placed 500 brass rods in five parallel rows of 100 rods each. Each rod is placed so that the spaces between the rods increase by five millimetres with each consecutive space from front to back. This is the companion piece to de Maria's 'Vertical Earth Kilometer' (1977) where a brass rod of the same diameter, total weight and total length is inserted 1000 metres into the ground.

Around the corner from 'The Broken Kilometer', at 141 Wooster Street, is de Maria's 'The New York Earth Room', an interior earth sculpture 335 metres square and 56 centimetres deep, which, unlike his two other earth room sculptures in Munich (1968) and in the Hessisches Landesmuseum, Darmstadt (1974), still exists. The earth has been treated with chemicals to keep it inert, more like the implacable brass, but the contexts into which these materials have been inserted are in constant flux, culturally and economically as well as physically (fig. 3).

In SoHo rents have risen dramatically since the original commissions 20 years ago. In 'If You Lived Here …', a project also commissioned by

the Dia Art Foundation between 1987 and 1989, ten years after de Maria's work, Martha Rosler emphasized gentrified places as sites of contestation and linked the arrival of art galleries in SoHo to rising property prices. Rosalyn Deutsche has argued of the project:

> *Extending the possibilities opened up by materialist aesthetics, 'If You Lived Here ...' articulated two forms of spatial practice: resistance to the uses of aesthetic space and opposition to the dominant construction of the city.*[19]

Along the street where the Dia Center for the Arts is located is a row of grey rocks, each one partnered by a young tree (fig. 4). The trees are part of Joseph Beuys's project '7000 Oaks' begun in 1982 at Documenta 7, in Kassel, Germany and completed by the artist's son at the opening of Documenta 8 in 1987. Beuys's plan was to plant 7000 trees, each paired with a basalt column, throughout the city and then throughout the world. In 1988 Dia installed five basalt stone columns, each paired with a tree, at 548 West 22nd Street and in 1996 another eight tree and basalt pairs were planted down 22nd Street from 10th to 11th Avenues. Beuys intended the work to be a social sculpture, a work of art made by many and transformed each time a tree was planted and a marker sited.[20] At the time of planting each tree was slender and not much taller than its basalt marker, but soon the trees will grow to overshadow their markers and sometime in the distant future the trees will die and all that will be left will be a line of rocks, looking just as they do today (see also Section 3: Chapter 2).

On top of the Dia Center for the Arts building is 'The Rooftop Urban Park Project', a small urban park with a pavilion set among the rooftops of New York. The pavilion consists of a glass rectangle surrounding a cylindrical form also constructed of glass. The cylinder is almost the same size and shape as the water towers perched on the roofs around. At times you can look through the pavilion and see further in the distance the grids of the façades of the downtown steel and glass skyscrapers and the space on the skyline where the Twin Towers used to be. At other times you are confronted by your own reflection, looking back – glass or mirror? It all depends on where you stand and whether clouds are obscuring the sun at that moment. Like many other works by Dan Graham, this one combines the cube and cylinder. Graham argues that the cube references the grid of the city and modernist architecture, while the cylinder relates the surface of the body to the horizon line. The artist always intended the park to be a place for performance, with timber flooring like that of the boardwalk extending New York City through Battery Park, and rubberized parapet walls so that children could play safely.[21] I am less interested here in considering the project in relation to Graham's intentions than in

3
Walter de Maria,
'The New York Earth Room' (1977)
Long-term installation at Dia Center for the Arts, 141 Wooster Street,
New York City.
Photograph: John Cliett © Dia Art Foundation.

4
Joseph Beuys,
'7000 Oaks' (1982–)
New York City.
Photograph: Cornford & Cross (2000).

identifying key questions that the work raises about the limits of this site for exhibiting artworks. On the roof you are on the outside of a building but still occupying the territory of the Dia Center for the Arts. Are you in a site or a non-site? Or are you off-site? How far from the physical fabric of the gallery does a work need to be to be off-site?

An installation by Mexican artist José Dávila, Camden Arts Centre, London, in 2002, further explores the boundaries between site, non-site and off-site. On my visit to the gallery the room was empty except for a platform made by scaffolding poles and planks running along the edge of two walls next to the windows. Stepping up onto this platform, I walked through the window, from inside to outside, onto a scaffolding gangway two floors above the street. Earlier, on looking up at the building from the street outside, it had appeared that construction works were under way and that this gangway was the site of the workmen's operations, off limits to the gallery visitor; in occupying the scaffolding platform, I was located in both a site and a non-site (following Smithson's definition where the gallery is the non-site and the work is the site), but simultaneously according to more contemporary distinctions, between site and off-site, able to trace the boundary between them with my fingertips.

Dávila's installation marked the start of a major refurbishment of the Camden Arts Centre, and continued 'North London Link', a two-year programme of off-site projects that had started in June 1999.[22] The aim of 'North London Link' was to work with groups and communities within Camden. When Adam Chodzko was invited to make a piece of work as part of this off-site programme, he questioned the notion of an identifiable 'public' and the possibility of producing an 'accessible' work. His intervention, 'Better Scenery' (2000), was 'an escapist proposition', consisting of two signs, one located in the Arizona Desert and the other in the car park of a new shopping centre, the O2 Centre, in Camden.[23] The O2 Centre is a highly simulated environment consisting of fake rock walls, a subtropical forest, water features and palm trees. A slice of Las Vegas on the Finchley Road, it is the kind of place that could easily be described as hyper-real, a simulacrum or an empty signifier.

The plain yellow lettering on the black face of each sign gives clear directions for how to get to the other sign (figs. 5 and 6). Both sets of directions end with the phrase:

> *Situated here, in this place, is a sign which describes the location of this sign you have just finished reading.*[24]

The signs relate the two sites dialectically, giving neither one preference. But in pointing only to each other, their relationship is entirely self-

referential; they make no attempt to relate to their immediate context. Neither sign can be described as marking a site or non-site; the two are entirely equivalent, each one bound up in the other. In speaking only about where they are not, Chodzko's signs critique the ethos of site-specificity and accessibility behind many off-site programmes. If art is placed outside a gallery, why should it be more accessible, how and to whom? If art is placed outside a gallery, should it be closely related to a particular site, which site and in what way? 'Better Scenery' questions the assumptions made about its 'off-site' location and asks the kind of questions we would expect from the kind of fine art discourse firmly positioned within a tradition of conceptual art.

When the Ikon Gallery in Birmingham moved site, artist Tania Kovat, supported by a Royal Society of Arts grant, worked with Levitt Bernstein architects to generate ideas for the new building. Kovat's initiative was to clad the 'plinth' on which the building sits in slate to increase its visual clarity.[25] On my visit, walking away from the gallery through the city, I passed the locations of a number of temporary works commissioned by the Ikon Gallery for *As It Is*, an off-site exhibition launched in 2000 under Claire Doherty's curatorship to focus on the urban issues that arise for a city undergoing rapid urban regeneration.[26] Birmingham's industrial history had left behind a legacy of transport networks in the form of canals and the more infamous Spaghetti Junction. Already in 2000, there were nostalgic feelings about the once hated concrete architecture of the 1960s, soon to be removed, as well as growing cynicism towards the supposedly affluent global future emerging in its wake. Created with composer James Bentley and played by the Birmingham Contemporary Music Group, Pierre Huyghe's 'Concrete Requiem' (2000), an orchestral composition synchronized with a video piece, had been constructed out of the artist's investigation of the city and his response in particular to the failed idealism memorialized by the brutal concrete architecture of the Bull Ring.[27] Along the canal, among the sophisticated designer shops and new bars, Japanese artist Tadashi Kawamata and his collaborators had made a meditation space. The delicate beauty of the raw and seemingly unfinished floating structure described to me formed a counterpoint to the slick concrete, steel and glass buildings going up at that moment along the water's edge. In a conversation I had with the off-site curator, Deborah Kermode, who had facilitated the work, she placed emphasis not on the aesthetics of the outcome but on how the process of working with the various participants had produced a social space at the heart of the project.[28]

In a nearby street, in a neighbourhood undergoing regeneration, set inside a warehouse due to be converted into new luxury apartments, Kermode took me through a seemingly insignificant unlocked doorway

Better Scenery.

Heading north out of London along the west side of Regent's Park is the Finchley Road (A41). Follow it through St John's Wood and half a mile beyond to Swiss Cottage. From here, bearing north-west for a quarter-of-a-mile the Finchley Road veers towards West Hampstead. Keep Holy Trinity Church and the Laser Eye Clinic to your right and Finchley Road Underground station to your left. Then take a left turn, following the graceful curvature of the prodigious, concrete and glass, O2 building. This takes you down a steeply inclined unmarked road which opens out to an expansive tarmac car park bordered to the north and south by the tracks of railway lines.
Situated here, in this place, is a sign which describes the location of this sign you have just finished reading.

5
Adam Chodzko,
'Better Scenery' (2000)
Arizona.
Photograph: Adam Chodzko (2000).

Better Scenery.

From Flagstaff, Arizona take route 89 northeast, then route 510 east, then 505 northeast for 7 miles until you reach a left turn soon after passing Maroon Crater. Follow this dirt track (the 244A) for 6 miles northeast passing the volcanic formations of The Sproul and the Merriam Crater on your right. Half a mile beyond a small well take the track that heads north towards Little Roden Spring. After exactly 6.7 miles a rough, overgrown cinder track leads off to the left. Head west along this for a quarter of a mile until you reach a fence post. Then walk 100 yards 160° south SE. At this point stop and face due east (visible on the horizon are the Roden Crater and the glow of pink rocks in the Painted Desert). Situated here, in this place, is a sign which describes the location of this sign you have just finished reading.

6
Adam Chodzko,
'Better Scenery' (2000)
London.
Photograph: Adam Chodzko (2000).

7
Andrea Zittel,
'A–Z Cellular Compartment Units' (2001)
Birmingham.
Photograph: Courtesy of Sadie Coles.

and up a staircase to the first floor of a warehouse. Looking past the invigilator sitting behind a table with brochures and a sign-in book, I saw that the space beyond was occupied by a structure of ten boxes stacked up, two high, made of metal frames covered in plywood panels in which circular holes had been cut. The whole structure was no more than two metres high. It was possible to crawl in through the entrance onto a pink-carpeted floor. In one place I could stand full height and look into all the rooms; one had a television, another had a computer and two more had sleeping sections with clean white duvets. As I was planning to slip beneath the inviting softness to take a nap, a voice called: 'Can you come back outside and take off your shoes?'

Artist Andrea Zittel had lived here for a short period of time in her artwork 'A–Z Cellular Compartment Units'. Engaging with our aspirations for dwelling, from the hermit existing in splendid isolation to the fun we have playing 'house', the piece raises important issues about housing: the amount of space each person needs, difficulties of sharing living accommodation and the desire to compartmentalize activities. On first glance 'A–Z Cellular Compartment Units' looked a little like a show house at an Ideal Home exhibition, but on closer inspection the construction did not reveal the qualities of a prototype or functional structure. The lack of weatherproof finishes, the omission of any plumbing and the difficulty the construction creates for its occupants in terms of size and scale make it clear that this is not a machine in which it is easy to live. This work might look like architecture but we are not allowed to take a nap here or, with the exception of the artist, take up residence; rather, we are asked to think about what that might mean (fig. 7: opposite page).

Despite being located outside the physical confines of the gallery, the visible invigilation of this particular off-site project, as in many others, operates to maintain the institutional boundary of the gallery and positions the work, in Smithson's terms, as a non-site. In the UK, works commissioned as part of off-site programmes are identified as existing within the gallery system, but usually under a different team of curators from those who oversee the internal spaces of the gallery. 'Off-site' programmes can be initiated as part of an ambition to encourage socially engaged practice – see my discussion (Section 3: Chapter 2) on 'Park Products' (2004) by public works (artist Katrin Böhm and architect Andreas Lang), produced by Sally Tallant of the Serpentine Gallery, London – but they are also carried out simply for pragmatic reasons, for example when gallery premises are compromised by a need to relocate or carry out refurbishments or repairs. There is an expectation, not always made explicit, that these off-site works should be accessible to the general public and aligned with the needs of an educational programme. Thus,

the works, artists and curators connected with off-site programmes are allocated a special role within the gallery system, one that on many occasions, while not openly or formally acknowledged as such, is not assigned the same status as those located inside the physical site of the gallery. For this reason, I would have to disagree with one-time director at the Ikon, Elizabeth McGregor, who in 1999 stated that the distinction between art commissioned inside and art commissioned outside the gallery was becoming 'less and less relevant'.[29] On the contrary, precisely because, within the gallery system, curatorial practices associated with sites outside the gallery continue to be valued as cultural rather than aesthetic production, the differences that exist between sites, non-sites and off-sites demand ongoing critical investigation.

How do the dialectical pairings of site and non-site, site and off-site, get played out in architecture? Although in art discourse the term site-specific usually implies a critically informed response to a site, in architecture the term site tends to define a location that can be measured in terms of physical rather than cultural qualities, such as geometry, geology and aspect. Anita Berrizbeitia and Linda Pollak offer us five ways of thinking about the relationship between architecture and site: reciprocity, materiality, threshold, insertion and infrastructure. In some of Herzog and de Meuron's architecture both reciprocity and material continuity between building and site are suggested through the construction methods chosen. For example, the external walls of 'Stone House' in Tavolo, Italy (1985–8), composed of dry stone walling set within an exposed concrete frame, adopt processes and materials practised historically around the site.[30] At the 'Dominus Winery' in California's Napa Valley (1997), the walls are also constructed of rough stone, yet here the construction technique, the gabion wall composed of wire cages filled with stones, borrows the materials but not the processes from the site – the gabion wall is a method developed through engineering projects rather than vernacular tradition though in this project the technique is used to moderate the extreme temperatures of the location.

In a former quarry in the industrial estates on the outskirts of Barcelona, architects Enric Miralles and Carmen Pinos created the 'Iqualada Cemetery'. Wooden sleepers the length of bodies lie across the main route through the site between tombs stacked up into both hillsides. Each tomb has a concrete surround, a photograph and more often than not a small sprig of flowers. In between the tombs, concrete stairs lead up, while light is cast down through a circular hole in the ground that forms the roof. On the top, one can circle this skylight, which forms a sculpture in the soft grass, and look down into the canyon of graves. For Miralles and Pinos 'ground' is a concept that allows the intersection of architecture,

landscape and memory through the theme of 'embedment'. The action of cutting into the ground is a feature of the site's history as a quarry and its new use as a cemetery (figs. 8 and 9).[31] Such works lie between land art and landscape architecture,[32] resonating with Smithson's interest in artworks that could regenerate post-industrial landscapes and Morris's discussion of 'land reclamation as sculpture'.[33]

So, if for Smithson the site is the work and non-site the location of the documentation of the work, how does this dialectic operate in architecture? In these examples, where the architecture appears to be constructed out of materials taken from the site, the rearrangement of the displaced materials coincides with the location of the physical extraction, producing the 'work' of architecture as simultaneously site and non-site, yet photographs of that architecture might be exhibited elsewhere, defining through dissemination multiple non-sites – published works or exhibition venues. For such an interpretation to hold, it is important that the processes of construction as well as the materials themselves are 'actually' derived from the site and do not only refer to a process of material continuity between the building and the site.

This condition, however, is not usual for architectural production. More commonly, the sites of material extraction are not physically linked to the location where architecture is built, but might be dispersed around the globe. Current debates on environmental issues have been slow to influence the construction industry, yet there are examples of architectural projects that are exemplary in focusing on questions of sustainability. The ethical conditions operating at the sites of material extraction, as well as the distances materials must travel from their place of origin to their point of use, have been questions at the heart of much environmental activism and are most obviously visible in debates on agriculture and food consumption, but are yet to influence the production of urban and architectural space.

Although the reuse of materials found on the site may appear to adopt processes similar to land art, the process of architectural design is so enmeshed in institutional codes that it tends towards producing the qualities Smithson associated with non-site. Smithson's dialectic and a number of the artworks described earlier suggest that a critique of the gallery system can operate by proposing alternative sites for art. Where are the sites architects must investigate and invent for critiquing the systems within which they operate?

In 2000, as part of the *Protest and Survive* show at the Whitechapel Art Gallery, London, Swiss artist Thomas Hirschhorn had a bridge built across Angel Alley between a window of the gallery café and a window of the Freedom Press Bookshop opposite. Visitors to the gallery could cross over

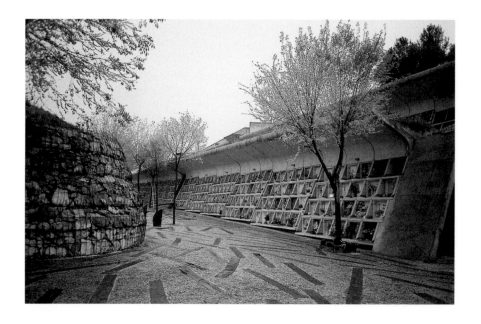

8
Enric Miralles and Carmen Pinos,
'Iqualada Cemetery' (1988–94)
Barcelona.
Photograph: Jane Rendell (1999).

9
Enric Miralles and Carmen Pinos,
'Iqualada Cemetery' (1988–94)
Barcelona.
Photograph: Jane Rendell (1999).

to the bookshop and pick up leaflets on anarchism.[34] A book was published containing all the letters written to gain planning consent for the structure as well as interviews with people describing their opinions of the bridge. Working in a similar manner, Mexican artist Juan Cruz engaged with the cultural processes that regulate planning. In 'Application for a Planning Permit: Proposal to Build a Metaphor', the artist submitted 12 planning applications for different sites in Melbourne. Each was a proposal to build part of a fictitious Castilian village. For Cruz, this village operated as a metaphor for social interaction. For each application he wrote a fictional description of a site in the village. He suggested, for example, that the Melbourne Museum, a site of local gossip and often mistaken by tourists as a hotel, should be a brothel. The project existed as 12 sheets of A1 paper displayed on the relevant sites. When a construction company tendered for one of the proposals, the project threatened to become a reality.[35]

Here, the positions artists occupy allow them to question the premise of an architectural proposal and the complexities of the planning process and building regulations, and to locate this as the site of an artwork. So, although the architectural drawing and the documents describing the construction process can be equated with Smithson's institutionalized gallery or non-site, it is also possible to think of things the other way around and to consider the architectural drawing as the site from which the institution of architecture can be critiqued.[36] There is a long history of architects producing their most innovative work as so-called paper architecture. The relationship constructed between imagined and real becomes quite complicated here. In professional practice, architectural drawings describe an intended physical construction, whereas critical practitioners often use the same codes to question the assumptions implicit in architectural discourse. Here the sites of architectural education, exhibitions and publishing are essential to architectural design in providing places to explore the critical and conceptual potential of architecture.

Chapter 2

The Expanded Field

The field provides both for an expanded but finite set of related positions for a given artist to occupy and explore, and for an organization of work that is not dictated by the conditions of a particular medium.[1]

In her 1979 essay 'Sculpture in the Expanded Field', Rosalind Krauss adopted the term 'expanded field' from Robert Morris as an extended physical and mental terrain for understanding 'sculpture'.[2] Krauss argued that in post-Renaissance art, sculpture was defined as not-architecture and not-landscape, but that modernist sculpture had lost any relation to site, even a negative one, and had become an abstraction or pure negativity. Adopting a technique called the 'Klein' group, Krauss repositioned contemporary sculpture in relation to the positive as well as the negative aspects of landscape and architecture.[3] Within this field, as well as 'sculpture' (not-architecture and not-landscape), Krauss identified three new sculptural conventions: 'site construction' (landscape and architecture), 'marked site' (landscape and non-landscape) and 'axiomatic structure' (architecture and non-architecture).[4]

The central feature of the method Krauss used is called the semiotic square.[5] Based on binary opposition or, in philosophical logic, a contrary or strong opposition, for example black versus white, the semiotic square is capable of generating at least ten positions. First, there are the contradictory or simple negatives of the two dominant terms, non-black and non-white,

10
Bournville.
Photograph: Jane Rendell (1999).

then the complex term, white and black, and finally the neutral term, non-black and non-white. Krauss's expanded field, then, is a setting out of a combination of categories and their negations in an attempt to extend the definition of sculpture. In 1979, Krauss's essay indicated a need to extend the critical discourse of art to accommodate new kinds of artworks being produced in the 1960s and 1970s. It is important, however, not to use the square as a map that defines a finite set of categories but rather to regard it as a mapping that remains open to the emergence of new possibilities. Cultural theorist Fredric Jameson has suggested that the square offers a 'discovery principle', one that can be used to 'map out and articulate a set of relationships'; he emphasizes the importance of understanding the square as dynamic, not static.[6]

Hal Foster has more recently suggested that the expanded field described by Krauss has 'imploded' and that the categories are no longer held in 'productive contradiction'.[7] I wonder if this is the case because it seems to me that the field has exploded rather than imploded and that it is for this reason that the categories are no longer held in tension. Today, definitions and categorizations of art are occurring across multiple disciplines rather than within one, requiring new terms and modes of thinking that allow us to identify the particularities and differences of the various related practices in ways that go beyond opposition. To do this I propose that we need to understand artworks as products of specific processes, of production and reception, that operate within a further expanded and interdisciplinary field, where terms are not only defined through one discipline but by many simultaneously. If artists choose to operate at sites within, at the edge of, between and across different disciplinary territories, for example art, architecture, design and landscape, then they do so by adopting methods that call into question disciplinary procedures. I shall explore this situation through a project that took place in the UK in the late 1990s.

Bournville was built in the late nineteenth century as a village and factory complex, a paternalist development. It was conceived by an enlightened capitalist, George Cadbury, a chocolate manufacturer who wanted to create a pleasant environment for his workers (fig. 10). Despite Bournville being built around a factory, an industrial development, it is modelled on an English village with a green and bandstand, country-style 'cottages' and a row of shops. For *In the Midst of Things* curators Nigel Prince and Gavin Wade invited 27 artists to make artworks at Bournville, both outside and in the buildings themselves:[8] 'We were interested in developing an exhibition that would provide a critique of existing social models and begin to move toward offering new propositions.'[9]

Concern for the single women working in the factory at Bournville had resulted in a 'Women's Recreation Area', a space just for women with

a pond and fountain. The area had been neglected and Cornford & Cross decided to restore it for their project 'Utopia (Wishful Thinking)'. The artists refilled the pond with water dyed purple, installed two splashing fountains and had new paving stones laid around the edges. Purple is the trademark colour of Cadbury's and, along with white and green, is also one of the three colours of the suffragette movement. The dye prevented photosynthesis from taking place, so slowly the plant life in the pond died away. Since the artists spent their budget on repairing and restoring part of the property, in a sense their art is an offering, a gift to Bournville, but as with all gifts, something is expected in return. In referencing the sickly and suffocating effect of paternalism, the work questions the idealism of utopian schemes, suggesting perhaps that the apparently benign aspirations at Bournville have a patronizing and controlling edge. This work being given as a gift challenges the ideology and values of Bournville and demands critical thinking as its counter gift.[10]

At first glance 'Utopia (Wishful Thinking)' could easily be mistaken for a piece of design rather than fine art (fig. 11). It is only the disturbing realization that the dark purple pond water is inert that starts to hint at something other than simple restoration. The work raises a thematic that appears in the practice of a number of other artists invited to participate in *In the Midst of Things* – the crossover between art as a critical venture and design as a creative problem-solving exercise. For example, another project that can also be understood as 'design' consists of the new canopies in the canteen (fig. 12). Katrin Böhm started her research by asking members of staff at Cadbury's if there was anywhere on the site that required an artist who worked with public space and colour.[11] Böhm produced fabric 'canopies' for the canteen in bright stripes of blue and yellow, stating, 'I wanted to respond to a need rather than just go looking for a possibility offered up by the site' (see also Section 3: Chapter 2).

How is this work different from what a textile designer might produce? Why is one thing designated art and another design? These are questions increasingly emerging as a growing number of artists engage in territories usually associated with urban design and architecture.[12] As well as 'looking like' design – a piece of paving or a canopy – these artists adopt design-like working methods, for example responding to a need or fixing things that are broken, activities that would usually fit within the architect's brief or the repair and maintenance schedule. The artists in *In the Midst of Things* appear to be 'designing' objects, but not in the way a designer might. It might be argued that it is the reflexive nature of this mode of practice that makes the work art and not design.

Utopian design visions have often addressed social problems by attempting to solve them. Modernism had it that new designs and spaces

11
Cornford & Cross,
'Utopia (Wishful Thinking)' (1999)
Bournville.
Photograph: Cornford & Cross (1999).

12
Katrin Böhm,
'Canopies' (1999)
Bournville.
Photograph: Gavin Wade (1999).

could determine new forms of social relation. Architecture, as Le Corbusier was keen to point out, was the alternative to social revolution.[13] But the curators and artists involved in *In the Midst of Things* are not interested in a modernist utopia that attempts to solve all the problems of the world through design. The projects that tend towards the utopian in their vision propose questions rather than answers. It is in this sense that art can offer architecture and design a chance to think critically about their recent history and present aspirations.

Gary Perkins makes models of interiors – sometimes of domestic settings, at other times of the insides of lorries and vans. By placing cameras in the models and relaying the image to a nearby monitor, Perkins highlights the viewer's position as voyeur. His work suggests the subversive and fetishist aspects of looking, particularly when we gaze into spaces that have been miniaturized and that locate us as omnipotent subjects. The piece of work Perkins made for Bournville was prompted by a visit to London's Millennium Dome. 'Soon all this will be yours' consisted of a half-circle of rooms complete with the detritus of simple everyday activities like mending the car.[14] Despite being perfectly made and representing ordinary domestic settings, the scenarios Perkins replicates are strangely disturbing. They invite us not only to consider the 'real' spaces or yet-to-be-realized full-size buildings to which they refer, but also to think of them as real spaces in their own right, as miniature worlds.

Placed within architectural discourse, these objects would be understood as scale models of existing spaces or proposals for new designs, but positioned as artworks they can be considered in a different way. Architectural design conventions locate models either as representations of real spaces or as fictions, not as both. Models might be conceptual diagrams to be used as research tools for clarifying an idea or scaled-down replicas of the 'real thing' that demonstrate to the client, developer or end-user the way the building will look and be constructed. Taken out of such a context and presented with no site plan or map, the architectural model can operate both as determination and speculation.

Nathan Coley's 'A Manifesto for Bournville' also uses architectural models but in a different way. The project reworks the famous 'New York Skyline' of 1931, a photograph taken at the Beaux Arts Ball in Manhattan, where the architects of famous buildings, such as the Chrysler Building, came dressed up as their own work. Coley created a series of architectural models that could be worn as hats, including a model of the rest house in Bournville and a Frank Gehry and Mies van der Rohe building. Coley then asked a photographer to take an image of five people with these cardboard models on their heads. A text placed below suggested that the models were responses to an invitation to redesign the rest house (fig. 13).

13
Nathan Coley,
'A Manifesto for Bourneville' (1999)
Bournville.
Photograph: Gavin Wade (1999).

The photograph, measuring six feet by three feet, was placed at the end of a tunnel that ran from the women's recreation ground to the factory. This involved developing a site not previously open to the public. Since the men's recreation grounds were located at the far end of the tunnel, Coley speculated that the tunnel might have been used as a place for secret assignations.[15]

In February 1966, in 'Notes on Sculpture, Parts 1 and 2' (1966), artist Robert Morris argued that, unlike pictorial work, sculpture was not illusionist but had a 'literal nature' and that clearer distinctions needed to be made between sculpture's 'tactile nature' and the 'optical sensibilities involved in painting'.[16] In June of the same year, art critic David Antin wrote that sculpture was 'a specific space in which the observer is thrust, namely it is a place'.[17] Again, in the same year, in October, David Bourdon quoted artist Carl Andre's account of the development of modern sculpture from form, through structure, to place and noted Andre's statement on 'Cuts', his show in March 1967 at the Dwan Gallery in Los Angeles: 'I now use the material as the cut in space.'[18] In the same issue of *Artforum*, in Part 2 of his 'Notes on Sculpture', Morris, following Tony Smith, took up the question of scale and located minimalist work at a human scale between the private object and public monument, as one term in an expanded situation.[19] Robert Smithson describes his own shift at this time from an interest in specific objects to a more relational way of 'seeing' the world, where the works 'became a preoccupation with place'.[20] And Dennis Oppenheim describes 1967 as the year when the 'notion of sculpture as place was manifest'.[21]

The discovery of sculpture as place articulated above by a number of prominent artists was startlingly new in 1966 and 1967. Today, an interest in the relationship between art and space continues to underline much contemporary practice, but what distinguishes this artwork of the past few years from the work of the 1960s and 1970s is the kind of occupation the works require in order to function and the interest in operating 'in terms' of another discipline. The new kinds of artwork in Krauss's expanded field are discussed only in relation to the possibilities they offer for the making and viewing of art. In this sense, her expanded field extends, if critically, the terrain of the gallery. The other structures that populate sites outside the gallery, the diverse practices, meanings and uses that inhabit such locations, are not brought into play by either the artists or the critic. So, is it possible to expand the field, to think of art in terms of the spatial practices that occur 'beyond' the gallery, so that activities that are not associated with art can question what art might be?

At Bournville, many of the invited artists made pieces of architecture that required occupation to allow them to function. Liam Gillick's 'Big

Conference Platform' (1998), a 'canopy' grid of anodized aluminium and perspex jutting out into an interior space above head height, was a continuation of his exploration of the tensions between planning and speculation through the language of architecture.[22] Placed on a green and open at both ends, 'Holy Ghost', Jacqueline Donachie's Quaker-inspired shed-hut, became inhabited by a group singing 'Amazing Grace' and surrounded by a crowd drinking beer.[23] A group of ten kiosks for dialogue created another social space in Lucy Orta's 'Life nexus Fête'.[24] In an attempt to realize a utopian village and free state called AVL-Ville, Atelier van Lieshout made 'AVL-Canteen' by transforming a 40-foot sea container into a kitchen.[25]

Darren Lago's project demanded participation rather than occupation. He worked with the Gardeners' Association to create a series of cabbage beds following the design of a chocolate bar (fig. 14). Chocolate was included in the soil and the cabbages were grown in purple dye so that they looked faintly purplish in colour. 'Chocolate Garden' was planted like a series of ornamental rose beds in the green lawns of Bournville. In England, where a vegetable patch is usually associated with the back garden rather than the flowerbeds of the front garden or park, they felt strangely out of place.[26]

In art critic Hal Foster's reading of minimalism, the sculpture is also off the pedestal in relationship to the viewer, 'repositioned among objects and redefined in terms of place'.[27] Foster argues that the need to create a direct physical relationship with the viewer was part of an attempt to avoid positioning the work as idealist, and that for certain artists minimalism replaced the idealist Cartesian 'I think' and the abstract expressionist 'I express' with 'I perceive'.[28] I suggest that today's artworks located outside the gallery require both perception *and* conception as responses from the subject. In a radical development of the choice Foster describes between the perceptual experience offered by minimalism and the intellectual challenge posed by conceptualism, many works produced for *In the Midst of Things* demanded both intellectual and perceptual engagement, as well as actual inhabitation and active occupation. The scale of Bournville made it possible to walk through the entire site and to see works sequentially and in juxtaposition. A work might occupy the foreground and then recede to become a backdrop, offering the viewer multiple, changing and sometimes conflicting ways of experiencing art. By choosing a place with a contentious social and architectural history for *In the Midst of Things*, the curators offered artists a chance to investigate complex interdisciplinary territories by working with the socio-spatial as well as the aesthetic qualities of certain locations.

14
Darren Lago,
'Chocolate Garden' (1999)
Bournville.
Photograph: Gavin Wade (1999).

What happens when we consider architecture along the lines of Krauss's 'expanded field'? In *Artscapes: Art as an Approach to Contemporary Landscape*, Luca Galofaro points to landscape as the place where artists and architects establish a relationship of exchange.[29] The reduced functional requirements and larger scale of many landscape projects compared with buildings offer architects an expanded field or terrain in which to experiment and engage in operations that would usually be considered the work of artists or landscape designers. Galofaro describes the practice of architects Casagrande & Rintala as an example. In Finland, for '1000 Banderas Blancas' (2000), sheets from hospitals for the mentally ill were attached to three-metre iron bars positioned on a downhill ski slope in Koli National Park. The intention was to commemorate the 'madness of businessmen who cut down the ancient forest in the most beautiful sylvan areas of Finland' (fig. 15).[30]

Projects like these currently being produced by architects might look much like, or even borrow techniques from, the works of many artists in the 1960s and 1970s, but do they operate in the same way? Galofaro suggests that they do and that architects such as Diller + Scofidio (see Section 2: Chapter 2) and Foreign Office Architects (see Section 1: Chapter 3) are playing the role that artists played in the past.[31] In moving outside the gallery in the 1960s artists sought to critique the operations of their own discipline. Have the architects who today have moved into the landscape done so to reflect on the processes of their own discipline? As in *In the Midst of Things*, the question is whether, by adopting certain aspects of another's way of working, one field is expanded to include another, or one can critique the very terms through which the field is defined.

In questioning one of the key characteristics of its own disciplinary practice – the materiality of architecture – I would argue that the work of Décosterd & Rahm operates in this way, creeping into the territory of conceptual art in order to inform and question its own discipline.[32] Décosterd & Rahm wish to make architecture that operates on a presensory level, creating what they call 'a sort of infrafunctionalist architecture', the forms of which are generated within 'the neurological and endocrine space of the body'.[33] In some of their projects, certain conditions or invisible amounts of active ingredients stimulate the atmosphere and trigger particular physiological responses in an attempt to produce an architectural action. For the 'Hormonorium', the Swiss Pavilion at the Eighth Venice Architecture Biennale in 2002, the intention was to dissolve the physical boundaries between the space and the occupants and establish through electromagnetic and biological processes continuity between the two (fig. 16). The 'Hormonorium' was a rectangular space approximately 10 metres by 30 metres with an alpine climate. The white light emitted by

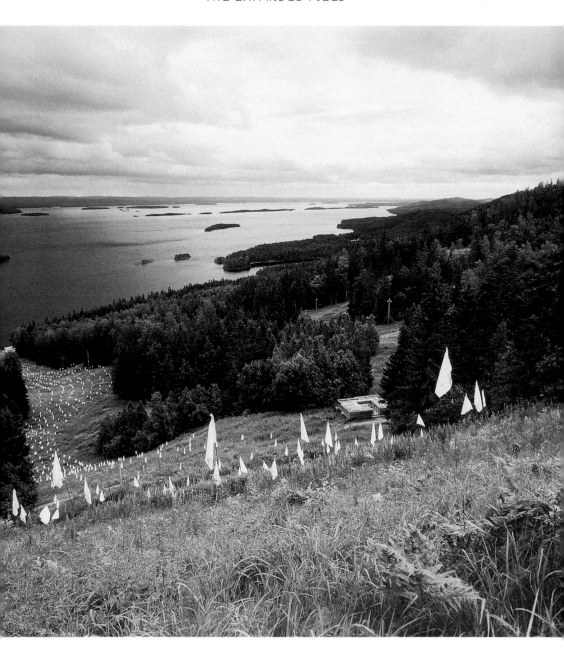

15
Casagrande & Rintala,
'1000 Banderas Blancas' (2000)
Finland.
Photograph: Courtesy of Sami Rintala (1999).

528 fluorescent tubes through the plexiglas of the floor decreased melatonin secretion, reducing fatigue and increasing sexual desire. UV-A tanned the skin while UV-B synthesized vitamin D; the low levels of nitrogen produced the slight euphoria and confusion of an altitude of 3000 metres. This was an architecture Décosterd & Rahm hoped would be experienced through the retina and dermis, 'an endocrine architecture, to be breathed, to be dazzled by'.[34]

The architects' proposal for the 'Salle Omnisports' was also based on biological processes, this time inspiration, expiration, transpiration, condensation, photosynthesis and feeding. However, in this project, the process was reversed – a physiological by-product of activities already taking place in a space, carbon dioxide excreted through exercise was to be used to complement and enrich the building's programme.[35] The intention was that the carbon dioxide and water vapour the occupants lost during exercise would condense on the outer skin of the façade and trickle down to nourish plants growing in the earth positioned between the double glass skin of the exterior wall. These plants were chosen because of their ability to produce certain vitamins and minerals beneficial in exercise, such as asparagus, a vegetable that provides vitamin B_1 and helps increase muscle tone and prevent cramps.[36]

The work of Décosterd & Rahm focuses on an aspect of the architectural design process that places emphasis only on the physiological responses of the occupants in the programming of the space, exaggerating the effect of the architecture to a critical extreme. There are long-standing arguments about architectural and environmental determinism; on the one hand architects are located as the culprit of all crimes and misdemeanours committed in the buildings they design; on the other hand questions are raised about whether architecture has the power to control how we behave. As architects, when we design it is hard not to believe that the places we make will affect the occupiers in the ways we intend, yet this optimistic hope can easily be perverted to create an architecture of control. In creating designs that push architectural determinism to an unhealthy extreme, the architecture produced by Décosterd & Rahm could be said to offer a critique of determinism.

Architectural critic Aaron Betsky has argued that Décosterd & Rahm relish an architecture in which 'there is almost no building, which is usually the measure or ground of architecture. There is nothing left but the ritual, experience, code and effect of architecture itself.'[37] Yet what if we agree that architecture is made as we exhale air and excrete moisture, or that architecture exists in the fleeting glow of an uplifting mood; what then are we to make of what is left, the concrete, steel and glass structures that surround us? What contribution does this inorganic matter make

16
Philippe Rahm & Jean-Gilles Décosterd,
'Hormonorium' (2002)
The Swiss Pavilion, Eighth Architecture Biennale, Venice.
Photograph: Niklaus Stauss, Zurich (2002).

architecturally? For Décosterd & Rahm, it plays a role in supporting physiological triggers, yet paradoxically, their practice hovers, it seems, between delighting in the design of a clean and restrained aesthetic of a highly controlled and functionalist environment, and the removal of all material pleasures, except those that are physiological. It is this paradoxical attitude, the desire to design architecture that is an 'effect' of architecture, that allows their practice to operate critically and question definitions of the architectural design process itself, relating architecture to art and design in a re-invigorated expanded field.

Chapter 3

Space as a Practised Place

In relation to place, space is like the word when it is spoken, that is when it is caught in the ambiguity of an actualization.[1]

For 'Breakdown' (2001), in a vacant C&A store at the western end of London's busiest shopping thoroughfare, Oxford Street, Michael Landy decided to divest himself of all his possessions, from a sheepskin jacket inherited from his father to a drawing given as a gift by an artist friend: 7010 objects in 15 days (fig. 17).[2] For a period of a month, a big conveyor belt was installed inside the store to form a large circuit with men and women in blue overalls positioned inside it at various machines. All kinds of household items, from books to a pair of slippers, each in a plastic bag and labelled with an inventory number, circulated on the belt. The people in overalls, including the artist, engaged in different operations – one removing the plug from a fridge, another passing pieces of wood into a shredder. Behind them, pinned onto the wall, were lists of objects under categorized headings such as 'Electrical Equipment', 'Furniture' and 'Clothing'.

In the context of Oxford Street, any attempt to refuse to buy, let alone to destroy, commodities makes a strong statement, but, however clear the gesture, Landy's artwork raises a number of problems. Landy chooses not to distinguish between different kinds of object – gifts, souvenirs, commodity consumables, originals, replicas – all were broken down.[3] Academic research into collecting, material culture and gift economies suggests that

17
Michael Landy,
'Breakdown' (2001)
London.
Photograph: Artangel (2001).

complex discriminations exist between different kinds of objects. This is an essential aspect of any critique of commodity capitalism, given an added twist if we consider that the economic value of the artworks Landy himself makes will increase in relation to his status as an artist, possibly as a direct result of destroying these objects. But perhaps this is doing Landy a disservice. The bluntness of the breakdown may well be intended to bring us to our senses and make us think about the sheer number of objects in the world as an effect of the increasingly particular knowledge we demonstrate as consumers.

Performance plays a major role in 'Breakdown', in the day-to-day activities that take place on the production line, in the recycling plant and at the landfill site. These actions or spatial practices are referenced by being 'performed' and in the process connections are made to a number of different locations linked to the lives of commodities. What kind of relationship is Landy trying to establish between these locations? And how does he use performance to make his points? Irony, parody, mimicry, all these are modes of performance where the relationship between the 'copy' and the 'original' action differ – some copies aim to be exact replicas of originals, others replicate in order to critique, and yet others exaggerate difference for comic effect. There was a lack of precision in the way Landy broke his objects down. Some were taken apart physically, but not all, and not all to the same extent; some materials were destroyed, but apparently only those that would go through the wood shredder.

It is useful here to return to Michel de Certeau's understanding of the difference between space and place discussed in the Introduction to Section 1 ('Space, Place and Site'). In the case of 'Breakdown', Landy's reference to locations involved in the breakdown of commodities demanded that shoppers reflect on the predominant activity of Oxford Street – shopping or the accumulation of commodities – in an extended manner. There are certainly problems with the work. For example, the decisions Landy made about the actual performance seemed to be based on pragmatic rather than aesthetic concerns, and what he had to say about the lives of different kinds of objects and the ethical issues surrounding consumption is less than clear. Yet, that said, I think it is still possible to suggest that Landy transformed a place into a space. In other words, his art intervention operated as a critical spatial practice by acting out the various spatial practices of destroying or 'breaking down' objects in a location where the spatial practices of commodity accumulation normally predominate; his work provided a 'space' of critical engagement in the 'place' of commodity consumption.

On a cold grey day in June, on a field somewhere outside Sheffield, a fight took place between the police and a huge gang of men in jeans and

T-shirts. Surrounding them, yet held back by a rope, a crowd strained for a view. I stood in that crowd, trying to take a photograph, one that would crop out the man with a microphone, the heads of the crowd around me, the array of hot dog stands and ice cream vans and the film crew taking footage of the event for broadcast on Channel 4. At a certain point I started to realize that my framing endeavours were entirely misplaced, and I needed to document the event 'the way it really was'.[4]

Jeremy Deller's 'The Battle of Orgreave' (17 June 2001) was a restaging of one of the most violent confrontations of the miners' strike that took place on 18 June 1984 in the town of Orgreave outside Sheffield in the UK.[5] Although the site was the same, the cold and windy weather of 2001 compared with the boiling heat of 1984 made the crowd at the start of the day mutter that things were not quite the same as they remembered them. But, at the sound of the cry 'Maggie, Maggie, Maggie, Out, Out, Out', the atmosphere changed; my own fury at the aggression of Margaret Thatcher's policies, the unrealistic characterization of the mineworkers, the dismissal of the unions, all this came flooding back to meet, in the dreadful wake of Thatcherism, an apparent lack of dissent. I felt vaguely uncomfortable with such a powerful emotional response. Although I had an affinity with Sheffield – I had chosen to live there because of what the place represented to me: 'the socialist republic of South Yorkshire' – I was not a miner and I had not been in Orgreave on that day in 1984.

As a historian, I am slightly sceptical of empathy or speaking on behalf of the other on the one hand and the ease with which authenticity is ascribed to experiential accounts of the past on the other. In Orgreave that day miners and their families were keen to discuss the battle and its ensuing ramifications. Local opinion seemed to favour Deller's work and not everyone was worried about whether the acting out of events was an 'accurate' reconstruction of the past; some even focused on the importance of the 2001 event as an act of remembrance of the past in the present. Although Deller involved a battle enactment society to restage the battle, some of the miners chose to play themselves and some sons played their fathers, though only one policeman played himself. The presence of cameras filming the battle for broadcast as a documentary film directed for television by Mike Figgis enhanced the role-playing aspect of the event, prioritizing a consideration of the 'facts' not as they had occurred in the past but as they were being constructed in the present (fig. 18).

In its desire to examine a moment of resistance, Deller's work is clearly a piece of political art in a socialist tradition, but I am not convinced it is a piece of revolutionary history. Despite what we now know of the media's distortion of events, of their misrepresentation of police actions in a battle that served to undermine the power of the trade unions, Deller portrayed

the day in a fairly even-handed manner as a battle of two sides, miners and police. Somehow, I would rather he had been a bit more Benjaminian (see Section 2: 'Introduction') and had 'brush[ed] history against the grain', seeking to question the ways in which history usually supports the view of the victors.[6] After all, Orgreave marked a turning point in the strike and the first use of military strategies by the police for settling resistance. Perhaps by appearing to fall in line with 're-enactment', pursuing a dogged desire for so-called historical accuracy in replaying the battle scenes, Deller's approach revealed a certain irony and a mode of telling that, in pointing to its own obsession with historical facts, suggested that history writing is always a performing of the past in the present, even when those with a socialist ambition aim to draw from those strikes and struggles what has previously been ignored.

In recreating a political struggle that took place at a specific moment, 'The Battle of Orgreave' points to the importance of time in the practising of place, something that remains underdeveloped in de Certeau's theoretical propositions on space and place. By drawing on the importance of history in our understanding of certain sites, Deller's work shows how an act of remembering the past can reconfigure a particular place as a critical space in the present; for me, this act of reconfiguring could be described as a critical spatial practice. 'The Battle of Orgreave' points to the revolutionary potential offered by a specific historical moment and the importance of repetition as a way of recognizing this and keeping its potential alive in the present.

Deller's and Landy's projects were commissioned by Artangel, an agency that selects, funds and helps artists produce mainly temporary work for unusual locations in the UK, specifically in London.[7] From magazine inserts to short films for television, from an empty club house in London's West End to a suburban storage centre, the pattern of sites mapped by Artangel projects follows the choices of the artists with whom it has chosen to work. It is interesting to compare this approach with that of the Public Art Development Trust (PADT), a public art consultancy set up by Sandra Percival, for whom the starting point in a project has been the decision to work in a certain location, allowing the chance for one piece of work to build on another.[8] Many of PADT's projects have been long term, lasting between three and five years, emphasizing the importance of periods allocated for research and testing ideas on site.[9]

Work on the River Thames in London started in 1991 with funding for a selected number of artists to research the river for extended periods of time. Entitled the 'Thames Archive Project', this research ran in parallel with work undertaken by the Countryside Commission to construct a path along the Thames between 1993 and 1996. PADT chose Andrea Bulloch

18
Jeremy Deller,
'The Battle of Orgreave' (2001)
Sheffield.
Photograph: Cornford & Cross (2001).

and Henry Bond to produce artworks.[10] Between 1993 and 1995 Bond made eight hours of video footage documenting his walks along the river, resulting in a 26-minute film shown at the Design Museum, reformatted as inserts on Channel One, and finally as a book of stills, *Deep Dark Water*.[11] Bulloch's 'From the Chink to Panorama Island' (1994–6) was a recording of a walk between two defining points of the river that focused on the loading bay opposite what is now Tate Modern, which Bulloch renamed 'Panorama Island'. Here, Bulloch exhibited her archival material along with her idea to replant the jetty with imported tree species and organized a party to light up the jetty over several hours so that it gradually became redder, with its new name projected onto it in white light.

The Thames River Project intersected with PADT's programme of work for 'Fourth Wall', part of London National Theatre's public art programme, which included commissions of new works for projection onto the Lyttelton flytower and other sites around the building.[12] These early projects informed the thinking and ideas behind the second phase of the Thames project, the Thames and Hudson Rivers Project, envisaged to occur over a two-year period in London and New York City, with PADT operating in parallel with Minetta Brook.[13] The intention was to take a group of artists and commission new works for the River Thames waterfront between the South Bank and Canary Wharf in London, and the Hudson River waterfront between Battery Park City and 59th Street in New York City.[14]

Roni Horn's project took the final form of a book, *Another Water*. In her research, Horn became interested in the relationship of rivers to death, drowning, misadventure and suicide. Between 1995 and 1996 Horn investigated the causes behind the dead bodies found in the river through the Metropolitan Police Thames Division's reports of deaths in the River Thames and photographs of the surface of the river. These images are not what we would expect from water; they are sinister, dark, choppy and brooding. In her book, Horn subverts the usual sets of relationships that exist between image and writing in much textual material, where images illustrate or support the writing and where footnotes either provide the foundation or give detail to the research. In *Another Water* the observational images of the surface of the water are the main 'reading material', but they are punctuated by technical accounts of deaths in the Thames. The footnotes, rather than substantiate and expand the findings of the research, provide a series of subjective asides. They comprise different descriptions and comments about water and rivers written in the first person by Horn: more complex still, they cross-reference one another.[15]

Like the Internet, books are public sites accessible to diverse audiences, but not usually regarded as 'physical' locations. However, it is important to recognize that these kinds of sites have specific formal limits and material qualities, for example the size and layout of words on a page, and that they are produced through particular spatial practices or habits of use, 'surfing the net' as well as reading a book. Horn's work points towards how different texts, from the empirical account constructed through careful and systematic research to the more poetic reverie, can, by drawing attention to the spatial ways in which we read images and words, main texts and footnotes, produce critical spaces through the act of reading, asking us to question the relation of fact to fiction in the writing of a cultural history of a place.

In many other cities around the world there are similar organizations, each with its own particular approach to commissioning artworks in the sites in which it operates. In New York, the Public Art Fund (PAF) curates work for certain predetermined sites like Madison Square Park, City Hall Park, the southeast corner of Central Park and the Metro Tech Center in Brooklyn, as well as a number of more unusual locations in the city that the different artists with whom it decides to work choose.[16] While early projects included making community gardens and large-scale public sculptures, in more recent commissions we see a change in direction, not only in the kind of sites chosen but also in the artists' choice of media and process.

In the last couple of years a number of projects have operated across multiple sites, developing an understanding of one place by referring to another. A good example is the 1800-hour recording of a family of chicks reared in New York State's Sullivan County, played in real time for the duration of their development to adulthood on monitors at the base of the World Trade Center. For Paul Pfeiffer's 'Orpheus Descending' the chicks were filmed 24 hours a day by three cameras, from incubation, to hatching at 17 days, to the 75th day when they became classified as adult chickens. At the end of the footage the monitors reverted to displaying passenger information for commuters travelling to and from New Jersey by PATH trains. Locating the work here meant that the viewer had to make connections between the everyday existence of a chick growing up and the day-to-day life of a commuter travelling to and from work five days a week.[17] As PAF director Tom Eccles points out, this work demands to be understood over a period of time; 'Orpheus Descending' only reveals itself slowly, a characteristic rarely discussed in the more spatialized discourse surrounding public art.[18]

By conducting a socially engaged exploration of a place, a space of critical engagement is created, elaborating de Certeau's understanding of

space as a practised place. By positioning the activities of one location in another, relating the temporal nature of the practices that occur in them, Pfeiffer juxtaposed the monotony of the repetitive daily journey of the commuter to the progressive but soon-to-be-ended day-to-day cycle of chicks growing up. Connecting the two locations transformed both from places of unquestioning conformity to spaces of critical debate, potentially raising issues about the monotonous activity of work and poultry farming as well as about ageing. This kind of project demonstrates that site-specific work is not necessarily a condition of 'undifferentiated serialization' of 'one place after another' as art critic Miwon Kwon anticipates (see Section 1: Chapter 1) but instead, by considering the particularity of one location in relation to another, certain artworks produce sites that can be understood in terms of de Certeau's transformation of place as conformity into space as transgression, as well as cultural geographer Doreen Massey's emphasis on the importance of 'unfixing' place, mentioned in the Introduction to Section 1.

How does architecture engage with spatial practice? As I have discussed above, spatial practices such as performing one activity in the location of another or restaging a historical event have the potential to be transformative, to turn spatial practices into critical spatial practices. If, by performing practices, art can focus attention on the critical possibilities of a location, encapsulated in a particular moment in time or set of activities, do similar processes operate in architecture?

Work by Rem Koolhaas and the OMA (Office for Metropolitan Architecture) has emphasized the importance of researching the activities that already exist in urban locations, bringing these to the centre stage of architecture, as well as documenting the design process and publishing this as visual material along with images of final buildings. Published in 1995, *S, M, L, XL* brought together different modes of writing – description, proposition, manifesto, diary, fairy tale, travelogue and meditation on the contemporary city – along with documentation of the design work produced by OMA over the past 20 years, all arranged according to scale.[19] Presented in a documentary fashion, yet mixing the real with the imaginary, fact with fiction, research and documentation of the activities or practices active in a location prior to proposing a design are positioned alongside design processes from conceptual ideas to construction drawings of completed buildings.

At the same time, with students at the Harvard Graduate School of Design, Koolhaas started to focus on a number of large-scale research projects, including one on shopping.[20] Other projects included research into the intensive urbanization of the Pearl River Delta from Hong Kong to Macao and a case study of West African urbanization in Lagos,

Nigeria. Back in 1990, Alejandro Zaera Polo, now of Foreign Office Architects (FOA), described OMA's design tactics as two-pronged, both adopting the use of irony as a 'negative non-affirmative critique of the modernist Utopia' and reintroducing experiential subjectivity or desire into everyday reality through various scenarios.[21] Today, art critic Hal Foster believes that 'of anyone in the present' in architectural or design practice, Koolhaas is most able to 'ride the dialectic of modernization', in other words to bring out the contradictions of modernity – in Foster's view, the tension between 'social transformation and subjective liberation', and in my own, the tension between celebrating the advantages of advanced consumer capitalism and critiquing the social injustices this has produced.[22] Occupying such a position has led Koolhaas to make some ambiguous moves, for example to produce a critique of shopping in his research yet also to serve as house architect of Prada. While contemporary museums borrow modes of displaying objects from sites of commodity consumption, this design for a shopping space draws on the architectural devices used in museums and theatres, building types designed for displaying objects and bodies, allowing, for example, an area of the shop to be used as a performance theatre at night. However, playing on Koolhaas's own terms, Foster suggests that the design is 'likely to be more "Disney Space" than "alternative space"'.[23] And, although Foster praises Koolhaas's ability to provide 'critical insight and provocative schemes', he believes that his method of 'systematic overestimation', while intending to provide a critical reversal, instead 'lapse[s] into glib conflation', concluding that the problem with Koolhaas's practice is that it innovates but without any purpose.[24]

Koolhaas's focus on research, process and documentation in architectural design, and on pragmatism rather than ideology, has had a huge influence on contemporary architecture and architectural publishing, perhaps most visibly on Dutch architecture. The book *Meta City Data Town*, based on a video installation of the same name produced by the architectural practice MVRDV, is a publication that primarily deals with numbers.[25] An object-book similar to OMA's *S, M, L, XL* and MVRDV's own *FARMAX*, it is a dense document that combines visual imagery and typography in an intense engagement with the world of statistics. Through visual number-crunching MVRDV point out that statistics are not empirical facts but instances of speculation that can provide interesting raw material for spatial invention. Numbers can suggest a different way of designing architecture and cities through 'what if' scenarios. MVRDV argue that datascapes, or visual articulations of statistics, have an 'aesthetic appeal of their own' and are capable of generating schemes or architectural projects. According to architectural theorist Bart Lootsma, datascapes are 'updated versions of what architects used to refer to as the

site or the plot'.[26] This suggests that the research involved in the process of designing architecture, including the collection and interpretation of statistics, can be thought of as a site for architectural practice, in a way similar to the drawing, as discussed in Section 1: Chapter 1. Datascapes can be understood as sites where critical investigations into the status of so-called facts and objectivity take place, and where what is usually considered as the documentation of design research processes becomes understood as formal proposition.

Architects FOA (Farshid Moussavi and Alejandro Zaera Polo) also appear to have been influenced by the pragmatism of Koolhaas's approach, adopting quantitative rather than qualitative research methods. They believe that architecture has suffered from looking to sociology, cultural analysis and politics for legitimation. When FOA borrow from other disciplines, they favour instead science and geometry where they believe they can find processes that are architecture-specific in order to make links that are literal and based on material processes. FOA find the scientific model interesting because it is rigorous, and according to Moussavi and Zaera Polo, architecture, as a professional activity, needs rigour.[27] For FOA, rigour is not only rational and positive, but can also be used to 'create as well as solve problems'.[28] It is through the rigorous application of formula rather than artistic gesture that FOA's architecture is generated.

FOA believe that in the current global marketplace the identity of an architectural practice is of key importance and that the 'level of information and competition between locations' has rendered the older mode characterized as 'a practice of stylistic consistency' obsolete. FOA are interested instead in a practice that seeks to find a balance between similarity and difference. In seeking to classify the projects created between 1993 and 2003, they have chosen to adopt a term from the natural sciences, 'phylogenesis', whereby 'seeds proliferate in time across different environments, generating differentiated yet consistent organisms'. This process has allowed the production of a system of classification for FOA's architectural design work to date, which emerges from the material itself, from the 'existing populations', generating a taxonomy that is based on morphology rather than type.[29]

For the 'Yokohama International Port Terminal' (1996–2002), an early FOA project, the client's initial concept of 'niwa minato', a mediation between the garden and the harbour or between the inhabitants of Yokohama and the outside world, became interpreted by the architects materially. They decided to develop the building as an artefact or 'mediating device' between two social systems, 'the system of public spaces of Yokohama and the management of cruise-passenger flow'.[30] A focus on providing

circulation routes that offered different paths to the end of the pier and back, what they called 'the no-return diagram', and a desire to keep the building from appearing on the skyline and becoming a 'sign',[31] produced an 'architecture without exteriors', a design in which the surrounding land became the roof of the building projecting like a jetty into the water (fig. 19).[32] The landscape provided FOA with an opportunity to explore their interest in critiquing the figure–ground relation in architecture, where instead of the building in its location being thought of as a 'figure in or on the ground', the ground becomes the figure, 'the ground as a figure, the surface as a space', producing an architecture they describe as:

> *a highly differentiated structure, a seamless milieu which allows for the broadest number of scenarios: an ideal battlefield where the strategic position of a small number of elements will substantially affect the definition of the frontier. Mobile or collapsible physical barriers and surveillance points will enable the reconfiguration of the borders between territories, allowing the terminal to be occupied by locals or invaded by foreigners.*[33]

The need for architecture to operate in the service of global capitalism presents architects with a difficult situation. Since most buildings are responses to demands for programmes that support capitalism and the commodity consumption that goes with it, it seems that contemporary practitioners and their critics understand the potentials and dangers of this situation in different ways. FOA's approach could be compared with the work of many Dutch offices of the 1990s, which, according to Michael Speaks, focused pragmatically on what was '"just there", on the constraints and limitations of a global market', which they saw 'not as an evil to be resisted but a new condition of possibility'.[34] So, unlike cultural geographer David Harvey discussed earlier, who worries about the co-option of the diversity of place by postmodern capital, FOA, quoted by critic Lootsma, claim that globalization has created an 'artificial regionalization' that has enhanced diversity.[35] As discussed in relation to Koolhaas where Foster sees the dangers of conflation in overestimation, cultural theorist Fredric Jameson is more hopeful for the critical potential of irony in architecture as a way of negating certain actions and systems while appearing to repeat them. Jameson has suggested the minimal gesture as the 'almost imperceptible point' where 'replication turns around into negation'. In his view 'a minimal gesture' is what allows one 'to replicate the city fabric, to reproduce its logic, and yet maintain a minimal distance that is called irony and allows you to dissociate yourself ever so slightly'.[36]

Yet the architectures of FOA and OMA, who celebrate the diversities and tensions offered by global capitalism, are so closely blended with

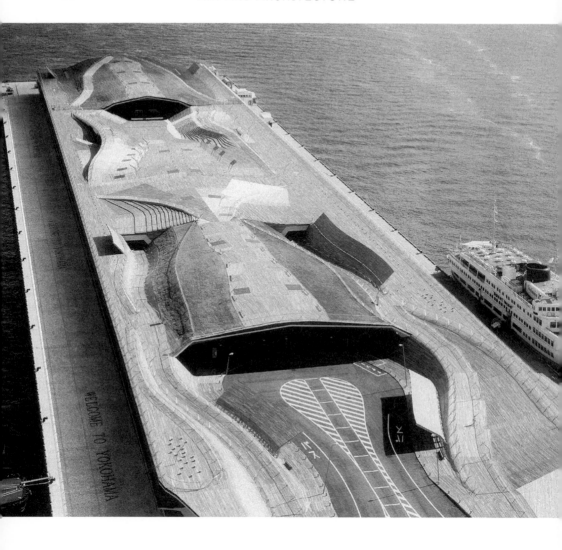

19
Foreign Office Architects,
'Yokohama International Port Terminal' (1995)
Japan.
Photograph: Satoru Mishima (1995).

normative situations that it is hard to find signs of resistance. Could FOA and OMA, along with MVRDV, and numerous other contemporary practices, be producing an approach to architectural design that is ironical and therefore critical, or does their work simply slip without trace into the normalized activities of commodity capitalism?

Section 2

Between Now and Then

Introduction

Allegory, Montage and Dialectical Image

Section 2: 'Between Now and Then' is concerned with artworks and architectural projects that reconfigure the temporality of sites, repositioning the relationship of the past and the present in a number of different ways. This introduction discusses aspects of the work of cultural critic Walter Benjamin, whose writings have addressed how history is written and is understood in the present, and whose concept of the dialectical image has great relevance for those interested in art and architecture, for it provides a way of thinking about temporal issues through visual, material and spatial registers. Here I focus particularly on Benjamin's discussions of the temporal aspects of allegorical and montage techniques in works of art.

In *The Origin of German Tragic Drama (Ursprung des deutschen Trauerspiels)* conceived of in 1916 and written in 1925, Benjamin discusses *trauerspiel* (a particular form of baroque theatre based on royal martyr dramas) as a play of sorrow, a ceremonial and ritualized expression of grief, where the hero is both a tyrant and a martyr, both sovereign and Christ, part man and part god, grounded in history rather than myth, and emphasizing the corporeal as well as the transcendental.[1] In these dramas sadness at the transience of life was represented, for example, as nature petrified in the form of fragments of death, skulls and corpses, and as civilization disintegrating as ruins of classical monuments and buildings – both were understood as allegories of the human condition. Benjamin stated that 'allegories are, in the realm of thoughts, what ruins are in the realm of things'.[2]

The figure of the ruin highlights a key aspect of allegory for Benjamin – its relation to time. He notes in baroque allegory 'an appreciation of the transience of things', as well as an expression of sadness over the futility of attempting to save for eternity those things that are transient.[3] Benjamin's study of the baroque also focused on allegorical engravings of the sixteenth century such as Albrecht Dürer's 'Melencolia' (1514), in which he describes the 'utensils of active life', as well as tools of creative pursuit, 'lying around unused on the floor' next to the figure of melancholy personified, as 'objects of contemplation'.[4] The category of time is key to Benjamin's definition of allegory, where in relation to the 'mystical instant' that for him defines the symbol, allegory is understood as 'contemplative calm'.[5] Cultural theorist Susan Buck-Morss has drawn out the importance of the temporal in Benjamin's definition of allegory, how in allegory 'history appears as nature in decay or ruins' and the temporal mode is 'one of retrospective contemplation'.[6]

Another important aspect of the allegorical method, according to Benjamin, is its focus on the image as an 'amorphous fragment' rather than an 'organic totality', where, rather than singularity, an ambiguity or multiplicity of meaning is produced.[7] Architectural theorist Jennifer Bloomer notes that, in Benjamin's unique understanding, allegory was 'analogous to the ruin' and was 'constructed of fragments'.[8] Art theorist Peter Bürger has defined Benjamin's understanding of allegory as a four-part schema that involves, first, the isolation of an element as a fragment and the removal of that fragment from its context; and second, the combination of various isolated fragments to create meanings other than those derived from the fragments' original locations. The third important aspect of Benjamin's understanding of allegory for Bürger is his interpretation of the allegorist's activity as melancholic, where the melancholic gaze of the allegorist causes 'life' to be drawn out of the objects she or he assembles; finally, Bürger considers the viewer's reception of allegory in which history is represented as decline rather than progress.[9]

So, for his commentators, Benjamin's study of allegory develops a number of temporal qualities, in particular a focus on the fragment as ruin and on melancholia as an attitude of retrospective contemplation. Benjamin's own major work, the unfinished *Passagen-Werk* or *The Arcades Project*, was composed of fragments, including both quotes collected by Benjamin and words written by him between 1927 and 1939, and focused on a particular ruin – the Parisian arcade.[10] Benjamin's specific interest in the Parisian arcades of the early nineteenth century, along with certain material fragments, for example dust and mannequins as well as figures like the collector, the ragpicker, the detective, the flâneur, the gambler and the prostitute, concerned their role as dialectical images. And, in an

initial intellectual 'sketch' of the project, he described it as 'a dialectical fairyland'.[11]

Dialectical thinking involves the clarification of ideas through discussion, specifically contradiction; an initial thesis is opposed by an antithesis, and resolved through a synthesis of the two terms, which can in its turn become a new thesis. According to Benjamin, as thesis the arcades 'flower'; they are palaces of commodity consumption and the wish-images of the dreaming collective of the early nineteenth century. As antithesis, in the early twentieth century, the arcades are in decline; they are ruins, no longer desired by the consuming populace.[12] 'From this epoch [1840s] spring the arcades and the interiors, the exhibition halls and the dioramas. They are residues of a dream-world. … With the upheaval of the market economy, we begin to recognize the monuments of the bourgeoisie as ruins even before they have crumbled.'[13]

As synthesis, the arcade is a dialectical image – an image of dialectics at a standstill – a moment where the past is recognized in the present as a ruin that was once desired. Buck-Morss has pointed out how for Benjamin this was the 'point at which thesis and antithesis converged. "Dialectical images" were meant to illuminate this point.'[14] Benjamin's concept of the dialectical image is far from straightforward, yet it is distinct in its attempt to capture dialectical contradiction in an instant as a visual image or object, rather than as an unfolding of an argument over time: 'The dialectic, in standing still, makes an image.'[15] This is perhaps clearest in the following statements he makes concerning the dialectical image:

> *It's not that what is past casts its light on what is present, or what is present its light on what is past; rather, image is that wherein what has been comes together in a flash with the now to form a constellation. In other words, image is dialectics at a standstill. For while the relation of the present to the past is a purely temporal, continuous one, the relation of what-has-been to the now is dialectical: is not progression but image, suddenly emergent.*[16]

The ruin that features in baroque dramas in terms of decay and disintegration, and as a site for a melancholic reflection on the transience of human and material existence, as a dialectical image in the *Passagen-Werk* becomes politically instructive. The arcade, an architecture that in the early twentieth century no longer represented the desires of the population, could be seen to stand for the transitory and destructive nature of capitalism. Buck-Morss argues that Benjamin's hope was that the shock of recognition produced through the dialectical image would 'jolt the dreaming collective into a political "awakening"'.[17] For Benjamin, a key quality of the dialectical image is its ability to produce shock, to create

a moment when the usual patterns of thinking and everyday living stop
and new ones are given the chance to emerge: 'Thinking involves not only
the flow of thoughts, but their arrest as well. Where thinking suddenly
stops in a configuration pregnant with tensions, it gives that configuration
a shock.'[18]

The techniques of montage can be said to produce just such an
experience in the viewer. Buck-Morss discusses how, in the work of John
Heartfield, montage techniques operate to switch two sets of signifier–
signified relationships in order to question dominant ideologies. In, for
example, 'Deutsche Naturgeschichte', a photomontage of 1934, Heartfield
places images of the heads of men who rose progressively to power in 1930s
Germany – Ebert, Hindenberg and Hitler – onto images of the stages
of development of the Death's Head moth – as caterpillar, chrysalis and
moth – suggesting a causal link between the Weimar Republic and fascism.
These are located on a dying branch, a further juxtaposition that makes the
viewer rethink progression in terms of disintegration or decay. The image,
in the tradition of the emblem, has a title and a caption. In the caption, the
title, 'Metamorphosis', is defined in terms of history and nature, but also
in terms of myths – those that describe transformations of human beings
into animals. The caption both explains the image and provides a way of
reading it critically, putting forward the suggestion that political history
has been presented as natural evolution. Buck-Morss argues that this work
of Heartfield's combines an allegorical form of representation with the
modern techniques of photographic montage.[19]

From evidence found in his correspondence, Buck-Morss suggests
that Benjamin had seen and was influenced by this Heartfield montage.
Certainly, Benjamin admired the use of montage in film and the shock
tactics of Dadaist artwork, which he described as 'an instrument of
ballistics' that 'hit the spectator like a bullet'.[20] For Benjamin, montage
was a progressive form because it had the ability to 'interrupt the context
into which it is inserted'.[21] According to Bürger, although montage is,
like allegory, an assemblage of fragments, what makes montage a distinct
aesthetic procedure is its lack of 'synthesis' or 'unity of meaning'.[22] The
defining quality of montage is the artwork's refusal to provide synthesized
meaning, and it is this that produces shock in the viewer.[23]

To argue for shock as a progressive way of experiencing artworks,
Benjamin differentiated between concentration as the optical mode of
viewing a painting, in which the work absorbs the viewer, and distraction
as the tactile experience of architecture, in which the viewer absorbs the
work: 'Distraction and concentration form polar opposites which may be
stated as follows: A man who concentrates before a work of art is absorbed

by it. ... In contrast, the distracted mass absorbs the work of art. This is most obvious with regard to buildings.'[24]

Benjamin argued that it was through film, where the public occupied the position of critic and where montage was used as an aesthetic process, that art was able to '[meet] this mode of reception halfway', and create an experience where the 'absent minded' viewer was able also to examine the work.[25] This kind of politicized art operated in support of social change and communist revolution, to politicize aesthetics, unlike the fascist mode, which in aestheticizing politics worked the other way.[26]

The technique of montage construction that Benjamin admired, he aimed to use in his own writing. Indeed, Benjamin describes his own method, in for example the *Passagen-Werk*, as montage: 'Method of this project: literary montage. I needn't say anything. Merely show.'[27] 'The first stage in this undertaking will be to carry over the principle of montage into history. That is, to assemble large-scale constructions out of the smallest and most precisely cut components.'[28]

In 'One-Way Street', for example, written between 1923 and 1926 and published in 1928, a meditation on the changing economic conditions of 1930s Russia, structured as a walk down a street, each of the 60 sections plays on the juxtaposition between the subtitle and the following prose piece.[29] The subtitles, which often consist of words and phrases taken from objects, signs and shop windows, are not related to the texts placed beneath them in obvious ways, but rather the relation of apparently unconnected thoughts and sentences borrowed from the city itself suggests alternative ways of reading and interpretations that might otherwise be overlooked.[30] Buck-Morss tells us that 'Benjamin described *One Way Street* as a "*vexierbilder*" or optical puzzle'.[31] In her view the short passages 'combined philosophical subtlety with a certain playfulness, a delight in those double entendres and unexpected juxtapositions which were the source of humour in puns, or picture puzzles'.[32]

Commenting on the construction of Benjamin's texts, literary theorist Sigrid Weigel suggests that the 'thought-image' (*Denkbild*), a term that Benjamin used to describe his 'shorter text-pieces', is key to understanding his thinking as well as writing processes:[33] 'His thought-images are as it were dialectical images in written form, literally constellations-become-writing.'[34] Weigel argues that Benjamin's texts are 'attempts to mimetically re-enact the constitution of meaning in the image', in other words to produce a written version of the visual dialectical image rather than an explanation of it.[35] Weigel examines this thesis carefully in relation to Benjamin's writing on Paul Klee's 'Angelus Novus' (1920), an artwork that Benjamin bought in 1921 and that remained one of his most important

possessions.[36] In the 'Theses on the Philosophy of History', the text begins with a poem by Jewish scholar Gershom Gerhard Scholem, followed by a passage written by Benjamin:

> *My wing is ready for flight,*
> *I would like to turn back,*
> *If I stayed timeless time,*
> *I would have little luck.*
> (Gerhard Scholem, 'Gruss vom Angelus')

> *A Klee painting named 'Angelus Novus' shows an angel looking as though he is about to move away from something he is fixedly contemplating. His eyes are staring, his mouth is open, his wings are spread. This is how one pictures the angel of history. His face is turned toward the past. Where we perceive a chain of events, he sees one single catastrophe which keeps piling wreckage upon wreckage and hurls it in front of his feet. The angel would like to stay, awaken the dead, and make whole what has been smashed. But a storm is blowing from Paradise: it has got caught in his wings with such violence that the angel can no longer close them. This storm irresistibly propels him into the future to which his back is turned, while the pile of debris before him grows skyward. This storm is what we call progress.[37]*

Weigel argues that his thought-images need to be understood as composed of discontinuous pieces, and that 'Benjamin's endeavour to capture dialectic in the image ... only really achieve[s] success with his read or written images'.[38] Philosopher Howard Caygill's work on Benjamin reinforces this position, placing emphasis on the process of writing dialectical images. Caygill suggests that over his life Benjamin's mode of critique changed from drawing out the 'constructive principle' of a work, to becoming 'part of the speculative effort to discover and invent new forms'.[39] Caygill describes Benjamin's work as 'sensitive to the incompleteness of a work and the negotiability of its formal limits ... dedicated to revealing the unrealized futures inherent in the work'.[40] If this is the case then it is vital that we position the dialectical image between the critic's writing and the artwork positioned 'under' critique. In this way, we can argue that the critical potential of a work or phenomenon is located not only in the internal contradictions held within the visual image or spatial construction itself, but also in the relationship produced between the work and the criticism.

As described at length by his friend, the scholar of Jewish mysticism, Gershom Gerhard Scholem, Benjamin's thinking on Klee's angel was a long-term project that took place through a changing series of reflections on the relationship between the angel's patience and his own personality,

particularly in relation to affairs of the heart – specifically with respect to his emotional experience of unrequited love.[41] So, while Benjamin was keen to prioritize the political imperative of the objective intentions of the dialectical image in terms of historical materialism, his own melancholic writings on the angel in terms of contemplation suggest that the two modes are not so easily separated.

To draw out the differences and connections made between allegorical, montage and dialectical images in the work of Benjamin's commentators is a difficult task. Buck-Morss, for example, argues that while the allegorical image is 'an expression of subjective intention', the dialectical image is 'an expression of socio-historical truth';[42] and in his book *Melancholy Dialectics: Walter Benjamin and the Play of Mourning*, Max Pensky, another Benjamin scholar, also distinguishes between these two modes of image-making but through the category of time: 'Now, it is surely correct to observe that one central polarity between allegorical and dialectical image, according to Benjamin, is the temporal one: allegorical slowness and repetition versus dialectical shock and temporal rupture.'[43]

However, to make an opposition between allegorical and dialectical images, both authors rely on an implicit assumption that the dialectical image is synonymous with a montage technique, an assumption that is not continuous in their writings and that is contradicted at other times by the connections they also draw between dialectical and allegorical methods. In a historical reversal of Benjamin's own proposition that in the seventeenth century allegory was the 'canon of dialectical imagery',[44] Buck-Morss suggests that the dialectical project of the *Passagen-Werk* was an attempt to 'revive allegorical techniques'.[45] Pensky makes the connection between the dialectical image and allegory from both directions. On the one hand he posits that certain modes of dialectical construction relate closely to allegorical techniques in that they constitute 'a perhaps unacknowledged degree of subjective involvement in the image itself',[46] and on the other that the allegorical condition of melancholia contains more than mere sadness and loss; it also contains a dialectical condition in which, in the space between subject and object, 'a question concerning the possibility of meaning' might become articulated.[47] And, if we return to Bürger, his position is that Benjamin's understanding of twentieth-century montage was informed by his research into baroque allegory and that montage is a development of allegory, not a replacement of it; in his words, montage is a 'more precise definition of a particular aspect of the concept of allegory'.[48]

In the following three chapters I would like to argue then that the differences between these modes of allegory and montage as specific forms of the dialectical image are perhaps not quite so distinct as one might think, especially not in the particular conditions of the twenty-first century,

which are neither those of the allegory of the seventeenth-century *trauerspiel* nor of the montage of the early nineteenth- and early twentieth-century *Passagen-Werk*. So, rather than simply consider allegory as a technique concerned with retrospective contemplation, according to Buck-Morss, and montage as shocking, following Bürger, I explore the proactive and politicized potential of several contemporary works that operate in the allegorical mode and also consider more subjective and intimate aspects of montage constructions.

I am interested in complicating 'shock', as the definitive experience of politicized art, to include concentration and to consider not only momentary and immediate reactions but also those reverberations that take place over a longer time span. I explore how it might be possible to reclaim the act of concentration, traditionally taken to be a reactionary mode of viewing art, which, linked to contemplation, can only provide an escape from the 'real' world, as a site or mode of critical response to a work.[49] It is important, however, to recognize that the potential responses to a work composed of fragments are always conditioned by the extent of a viewer's knowledge of the original context of those fragments, and their experience of these new relationships in a particular context at a specific moment in time.

Many of the locations currently of interest to artists and architects are empty, some through permanent neglect or abandonment, others through more temporary absences of activity. With the functions that once defined them removed, these places appear as ruins of the past in the present. In Chapter 1: 'Ruin as Allegory' I suggest that projects that focus on aspects of the ruin, disintegration and transience not only inspire feelings of melancholic contemplation in the viewer but also provide experiences where transformation can occur through quiet but active thought. In the *Passagen-Werk* we have the example of Benjamin's own attempt to claim the critical potential of the use of allegory in the work of bourgeois poet Charles Baudelaire. More recently, cultural critic Frederic Jameson has noted of nostalgia an attitude that shares much with allegory in terms of melancholy and retrospective contemplation, but also the potential for political critique. 'But if nostalgia as a political motivation is most frequently associated with Fascism, there is no reason why a nostalgia conscious of itself, a lucid and remorseless dissatisfaction with the present on the grounds of some remembered plenitude, cannot furnish as adequate a revolutionary stimulus as any other: the example of Benjamin is there to prove it.'[50]

Subsequently, in Chapter 2: 'Insertion as Montage' I examine the principle of montage not solely in terms of the production of a construction where materials with contradictory meanings are juxtaposed

with one another, but also as the creation of a critical experience. I investigate contemporary works in which new insertions into locations adopt 'inappropriate' materials or languages in order to displace dominant meanings and to interrupt particular contexts. These constructions create visual, audio and tactile environments in which the experience of engaging with the work may initially include shock, but over time starts to evolve and connect with the more subtle ambiguities associated with allegory.

While both these forms of dialectical image, allegory and montage, draw attention to the temporal qualities of the viewing experience, in Chapter 3: 'The What-has-been and the Now' the focus is on history and on the position of the dialectical image as a threshold between past, present and future. So, as in the previous chapter, I look at a number of artworks and architectural projects that insert new fragments into existing contexts, but here the act is more of a 'reinsertion', performed to reclaim or unearth certain aspects of history lying buried in the present. These reinsertions into sites often take the form of 'voices' that have been marginalized and comprise material traces of actions written out of history, revealing aspects of the 'what-has-been' in the 'now'. Such works could be said to operate dialectically, replacing existing histories of sites with alternative understandings, transforming present realities and so providing glimpses of new future possibilities.

Chapter 1

Ruin as Allegory

Allegories are, in the realm of thoughts, what ruins are in the realm of things.[1]

In this chapter I explore artworks and architectural projects that operate, according to Walter Benjamin's understanding of the allegorical mode, through isolating fragments and recombining them to create new meanings, adopting a melancholic gaze and representing history as ruin. I first look at the current interest in abandoned spaces in art and architecture and explore works that focus on emptiness and absence; I then go on to consider a number of projects that explore materials that are transient or disintegrate over time. My interest is in demonstrating that, while the contemplative or melancholic view that looks inward or backwards into the self or towards the past has often been criticized for being nostalgic and turning away from a social critique of current conditions, it is possible for such a position to be critically productive and provide the potential for new and different futures.

Tacita Dean is an artist drawn to empty spaces. Often working in film, her interest is in highly functional architectures that are now redundant, whose original reasons for construction are no longer valid or viable. In 'Delft Hydraulics' (1996) Dean focused on a machine located in De Voorst, in the Netherlands, designed to measure wave impact in order to study coastal erosion, but which, because of the emergence of new technologies, became redundant. The story is quite similar for 'Sound Mirrors' (1999) – huge listening devices conceived of during the First World War to pick up

the sounds of approaching aircraft; these were constructed between 1928 and 1930 at Denge, near Dungeness, as well as at two other sites along the Kent coast of the United Kingdom. These strange-looking objects were soon rendered obsolete as they did not allow the listener to differentiate between different kinds of passing traffic – land or sea, local or more distant – and as a result they were replaced by the use of radar. Rather than portray them as 'ahead of their time', as high-tech, Dean's films emphasize the arcane qualities of these architectural object-spaces: 'Her films are haunted by architectural relics, which seem to embody outmoded or bankrupt beliefs, but at their time of execution offered much.'[2]

Dean's work is a critique of a certain mode of scientific thinking that links technological progress to a timeless future in which rationality and abstraction remain untouched by reality. Yet these highly designed objects stand futile, sorry witnesses to the unfolding of events. Dean's interest in the heroic, but doomed, endeavour can also be found in 'Trying to Find the Spiral Jetty' (1997), her homage to Robert Smithson, who died while researching one of his works (see Section 1: Chapter 1).

What interests me here is the way in which Dean's films engage with time. She tends to focus on one viewpoint for too long; our interest starts to wane, our attention wanders and other thoughts drift in. Then, with no warning, Dean will switch viewpoint and offer us another long gaze at the same place or object. Each point of view offers an object to study, but although the framing is highly selective and asks us to 'look' in concentration, as we would at an artwork in a gallery, the subject matter never quite offers enough to hold our attention, so we experience the work in a manner more akin to the way we look at buildings in the city, as backdrops against which other images and conversations meander in and out. The decisive yet seemingly random choice of view, combined with the slow pacing of the rhythmic interruptions, are recurring motifs in a number of Dean's works. It is possible to compare these different modes of looking – the overlong view that starts to dissipate, the turn from contemplation to distraction and the sudden disorientating shifts in viewpoint – with Benjamin's comments on contemplation. He saw contemplation as the absorbed mode of looking through which we apprehend painting and the state of awakening, or coming into consciousness, as a shock response to juxtaposition in the early use of montage construction in film, as well as the distracted mode in which we experience architecture.[3]

For some years now, for example in 'Stasi City' (1997) and 'Gamma' (1999), artists Jane and Louise Wilson have also been investigating architecture in ruin – the ruins of the cold war – centres of power and coercion now abandoned. 'Stasi City' was the unofficial name a West German journalist coined for a prison and phone-tapping centre – the

headquarters of the GDR's intelligence service, the Staatsicherheit, that included a former Stasi prison, Hohenschönhausen. Now vacated, the location appealed to the Wilsons, for during the cold war few people knew the function of these buildings at the end of a suburban street in East Berlin. Likewise, when Greenham Common came up on a list from the Ministry of Defence of buildings that had been decommissioned, the Wilsons, with their recent memories of Greenham, CND and the women's movement, were curious to find out more. In both cases, the buildings had once occupied the very centre of power for a key moment during the cold war. In different ways their architecture enabled scenes of domination to be enacted, psychologically and physically, through real acts of violation and the threats of future abuse.

When exhibited at the Serpentine Gallery, London (2000), both 'Stasi City' (1997) and 'Gamma' (1999) comprised installations that combined 'fragments' or images of these 'ruins', placing different scenes as video projections and still photographs next to one another.[4] These media work in different ways to represent and communicate spatial experience, through the visual content of the images and the time-based sound track of the video. The Wilsons state that they are interested in 'animating and revealing a specific space', but Stasi City and Greenham are not 'revealed' to the viewer; rather the viewer is presented with the artists' animations of these sites. These animations generate a questioning of the relationship between power, representation and the occupation of space. For example, the use of double wall projections in the corners of the gallery provides simultaneously two different views, where the relationship between them is constantly changing. Viewers may find themselves at once looking at the missile control panel and at an empty decontamination chamber, leaving the choice of position open – empowered or disempowered, neither or both at once? It is also possible therefore to consider how the recombination of fragments of architectural ruins takes place between the locations where the films were shot, their new position as installations in the gallery, and the spatial experience produced through these images in the mind of the viewer.

The visual fragments present a series of apparently empty rooms, banal institutional spaces filled with the remnants of their one-time habitation, in the form of furniture: beds and desks. But closer inspection reveals scenes and devices that are potentially more suspicious: an upturned chair, a telephone with its line unplugged, strange spotlights, machinery with multiple levers and knobs. The sounds suggest a little more, the cranking of machinery, heavy breathing and footsteps – approaching or receding? Having been told that these were once places at the heart of various cold war activities, we start to feel uneasy, to imagine the worst: in the gap between these two doors, a person could have been concealed; with that red

button, a nuclear missile could have been launched; on the bed over there, a person may have been tortured. These seemingly indifferent environments have traumatic histories; their empty interiors bear the traces of psychic disturbance, the images of which seem to want to be read as clues. Despite the appearance of the artists (whom we recognize) as figures in a number of scenes, it is still possible to read these images as rooms untouched since they were evacuated, rather than as stage sets constructed by the artists. We want to know who last sat on that chair? Who lay on this bed? What happened over there? What happened down here? What really happened where? (But do we really want to know?)

In a vacant hospital theatre, feeling both melancholic and also sick with anxiety, we watch paint crumble from the ceiling. The work provokes difficult choices; we are offered a scene to enter, one that we would rather had never existed, and offered the role of perpetrator or victim. The seductive quality of these images simply does not inspire an act of melancholy contemplation; the invitation is a narration that forces us to think about what it means to take up a position. It is not possible to regard these places without imagining an engagement and, in becoming emotionally connected, the work requests, if somewhat gently, that we confront the ruins of the cold war in these particular architectures of absence. The question is whether in confronting these ruins the artists divert our attention from, or draw our attention to, the crimes and injustices perpetrated by the victors of that conflict.

'Caliban Towers I and II' (1997) is one in a series by artist–photographer Rut Blees Luxemburg entitled *London – A Modern Project*.[5] The photograph images two high-rise buildings aspiring to touch the skies. Shot at night with a long exposure, the images gain a strange luminescence. For a short period in 1998, as part of a public art project, 'Wide', curated by art–architecture collaborative muf (see Section 3: Chapter 1), 'Caliban Towers I and II' was installed under a railway bridge on the corner of Old Street and Shoreditch High Street in east London, a mile or so down the road from the very housing projects depicted in the image.

Along with the commercial billboards, pigeon dirt and rough graffiti, the insertion of fine art photography into a grubby bit of Hackney could be understood as an indication of the future of the area. Within a few months the photograph was removed, but for a short while in 1998 a fragment of the democratic socialism of the modernist high-rise dream was juxtaposed with a particular stretch of street undergoing the first stage of gentrification, the kind of urban improvement typical of the postmodern capitalist city (fig. 20).

The buildings captured in the frame have a mournful feel; the absence of people produces an elegiac quality, suggesting that the modernist

project is a failed endeavour rather than the progressive vision for which the modernist designers might have wished. Indeed, up the Hackney Road on a sunny Sunday in July, while 'Caliban Towers I and II' were resident in south Hoxton, a block of flats just like them was demolished, dust in nine seconds (fig. 21).

What does it mean for the 'modern' project to be seen as beautiful and mournful? If the work is an elegy, a mourning of the modernist project, concerned as it was with social justice and progress, what does the suggestion that such a project is over imply? Who has the right to decide if these buildings have failed, that they should be demolished and on what grounds? Is a better future on offer? However, the desire to portray these buildings as beautiful might be taken as a plea to celebrate them. Yet, for those who live in these often decaying infrastructures, is it possible to consider them as such? Is this a vision that only someone removed from the realities of living in these poorly maintained environments could afford to have?

In a gallery setting, Luxemburg's seductive images of the modernist dream as a sad and beautiful failure certainly fail to invite critical engagement and face the charge of a luxurious and perhaps nostalgic disengagement that only some are in a position to adopt – the ability maybe to escape certain aspects of social reality such as impoverished housing conditions. Yet, being situated in this particular urban location at a moment when debates about which buildings to demolish and which to maintain in order to fulfil the developers' ambitions for regeneration were ongoing activates the work with social potential. Positioned back in its own neighbourhood – a site undergoing redevelopment – this imaged fragment of a modernist London housing project is able to ask quite different questions.

Following on from *London – A Modern Project*, Luxemburg's 'Liebeslied' (2000) provides a further exploration of emptiness, time and nocturnal urban space. These images, also taken at night with a long exposure and saturated in the golden colour of street lamps, also have an elegiac quality. They too are concerned with spaces of neglect and decay, less with a mourning of the utopian project, more with an engagement with themes of loss and emptiness. There is liquid in nearly every shot: small globules on the tarmac, rivulets running down the pavement, trickles following cracks in walls, pools of still black water, and the planar surfaces of the night river. All this water, thick, sultry, glossy, almost as gorgeous as the limpid images themselves, makes the abandoned locations they find themselves in appear beautiful. As the dark water gives itself up to the light, the lustrous surfaces become mirrors, multiple pools that mark sites of and for reflection. The images certainly place the act of reflection centre stage, yet whether the portrayal of the dereliction of London's public spaces as sites

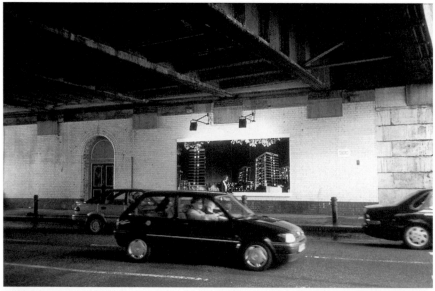

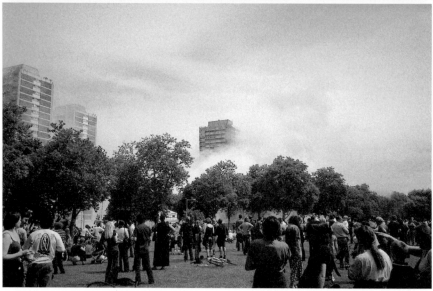

20

Rut Blees Luxembourg,
'Caliban Towers I and II' (1997)
London.
Photograph: Jane Rendell (1999).

21

Demolition of Farnell Point,
Hackney,
London.
Photograph: Jane Rendell (1999).

of beauty invites viewers to enter a space of critical reflection, or whether it aestheticizes a certain social betrayal and produces a contemplative melancholy that is sad yet accepting, is a point of contestation.

The artworks so far discussed have taken as their subject matter images of architecture empty of occupation. However, unlike photographs of buildings in the architectural press, rarely cluttered by occupants or even traces of habitation, this current fascination with locations devoid of people is different. In these photographs, the emptiness is not about keeping the details clean in order to get a better view of the architectural object, but rather to provide a space for the viewer to remember and to imagine. These images of permanently or temporarily abandoned buildings are suggestive; these places have not always been and will not always be empty. Their emptiness in the present moment provides a place for contemplation. Art critic Ralph Rugoff has suggested, as a counterpoint to the work of art (or painting) as the site for contemplation, that the photographic document can be located as the site of analytic thinking.[6] I have suggested, however, that the images of architecture in these photographic, film and video works demand to be viewed in a contemplative mode, but not one in which we are wholly absorbed by the work. The emptiness of these sites, many of them the location of failed endeavours in the exercise of power, prompts a search for clues and an analytic deciphering of the traces of past occupations and aspirations. This may be accompanied by a more contemplative mode of critical reflection concerning the actions that have been associated with these architectures historically, and those that might be imagined for the future, where these buildings play a new role as settings for alternative and, it is hoped, rather different scenarios.

At the 'Palais de Toyko' (2001) or the 'Site de Creation Contemporaine' in Paris, architects Lacaton + Vasal have also been working with a ruin and with, in their terms, 'an architecture of omission'.[7] Originally built in 1937 as an art museum for the International Exhibition, this neo-classical building on the north bank of the Seine housed the collections of the Musée National d'Art Moderne until it was moved to the Centre Georges Pompidou in 1974. A major renovation project to create a 'Palais du Cinéma' began at the start of the 1990s. Interior partitions were removed and the services and decorative fittings pulled out. The 'Palais du Cinéma' project collapsed and in 1999 Lacaton + Vassal won a competition to produce a place of 'contemporary creation', a more expansive way of defining art and its curation, as a venue that would encourage international dialogue and allow a more intimate interaction with the public.

At the Palais de Toyko, the architects made no attempt to cover up what the stripping out work had revealed. Their first move was to make the building structurally sound and then to provide basic functions, such

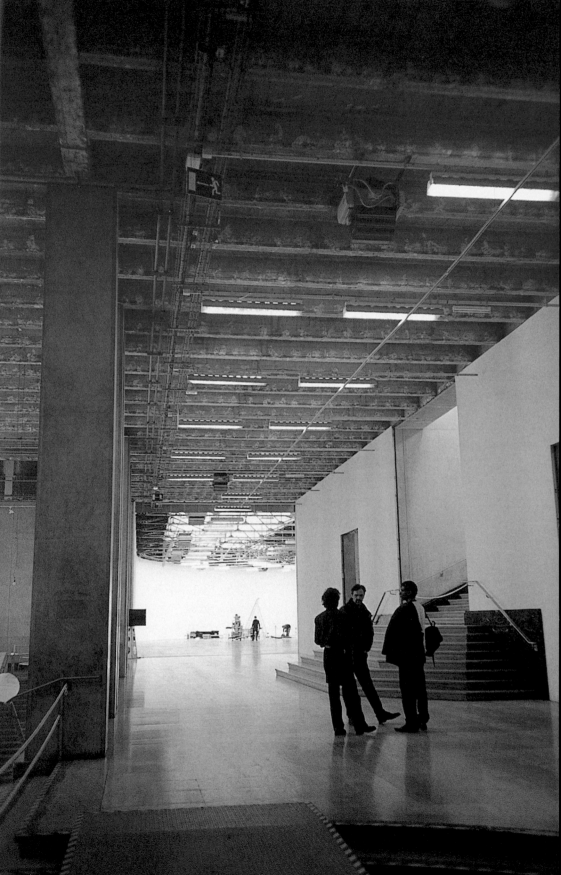

22–3
Lacaton + Vasal,
'Palais de Toyko' (2001)
Paris.
Photographs: Jane Rendell and David Cross (2005).

as the external spiral staircases that play a key role as a means of escape in the event of a fire.[8] Lacaton + Vasal refused to fit the ventilation shafts and mechanical air-filter system the engineer had recommended and instead used natural ventilation supplemented by sliding panels and automatic shades.[9] What appears to be a paring down or removal of the pomp of neo-classical architecture turns out to involve the provision not of subtraction but of excess. Lacaton + Vasal define luxury not through the acquisition of expensive materials but through the creation of space; the ability to provide extra space in terms of floor area and volume can, through their architectural design approach, be achieved through the efficient use of materials. For Lacaton + Vasal, therefore, polished concrete is more 'luxurious' than marble because, being cheaper, it allows the renovation of a greater surface area and volume of space (fig. 22). It is worth noting that, in a similar vein, when asked to embellish Leon Aucoc Square in Bordeaux in 1996, the architects merely proposed a 'simple and rapid maintenance works' programme rather than any material additions. In their opinion, the square already had an 'authenticity' and this made it beautiful enough.[10]

The 'Palais de Tokyo' is huge, but it is only one wing of a building even more vast; the other part is occupied by the official Museum of Modern Art. The architects' reference point for their design was the marketplace at Djemaa-el-Fnaa in Marrakech, a vast square that, according to the architects, 'renews and metamorphoses' each day 'according to people's movements'.[11] Inside, as well as two cafés and a bookshop, there are eight-metre high spaces that would pose a challenge to any curator. However, the curator Nicholas Bourriaud's approach to the programming of the space has been to create events rather than hang art on walls. At weekends, the place is packed with families; children run in and out of the neo-classical colonnade and during the week skateboarders congregate on the plaza in front of the building, clattering down the ramps and steps. The stone façade is covered in graffiti and around the corner are allotments. In the ditch to the north, Berlin-based landscape architect Atelier de Balto produced a wild garden and on the west side artist Robert Milin composed and orchestrated the 'Inhabitants' Garden'. This 'long slice of kitchen garden' is divided into plots tended by people from the neighbourhood (fig. 23).[12] The experience of the Palais de Toyko is one in which the exposure of a ruin – the fatigued concrete structure – is superimposed with the dynamism of largely unplanned actions involving vegetation. Thus, it does not work simply in a melancholic mode; instead, by adding life and vitality to the ruined building and spatial luxury through material efficiency, fragments are combined in a manner that might be considered allegorical in the focus on disintegration, yet also montage in the juxtaposition of decay with vitality.

Another arts space where the architectural approach has focused on maintaining, yet not fetishizing, the disintegrating and worn aspect of the ruin is 'Wapping', located in a pumping station on the north bank of the Thames in London adjacent to the Shadwell Basin. The building is constructed out of red brick with a timber and iron trussed roof and a stone floor. It is composed of two large masses placed at an angle to each other linked by a corridor with a store and mess room. One is the engine house for the steam pumps with a turbine house and accumulator tower. The other is the boiler house with a coal store, filter house, two water tanks and a chimney. 'Wapping' was built by the London Hydraulic Power Company in 1890 and operated as a steam-generated pumping station until the 1950s, when it switched to electricity. After closing in 1977 the pumping station lay empty until its discovery by Jules Wright of the Women's Playhouse Trust. In October 2000 'Wapping' reopened, this time as an international arts venue with performance areas, gallery spaces and a restaurant.

Change over time is particularly pertinent with regard to 'Wapping', a building that depends for its very existence on elemental transformation and flow. As a steam-powered hydraulic pumping station, its purpose was to transform liquid water into gaseous air. Water from a well was circulated between rooftop tanks, underground reservoirs and the pumps through a complex system of pipes. Some 187 miles of pipe connected 'Wapping' to four other pump houses and 8000 machines. This network linked objects like vacuum cleaners to places as diverse as Tower Bridge, the docks in east London, the railway goods yard at King's Cross, West End London theatres and apartment blocks in Kensington and Mayfair. Wright's initial attraction to the building was in no small way due to its defunct status – her fascination was with the building's history as well as its possibility; it was a place built with a clear function but was now empty and devoid of purpose. The approach of the architects, Shed 54, to the design was to make clear the architecture's original function and, beyond allowing the building to operate in its new capacity, to do as little as possible.

'Wapping' opened with 'Conductor' (2000), an installation by Jane Prophet in which the boiler house was flooded to knee height and 120 glowing fibre optic cables were suspended from the ceiling (figs. 24 and 25). The materials chosen, water and fibre optics, refer to the history of the architecture; after the power station was decommissioned, a telecommunication company purchased the system and ran fibre optic cables along the pipelines. In the dark it was impossible to discern the edge of the space and the glow of white lines of light reflected in the black water suggested infinite depth. By creating an atmosphere that dissolved the finite

boundaries composed by the architecture, Prophet's work resonates with the qualities of the building and the commissioning ambitions of Wright – to produce interventions that respond to 'Wapping's' history of fluids and flux.[13]

In an earlier installation, 'Prestige' (1991), artist Anya Gallaccio filled the space of an abandoned tower at 'Wapping' with 21 whistling kettles linked to a compressor. Later, for 'Intensities and Surfaces' (1996), also at 'Wapping' and commissioned by Women's Playhouse Trust, Gallaccio made a 32-ton cube of ice bricks measuring three metres by four metres by three metres on the boiler house floor. This ephemeral sculpture slowly melted away, aided by a large chunk of rock salt being embedded in the centre (fig. 26). Both these pieces of work make reference to the importance of water in the original function of the building, but rather than put an object in place to make visible a forgotten aspect of history, these installations involve the audience in a process that makes them aware of transience itself. At 'Wapping', by focusing on the melting point of ice and the boiling point of water, Gallaccio's work aims to capture the transitional points in the ongoing processes of elemental transformation.

'Two Sisters' (1998), a public work Gallaccio made for 'Artstranspennine', a series of arts interventions running across the north of England, from Liverpool to Hull, also refused to remain a stable entity. 'Two Sisters' was a column of locally quarried chalk bound with plaster, six metres tall and 60 tons in weight. The column was placed in Minerva Basin, Hull, a site Gallaccio chose for its shifting nature. Continuously under erosion, according to Gallaccio, parts of the coastline of Hull will eventually end up in the Netherlands. Hence the name 'Two Sisters', a term that refers to a Dutch expression used to describe two architectural features of a similar nature placed next to one another. Within five months 'Two Sisters' had disappeared.[14]

As well as ephemeral materials and unstable elements such as steam, melting ice and chalk, Gallaccio is interested in organic substances like flowers, fruit and chocolate caught in a state of flux. The 800 red gerbera of 'Preserve Beauty' (1991) placed between glass and the window of Karsten Schubert Ltd, London, and the bed of 10,000 slowly rotting tea roses that comprised 'Red on Green' (1992) at the Institute of Contemporary Arts, London, engage with transformation through processes of decomposition.[15] As the moments pass, Gallaccio's work continues to hold our attention; so engrossed do we become in contemplating the aesthetics of decay that we start to feel the sad futility of the very act in which we are caught up – the impossibility of holding time still. For me, the focus on material disintegration makes evident an important temporal aspect of the ruin, whether natural or cultural, that it is not simply a sign of the past in the

24–5
Jane Prophet,
'Conductor' (2000)
The Wapping Project, London.
Photographs: John Spinks (2000).

present, but rather marks the moment at which what is now becomes what
has been.

In other works, Gallaccio has emphasized an alternative side to nature's
transience, the process of growing rather than breaking down. In 'Keep off
the Grass' (1997) on the lawn of the Serpentine Gallery, London, Gallaccio
sowed vegetables and flower seeds into the decaying patches of grass that
other sculptures had left behind, while at 'Glaschu' (1999) at Lanarkshire
House, Glasgow, she planted a green line of grass into the concrete floor.
Architect Robert Adam took inspiration for his interior designs from the
formal elements of nature and, at Compton Verney, Gallaccio created
'Repens', an ornate pattern for the lawn inspired by one of Adam's ceiling
decorations for the interior of the house designed in 1763. The pattern
was mown into the lawn and slowly disappeared as the grass grew. In all
three works, the garden as a transient place provides a temporal threshold
for Gallaccio: 'The garden as an idea seems to fit perfectly with all my
main preoccupations – the garden as palimpsest perhaps, letting the past
show through and seeing what happens in the future.'[16]

Hovering 75 feet over Lake Neuchatel in Switzerland and formed
by a mist of lake water shot at high pressure through nozzles built into
a platform structure, 'Blur', created by Diller + Scofidio for the Swiss
Expo.02, was a cloud measuring roughly 300 feet by 200 feet.[17] While a
number of artists have experimented with invisible materials such as air
and water, 'Blur' is the first and possibly only attempt to make architecture
out of vapour. 'Blur' was intended as a critique of the visual spectacle
of the Expo and on a number of occasions the architects had to refuse
attempts by the media and at times the client to represent 'Blur' as an
icon, a cloud with a definable shape (fig. 27). It was the opposite that was
interesting to Diller + Scofidio, the indefinable and changing form of fog
and its ability to blur or 'to make indistinct, to dim, to shroud, to cloud,
to make vague, to obfuscate'.[18] The architects' intention was that, as the
lake was approached, a cloud-like form would come into view and a ramp
would take the visitor up into the fog, an atmosphere of white noise and
'optical white out', and back out up a stair to the Angel Bar located on a
platform above the clouds.[19]

Throughout the complex process of developing 'Blur', Diller + Scofidio
resisted definitions of their work as art or architecture and asserted instead
that Blur was not a building but an atmosphere.[20] It seems that in this
particular context – the exposition – the experience of their architecture as
atmosphere was neither one of distraction nor solely one of contemplation,
but it provided a place for critique by positing the importance of a lengthy
wandering through a site under conditions when visibility is low and it
is possible not to 'see', in place of the rather faster visual consumption

26
Anya Gallaccio,
'Intensities and Surfaces' (1996)
The Boiler Room, Wapping Pumping Station, London.
© Anya Gallaccio.
Courtesy of the artist and Lehmann Maupin Gallery, New York City.

27
Diller + Scofidio,
'Blur' (2002)
Swiss Expo.02,
Lake Neuchatel, Switzerland.
Photograph: Beat Widmer (2002).

expected of such a society of spectacle as an international exposition. In the way that Gallaccio's ice melts, Blur's fog disperses, yet material instability is explored in the later project not in terms of organic decay or the ruin's disintegration, but rather in order to critique the definition of architecture as visual spectacle.

For Benjamin, the baroque form of allegory produced a state of melancholic contemplation in the viewer, while works of art in the form of paintings encouraged concentration, creating a situation in which the viewer was absorbed by the work. The artworks and architectural projects described above do on first glance seem to produce just that: contemplation rather than reflection, concentration rather than action. This seems a dangerous tactic for critical spatial practice, but given the number of artists and architects who are currently operating in this mode, focusing on the fragment as ruin, on disintegration and transience, such work demands close examination. As I hope to have shown in relation to the works discussed here, an interest in spaces empty of occupants yet marked with traces of previous occupations is often motivated less by a concern for conservation or preservation and more by a desire to focus on the past in order to learn from historical mistakes, to imagine (if you will) a better future. A focus on decay can be less a mourning of the passing of time than a possibility to make visible to the viewer material substances other than those timeless and completed objects often prioritized in art and architecture. A concern with loss and sadness may be part of any project concerned with addressing failure, yet these emotional states can also provide the impetus for a strong critique of historical acts involving the misuse of power. Perhaps it is possible then to understand the experience of viewing and occupying some of these artworks and architectural projects as acts of a critically aware and active, rather than an internalized and self-reflective, contemplation.

Chapter 2

Insertion as Montage

For Benjamin, the technique of montage had 'special, perhaps even total rights' as a progressive form because it 'interrupts the context into which it is inserted' and thus 'counteracts illusion'.[1]

In this chapter, I explore montage as a particular aspect of the dialectical image in a number of contemporary artworks and architectural projects that have used new elements as insertions into existing locations in order to interrupt their dominant meanings. Montage in art and film has historically involved juxtaposing elements in a way that makes them question one another. This most often entails the insertion of everyday objects into an artwork or gallery, as the institutionalized location of art, in order to provoke a redefinition of what art might be. Here, I consider how locations outside the gallery operate as contexts for critical insertions and how montage techniques function in architectural design.

Marcel Duchamp's placing of an everyday object, a urinal, in a gallery setting could be cited as perhaps the earliest example of the insertion of an object into a gallery to reveal the ideological constraints structured by such a location.[2] In constructing a critical juxtaposition between art and gallery or work and location, Duchamp's critique of the aesthetic criteria used to categorize objects as art has since been developed into a strand of conceptual practice that art critic Benjamin Buchloh has described as 'institutional critique'.[3] Hans Haacke, for example, in his investigation

of the social and economic relationships between art institutions and corporations, inserted economic data on the sale and ownership of art into the gallery setting.[4] Michael Asher's work, on the other hand, has utilized the principle of material subtraction in a number of projects in order to draw attention to the architectural and institutional space of the gallery. For example, in the Claire Copley Gallery, Los Angeles (1974), he removed the partition between the office and exhibition space, revealing to the public viewer the usually hidden operations that allow the gallery to function economically.[5]

The early work of artist Victor Burgin operated explicitly through montage, using one form of visual representation to displace the meaning of another. Drawing on French structuralist and poststructuralist linguistic (and later psychoanalytic) theory as a conceptual basis for his work, Burgin describes his visual art practice in terms of linguistic structures such as addition, suppression, substitution and exchange in rhetorical forms.[6] Citing critic Roland Barthes, Burgin suggests that text can act either as an 'anchor' to emphasize meaning selectively in an image, or as a 'relay' to import new or external meaning to the image.[7] According to Burgin, art should be in 'direct engagement with the forms of imagery found in the outside world'.[8] For 'Photopath' (1967) he photographed the floor of the gallery and reinserted his 20 photographs back onto the gallery floor, allowing the floor of the gallery, or the 'outside' of art, to be produced as the content of the artwork itself.[9] In his later photomontages, Burgin inserted political texts as 'relays' into advertisements in order to disrupt the fetishizing power of the image.[10] Describing his practice, Burgin states: 'My strategy was a kind of *guerrilla semiotics*: capturing images and turning them against themselves.'[11]

What happens if we extend the interruptive potential of an insertion into contexts other than an artwork and a gallery and consider instead how montage might operate in other public locations? Built structures, such as monuments, which tend to represent the value systems of dominant cultures, have provided opportunities for critical art practice to bring concerns that have been marginalized into a close relationship with those objects and histories on display. In this chapter, I discuss a number of projects in which the insertion of objects, texts, images and voices into a context already thick with meanings has produced a complex scene, which invites the viewer to move through the work, drawing out hidden and differing meanings over time, rather than through the one-off shock effect usually associated with montage.

Japanese artist Tatsurou Bashi (alias Tazro Niscino) makes artworks that appropriate and question the language of monumental public sculpture and architecture. Viewed from the outside, his projects borrow from the

language of the building sites, involving the use of breeze-blocks, scaffolding poles, plastic sheeting and prefabricated components. On the inside, bland furnishings, carpets, curtains, lamps and plants make the interiors look like show homes. In 'Obdach' (1997) what appears to be a site hut wrapped in blue plastic is perched on scaffolding, covering a stone figure on a pedestal. Inside we find a living room furnished (perhaps by Ikea) and inhabited by a monumental man. In 'Lilie' (2000) the tip of the cupola of a public building appears on top of a pine table in a contemporary home; and for 'Das habe ich gar zu gern' (1999) the lamp of a streetlight has been turned around so that it enters the window of a neighbouring house. The window dividing inside from outside is lined with chipboard and painted white; the lamp appears to be a fitting attached to it, casting light over a table set with floral cloth, candles, a sugar bowl and ashtray.[12] These works juxtapose the architectural elements of inside and outside, using the monumental figure of the statue and the civic language of street furniture to disrupt the domestic setting and its associated material culture, allowing public history to interrupt scenes of an intimate and private drama.

For 'New Holland' (1997), by positioning a piece of the local vernacular, a shed for factory-farming turkeys throbbing with techno sounds, at a rakish angle next to a Henry Moore sculpture and Norman Foster's gallery for fine art at the Sainsbury Centre for Visual Arts, Norwich, England, for *East International*, artists Cornford & Cross have produced a sculpture that, like Bashi's, holds in tension everyday materials and monumental structures. In relation to Moore's modernist artwork, Cornford & Cross's insertion could be viewed as an everyday object or as architecture, yet in this context, which also includes Foster's piece of high-tech architecture, a building that functions as an art gallery, 'New Holland' is also to be understood as an object with no use, art rather than architecture. However, if Cornford & Cross's vernacular shed is taken to be an artwork because it is not utilitarian, because it has no function, then how are we then to relate it to Foster's gallery, itself a pseudo-shed with serious problems of overheating and glare, yet understood by some as such a fine example of high-tech architecture that it should be considered a work of art (fig. 28)?[13] 'New Holland' (1997) could be described as a montage construction, one composed of the new intervention and the buildings and objects already placed in the location – an insertion that interrupts the context into which it is inserted. The juxtapositions that are produced deconstruct certain binaries and replace a way of thinking that wishes to posit high *or* low culture, art *or* architecture, with one that allows the complexities of high *and* low culture, art *and* architecture. The constellation produced is one in which the objects are placed in a number of tense and contradictory relationships with one another.

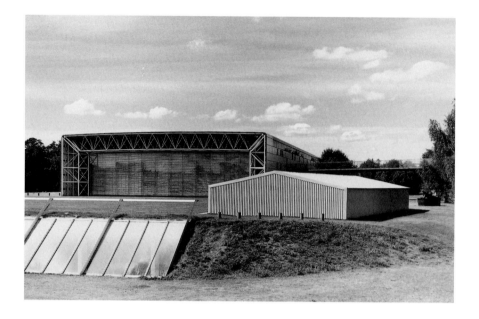

28
Cornford & Cross,
'New Holland' (1997)
Sainsbury Centre for Visual Arts, Norwich.
Photograph: Cornford & Cross (1997).

As described in Section 1: Chapter 2, Cornford & Cross's work draws on the conditions of particular sites to challenge the modes of production and reception of fine art, public art and architecture. Their work brings the critical concerns of conceptual art into an uncomfortable relationship with the pragmatic attitudes surrounding everyday architecture. Following Duchamp's 'ready-made', the use of ubiquitous materials and mass-manufactured items may (once) have had a disruptive meaning in the context of the art gallery, but the already dense material language of public spaces often dominated by the presence of such architectures operates to complicate such potential juxtapositions. So, while the initial reaction to 'New Holland' might be shock, as an outraged response to the transgressive nature of the gesture – a turkey shed on the lawn of an art gallery (surely not!) – a closer inspection begins to reveal that a more complex set of contradictions structure this work. Certainly, the insertion of a shed used for factory-farming turkeys in East Anglia is an obvious provocation to the more high-brow values ingrained in this cultural context. We are also led to compare sheds and to ponder, 'Is Sir Norman's shed really a shed?' In addition we are asked to examine close-held assumptions about the appropriate use of materials, details and formal composition in architecture. The initial experience of shock seems then to be replaced by a viewing condition in which gradually more intricate tensions start to emerge. Could it be that the shock operates as a form of camouflage, disguising the much slower and more complicated questions the work raises that invite the viewer to reflect on the contradictions within his or her own cultural and political positions?

In architecture, a similar mode of working with juxtaposition can involve a materially based process in which architects design details and constructions that aim to shock new meanings out of quite ordinary substances. The insertion of everyday elements to disquiet highly designed environments has become a familiar tactic for architects. OMA's Kunsthal in Rotterdam, the Netherlands, was perhaps one of the first to disturb the logic of inside and outside, artificial and man-made, by positioning, for example, tree trunks as columns inside the building. As critics Ilka Ruby and Andreas Ruby describe: 'When Koolhaas clads the façades of his Kunsthal in Rotterdam with roofing felt and uses trashy corrugated plastic panels in the interior, he does it with the didactic intention of deconstructing the "Museum as a Shrine to Art".'[14]

Sarah Wigglesworth Architects' 'Straw Bale House' in North London develops the same logic through the invention of details that have been at the heart of arguments about environmental design.[15] One of the main criticisms of the straw bale house has been that the decision to clad the straw bales with a rain screen rather than the traditional practice of rendering

them was one of 'style over clear thinking'. Wigglesworth and Jeremy Till defend their decision on two counts, first technologically, that in a rainy climate such as that of the UK rain screens are required to counteract driving rain and the problems of rot potentially caused by interstitial condensation trapped behind render. They also defend their design choice on the grounds of polemic, arguing that they chose to use a transparent material, one controversially composed of petrochemicals, to 'show off' the straw bales, to 'provoke debate on the use and benefits of materials such as straw by making them visible'.[16] Quoting Sarah Wigglesworth Architects, Peter Davey describes how 'the juxtaposition of "shiny steel with rough straw" disturbs normal architectural categories "uniting the slick with the hairy, the fetishized with the repressed".'[17]

I would argue that in bringing together a 'vernacular' or 'traditional' material like straw and a polycarbonate produced using new technologies, Sarah Wigglesworth Architects have designed a dialectical construction, one that as a montage is 'pregnant with tensions' but that has had a slow-burning effect, provoking over time important debates on environmental issues in architectural design (fig. 29).

Polish artist Krzysztof Wodiczko's artworks in urban sites are well known for using projections that combine visual images with sound recordings to produce composite forms – montage constructions – of building, image and voice. In some works, Wodiczko has projected images onto monuments that directly critique the values those structures support. For example, for the 'Projection on the Monument to Friedrich II', Kassel, Germany (1987), images of a crate of axles belonging to Unimog S military trucks produced by the Daimler-Benz plant in Kassel were projected onto the base of a statue of Landgrave Friedrich II of Hesse-Kassel, along with a shirt, tie and Daimler-Benz identity badge over the statue's Roman armour. Wodiczko's aim was to link this Enlightenment figure's imperial conquests to Daimler-Benz's contemporary use of 'guest workers' to make military equipment employed in the subjugation of certain groups, for example the black population in South Africa.[18]

The 'City Hall Tower Projection, Krakow' (1996), in Poland, combined images associated with dominant and resistant ideologies in different way.[19] Here, Wodiczko chose to work with a monument with which, he argued, the population of Krakow identified positively – the fourteenth-century City Hall Tower at the centre of the central marketplace (Rynek Glowny), an architectural construction he described as 'a lonely, if not heroically alienated, but authoritative, stable, protective, and trustworthy civic structure.[20] This was the site of Wodiczko's first video projection, which was a departure from his more usual mode of projecting still images. Visual images of two hands moving as a story is told (wringing a rag, holding a

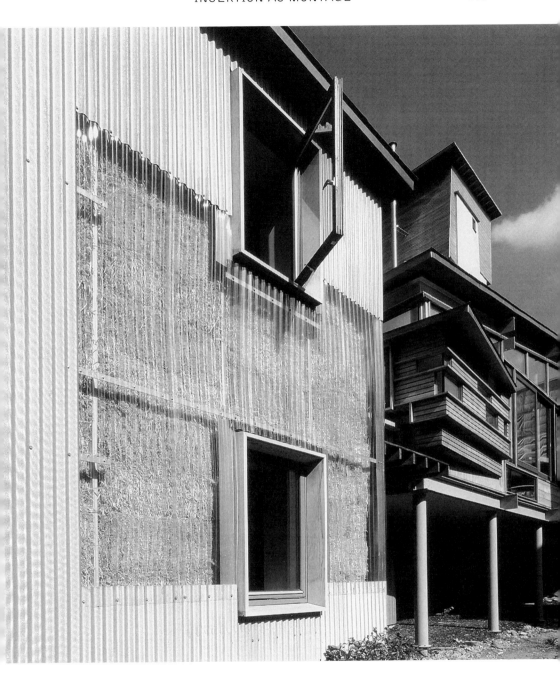

29
Sarah Wigglesworth Architects,
'Straw Bale House' (2001–)
London.
Photograph: Paul Smoothy.

30
Janet Hodgson,
'The Pits' (2005)
Canterbury.
Photograph: © Paul Grundy (2005).

candle and pulling the petals off a flower) were projected onto the 'body' of the tower while the voices of people who had suffered 'loneliness and alienation', for example as victims of domestic violence, were played through loudspeakers in the public square.[21]

Hands Playing with a Wedding Ring

The nights were the hardest for me, the nights when I didn't sleep, when I just sat in the armchair, my feet up on the footrest, staying up waiting. I stayed up and watched my baby sleep. I was afraid of his reaction, of my nightmarish drunken husband. I never knew what he would do.[22]

For Wodiczko, this tower operated as 'an unsettling junction' between the artist, positioned by Wodiczko as a viewer, and the person Wodiczko called 'Other', whose hands and voice were projected onto the tower and into the square, while those in the crowd played the role of third party or onlookers to the dialogue. Wodiczko's intention was that the artwork might play a role in helping to alleviate suffering, by allowing such dark and secret nightmares that usually lie hidden to come 'to light'.[23]

Also pointing to what has been displaced and marginalized as a way of critiquing contemporary culture, artist Janet Hodgson chose to inscribe archaeologists' drawings of rubbish pits into the York stone slabs set as a landscaped element in the new shopping complex designed by Chapman Taylor and built by Land Securities in Whitefriars, Canterbury, England. Since each drawing is composed of lines that travel across several slabs, the processes required to produce such an inscription demanded an amazing degree of precision and careful collaboration between the artist and MSS of Leeds (the subcontractor for the paving). Tasks that require this kind of slow and painstaking approach do not necessarily sit comfortably with prioritization of speed on many fast-track building sites (fig. 30).

Hodgson was entranced by the archaeological drawings. She described to me the scene of the site as a working dig where, divided by a grid of ropes, each archaeologist would set about excavating his or her own small square plot, revealing objects and spaces through the removal of earth.[24] Yet Hodgson's fascination was less with the archaeological practice of removal than with how archaeologists draw time. She described to me another scene, this one in the archaeologists' office where the small drawings produced by individuals on site were placed next to one another to establish a chronological sequence. The drawings inscribed in Hodgson's memory turned out to be called matrixial stratigraphs, which their inventor, Edward Harris, described as ways of 'seeing time'.[25]

Hodgson chose to title her work 'The Pits', so marking Whitefriars with information the site already contained about its own lost past and buried topography. Numerical figures indicate the depths and dates of historical layers, lines gesture to the holes beneath the surface, and various asides, notes the archaeologists perhaps made only to themselves, are now writ large upon the site.

Animal Burrow

Area not e.c. further as within 3m of edge of site/pile
Truncated by
Pile cap cannot dig beneath obviously

This renaming operates to bring the hidden indentations of the site into visibility. While one can easily pass through the work and experience it as a form of distracted visual pleasure, it is possible to look more closely, to concentrate and to read the lines as an image and at even closer quarters as a text. Such forms of viewing allow different negotiations with the site of Whitefriars past and present and the selection of rubbish as a cultural act.

Debates in archaeology on items found in pits and what they might tell us about human habitation are ongoing.[26] Are pits places where precious items were stored, perhaps over time in nomadic periods, or locations where rejected things were thrown – pots and flints as well as organic refuse? The use of pits for rubbish or waste certainly does not appear to be constant, but rather depends on historical period. There seems to be some agreement that in the Middle Ages the pits in people's back gardens were used for unwanted objects, but in the Neolithic period, for example, interpretations are less certain. Some research has shown that fragments of the same pot may be found in several pits, indicating a type of action that in today's terms is not easy to explain. Of all the drawings the archaeologists made in and of this site, including those of a rare and ancient street, Hodgson chose to inscribe only the drawings of the rubbish pits back into the location.

A brief browse in the windows of new shops in the Whitefriars redevelopment reveals a glittering array of clothing, jewellery and shoes, the lifespan of which from purchase, through use, to the landfill site will be staggeringly brief. It is possible for words and drawings inserted into a location to point to what is no longer there, or what has been pushed to the side, but also to question what is there, using the ambiguity of language to relay as well as anchor, to contradict as well as overemphasize. One reading of 'The Pits' then takes the term to describe what was present at one time but is now hidden beneath the surface, or perhaps has been

bagged, labelled and moved to another location, a storage point for items found at archaeological digs. But there is another reading that operates in relation to the brand-new items for sale in the shops surrounding the work, where 'The Pits' is read as a colloquialism, itself a kind of language often categorized as rubbish. Are we to understand then that the commodities *are* rubbish, or that they *are not* rubbish? It is not clear nor is it meant to be, for in working closely with a developer of a large-scale shopping complex, an artist like Hodgson, who may well be critical of commodity capitalism, must operate somewhat ambiguously, producing a work that offers a number of interpretations, a work that rather than tell us what to think asks us to question the ways in which we assign value to matter.

While a number of artists working in the public spaces of the city have engaged in the cultural politics of architectural sites, often using montage-based insertions to interrupt their contexts and draw attention to ideological structures that would otherwise remain invisible, have architects been doing likewise? The difficulty is that architectural projects provide fewer opportunities to critique the terms of engagement for a project and the context for a work. However, FAT, a group of artists and architects that have been making interventions into public spaces for over a decade in London, has set up a critical framework for architectural practice. As a response to amendments in 1994 to the Criminal Justice and Public Order Act outlawing a certain number of people meeting in a particular amount of space, FAT organized 'Picnic', an event that took place in Hyde Park, London. The park was divided up into a 'notional grid' that allowed a maximum number of people to gather before the event became 'illegal'. The work took the form of a protest, using a new layer of occupation to critique the specifically spatial codes of legislation governing public space (fig. 31).[27]

'Roadworks' (1997) also focused closely on the invisible social rules that govern behaviour on certain sites. For this project, for which FAT acted as curator, a number of artists and architects were invited to transform a series of bus stops in central London. For example, an artists' collaborative, Beaconsfield, converted the bus stop outside the Abbey National Building Society on London's Tottenham Court Road, an institution that lends money to buy homes, into a thatched cottage by placing a straw roof on the glass, metal and plastic structure – a mocking intervention that used both anchor and relay to highlight certain meanings of the site. On the one hand, the thatched roof clearly pointed to the utilitarian rather than domestic architectural qualities of a bus stop, while on the other it emphasized the aspirations of many clients of the adjacent Abbey National who entered the building society to borrow money in order to live out their dreams as owners of a small piece of England in the vernacular tradition (fig. 32).[28]

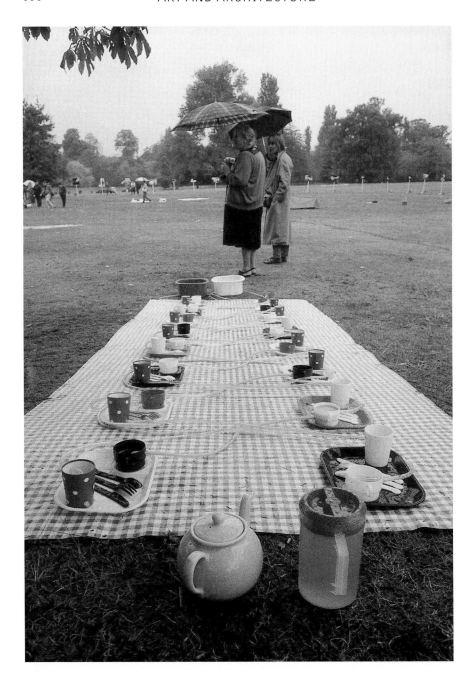

31
FAT,
'Picnic' (1995)
London.
Photograph: Josh Pullman (1995).

32
FAT,
'Roadworks' (1997)
London.
Photograph: FAT (1997).

It remains difficult, however, to make visible or material the ideological systems that structure social spaces as a juxtaposing layer in the design of a new building, but architect Bernard Tschumi's discussion of dis-, cross- and trans-programming suggests a mode of architectural practice that intends to do just this. Here, the layering of one 'function' on top of another provides the potential for multiple programmes to critique and destabilize each other – an attempt to bring the montage techniques of juxtaposition and perhaps also the allegorical techniques of recombination into the design of new spaces. According to Tschumi, cross-programming gives an old building a new function or programme not intended for it, trans-programming places two programmes that are not normally associated with each other together, and dis-programming is the positioning of two functions together so that one can potentially undo the other.[29]

In winning a competition to design a park on the site of an old meat market in a working-class district of northeast Paris, Tschumi aimed in 'Parc de la Villette' to take many of his critical and theoretical ideas about space and make a new kind of architectural proposition. In art discourse the term context-specific suggests a critical informed response to a context; in architecture the term does not really exist, but a project that pays attention to context would be one associated with reactionary attitudes, one that desired to follow the order of the given context, copying materials and forms to 'fit in' with the conditions as found and the requirements set by urban planning codes. Tschumi's critical view of the 'urbanistic program' was that architects either design a 'masterly construction, an inspired architectural gesture (composition)', or they 'take what exists, fill in the gaps, complete the text, scribble in the margins (a complement)'. Tschumi's preferred way of working, certainly in setting out a methodology for 'Parc de la Villette', was to 'deconstruct what exists by critically analysing the historical layers that preceded it, even adding other layers derived from elsewhere – from other cities, other parks (a palimpsest)' and/or to 'search for an intermediary – an abstract system to mediate between the site (as well as all given constraints) and some other concept, beyond city or program (a mediation)'.[30] So, rather than ignoring what is present in a given context or simply filling in the gaps, Tschumi advocated a design process that added or juxtaposed layers through montage, using one layer to disrupt or subvert another.[31]

At 'Parc de la Villette', Tschumi worked with three overlapping ordering systems: points organized in a grid, lines through the site, and surfaces. The layering was intended to bring the logic of each system into question. Each point was a *folie* (folly) reminiscent in form of a constructivist sculpture; the difference was that the red *folies* had no predetermined purpose.

Today, some *folies* are still left empty, but others have been taken over, as Tschumi intended, for example by hamburger franchises. The strange thing is though that, as structures intended to be appropriated, their initial design has not proved to be that flexible, making them rather difficult to occupy. In the hamburger restaurant nothing quite fits, yet given that in French the word *folie* also means madness, a linguistic relationship taken up in great detail by the philosopher Jacques Derrida in his discussion of Tschumi's design, this decision may well have been intentional (fig. 33).[32]

Tschumi's critique of architectural design methodology operates by attempting to disrupt many of its internal rules and ordering systems. To do this, Tschumi's work locates architecture in relation to deconstruction, which allows one to question the binary logic of certain architectural 'givens' such as 'form follows function'. His work has generated a new language of architectural design in which the term 'programme' has replaced the modernist word 'function', associating one site with multiple activities rather than a single use, and events that include the accidental as well as the planned and the intended.[33]

At 'Columbia University' in New York, Tschumi took his notion of the event, or activity, as a way of creating space. At the heart of the project is a void, or what Tschumi calls 'the place of event', a glass-fronted piece of architecture located between an existing building at the east end and another new structure at the west end. Along the northern edge of the construction are five levels of college activity; to the south is a glass wall and between the two lies an atrium. Along this southern wall, a staircase travels, going up from the west end to the east, then from east to west, all the way to the top of the building. On the other side of the atrium space, the floors are gently ramped, with lockers, tables and chairs laid out on an incline. The un-programmed spaces of the staircases and ramps are ready for all kinds of unpredicted occurrences, the locations where Tschumi hopes anything might happen. He staggered the two blocks so that the relationship between them was one of dynamic connection. All the generic activities might then get layered over one another and so 'charge the space in between, making it not a residual space, but a highly defined space', unplanned but vibrant:[34] 'architecture is always defined as the materialization of a concept. So the questions are first of all, what is the concept, how do you derive it, and how do you actualize its potentialities?'[35] It is interesting to note that, for Tschumi, 'concepts themselves have moments that are more acute, more crucial, in any given circumstance'.[36] In his recent work he has been locating technological developments in relation to such acute moments. Hence, at 'Columbia University' the event space is connected to the ramps, which are self-supporting and transparent, covered in glass, to create a 'hub of activities' (fig. 34).

33
Bernard Tschumi,
'Parc de la Villette' (1983–98)
Paris.
Photograph: Jane Rendell (1999).

34
Bernard Tschumi,
'Columbia University' (2000)
New York.
Photograph: Jane Rendell (1999).

At the time artists were debating the differences between conceptual art and minimalism, architects were discussing the relationship between form and function and the signifying qualities of architecture. Following Tschumi's lead, many architects replaced questions such as: 'What kind of form does a specific function produce?' or 'How can we design a building whose meaning is readable?' with explorations of programmes generated through narrative and event. Architectural form is today no longer seen as a result of functional requirements, but rather as the trigger to new programmes and occupations of space. The desire is not for an architecture that communicates one meaning directly, but rather for material and spatial forms that produce multiple associations and ambiguous situations. If contemporary arts practice operates spatially between concepts, sites and processes, then post-Tschumi architecture also implies a triadic process – one that explores the relationship of event, programme and form.

It is clear from the artworks and architectural projects discussed here that montage constructions can be understood in ways that go beyond simple juxtaposition and instantaneous shock. Many of the projects draw on allegorical techniques to combine fragments rather than oppose juxtapositions. These montage constructions of the late twentieth and early twenty-first century demand then to be understood differently from those of the early twentieth-century. They need to be considered in relation to today's political conditions and material circumstances, and the current state of aesthetic endeavour. We need to be attentive therefore to the varying ways in which the dialectical image might be made manifest now; to consider how currently it may not be appropriate to produce a condition of shock in order to politicize the viewer, but rather to produce works that combine optical and tactile registers, visual and aural components, to be experienced emotionally and physically, as well as intellectually, over time and through space, prompting critical reflection alongside a more subjective engagement. It seems to me, therefore, that it is even more pertinent, given the hesitance of many artists and architects to make work that is 'directly' political or 'didactic' in its message, that we, as Howard Caygill argues of Walter Benjamin's later work, are 'sensitive to the incompleteness of a work and the negotiability of its formal limits ... dedicated to revealing the unrealized futures inherent in the work'.[37]

Chapter 3

The 'What-has-been' and the Now

It's not that what is past casts its light on what is present, or what is present its light on what is past; rather, image is that wherein what has been comes together in a flash with the now to form a constellation. In other words, image is dialectics at a standstill. For while the relation of the present to the past is a purely temporal, continuous one, the relation of what-has-been to the now is dialectical: is not progression but image, suddenly emergent.[1]

In the two previous chapters I discussed projects that lean towards the allegorical or montage in their modes of production, towards melancholic contemplation, ruin and material transience on the one hand and towards juxtaposition and shock on the other, yet I have also suggested that these dialectical techniques overlap in the experience of the work. Now I shall focus on projects in which the new elements inserted into a given context aim to critique the construction of the past in the present, drawing attention to repressed aspects of history. In so doing they position what-has-been in relation to what is now in a way that is not sequential but that operates through simultaneity and juxtaposition, through immediate responses as well as more contemplative modes. The works I will discuss operate within a museum context, either as interventions into existing settings, as architectural designs for new projects, or as art and architectural works produced in relation to public spaces connected with a particular marking of cultural history.

35
Sophie Calle,
'Appointment with Sigmund Freud' (1999)
Freud Museum and Camden Arts Centre, London.
© Actes Sud 2005.

On the couch lies a wedding dress (fig. 35). The dark upholstery sets off the delicate fabric of the white gown. On the table downstairs is a blonde wig. Somewhere else is a shoe. And almost everywhere there seem to be small pink pieces of card typed with words that say something about her and him. They were married, married and unhappy, so they went on a long journey. No. Unhappy, they went on a long journey, and then fell in love and got married. It is hard to get the order of events right. Did they get married before or after the journey, before or after they were happy? But why should the details of another woman's love life matter so much?

> *I was invited to create an exhibition entitled 'Appointment' in the house at 20 Maresfield Gardens, London, where Dr Freud lived and died. After having a vision of my wedding dress laid across Freud's couch, I immediately accepted. I chose to display relics of my own life amongst the interior of Sigmund's home.*[2]

As she describes above, for 'Appointment with Sigmund Freud' (1999) at 20 Maresfield Gardens, Hampstead, London, artist Sophie Calle positioned 30 short texts and personally significant objects in relation to Sigmund Freud's own writings and things. The installation, with James Putnam as curator, coincided with Calle's show at the nearby Camden Arts Centre.[3] The texts reveal moments in Calle's personal history, including memories from childhood and intimate secrets concerning adult relationships. As the viewer makes a journey around Freud's house, Calle's biography unfolds, but not necessarily in chronological order.

The objects and cards are placed in such a way that connections and associations can be made between the details of her life and Freud's psychoanalytic theories. In Freud's talking cure, personal stories come to the fore as fragments, only to be reassembled as devices structuring the psyche. The context of Freud's life and work presents the artist's life in a more analytic manner than 'The Birthday Ceremony', a previous work in which Calle exhibited in separate glass cases all the presents she had received on her birthdays from 1983 to 1990. Like Tracey Emin, Calle takes the personal into the institutional and presents her life story as her artwork.[4] But Calle's autobiographical statements are less traumatic and more enigmatic than Emin's, more fictionalized and less direct. Calle's work lies more in the construction of herself as subject in the mind of the viewer and less in the drama of the confessional itself. It is not necessarily the 'real' Calle who is centrepiece here, but our imaginings of her prompted by what she chooses to tell us about herself. The particular positioning of words and objects not only allows us access to the artist's persona but also provides spaces onto which we project aspects of ourselves.

Our reflections on Freud are not far away either. Freud spent the last year of his life, from 1938 to 1939, in this house, which since 1986 has been the Freud Museum. The study and library on the ground floor contain all the books Freud was able to bring with him from Vienna, as well as the original couch and antiquities from Greece, Rome, Egypt and the Orient. The findings of archaeological digs operate as metaphors for psychoanalysis in which the gradual wearing away of conscious material reveals the unconscious still intact. Calle's work relates the memorabilia of Freud's personal life to the more foundational theories of subjectivity for which he is famous. The wedding dress on the couch perhaps makes the most significant connection between psychoanalytic practice and personal life, bringing the sexual tensions between the traditionally gendered male analyst and the female analysand into proximity with the contract established – economic, sexual and emotional – between husband and wife. The dress was accompanied by the following text: 'I always admired him. Silently, since I was a child. One November 8th – I was thirty years old – he allowed me to pay him a visit. He lived several hundred kilometres from Paris. I had brought a wedding dress in my bag, white silk with a short train. I wore it on our first night together.'[5]

What interests me here in Calle's work is the way in which the series of interlocking subjective and narrative insertions bring to the fore the museum's presentation of Freud and his writings from a more personal perspective. In a similar vein, though here the insertion takes the form of poems rather than objects and texts, the following project seeks to destabilize the cultural meanings associated with the site of a museum through the addition of more intimate moments.

The main hall of the Imperial War Museum in London is a place crowded with huge and unfamiliar objects. For those too young to remember the war, these machines seem strange and slightly exotic. Under the shadow of an aircraft's wing, between smooth steel missiles, is a red London bus where a small white sign with black words reads: 'OLE BILL (France, 1918)'.

There was a Once Upon a Time
I ran the golden miles –
Victoria to Seven Kings.
I was red, imperious. Style.
Now I've intestines of huddled
khaki. I'm boarded up to hide
the sons I hearse to the Somme.
Breed flies. And ache inside
to see your fresh red paint run.[6]

As part of the *Poetry Places* project at the Poetry Society, poet Mario Petrucci devised and was awarded a Poetry Society placement at the Imperial War Museum to research and write a series of poems for museum visitors, particularly children. The poems formed a poetry hunt called 'Search and Create' in the permanent exhibition (figs. 36–9).

Petrucci's poems deal with the emotional condition of war, the suffering of those in the trenches as well as those left behind.[7] Instead of inspiring fear or admiration for the sublime war machines designed to kill, the juxtaposition of poem with exhibit locates our worst imaginings of war on a more critical level. As cultural critic Susan Buck-Morss has pointed out of the dialectical image, what we require is the ability to 'shock … thought to a standstill and set … the reified objects in motion by causing them to lose their second-nature familiarity'.[8] Petrucci's poems certainly set the fetish objects around them in motion; this does not happen through shock, but rather through the longer, more absorbed, act of reading. In reading the poem as well as looking at the exhibit, we are caught up, not only in the visual and tactile properties of an object but also in a narrative space. This experience is physical as well as mental and emotional; to read each poem we have to crouch next to tall missiles and put our heads under guns. The effect of these tiny poems placed next to enormous pieces of metal is powerful. Fragile stories of human flesh make us question rather than delight in the power of military apparatus. Placed in intriguing places, like the treasure at the end of a hunt, these poems achieve something more complex than the pleasure derived from finding what one is already searching for. They produce an atmosphere of disquiet.[9]

In the same museum, but as part of a different exhibition, this time on the Holocaust and designed by an architect, another object has a similar affect. While the early history of the Holocaust was concerned with the task of recognizing that such an event had occurred, later research focused on the accounts given by victims and more recently there has been a deeper exploration of the lives of the perpetrators, from the camp guards to those who designed the trucks, authorized their refurbishment and organized the rail transportation to the camps.[10] 'The Holocaust Exhibition' at the Imperial War Museum, designed by Stephen Greenberg, then of DEGW, now of *metaphor*, consists of a variety of media: video, film, photography, text, as well as drawings and objects.[11] A large-scale model of Auschwitz is perhaps the most striking exhibit, but while the other objects are mainly items found in the former concentration and extermination camp museums in Germany, Poland and the Ukraine, this model was designed specifically for the exhibition (fig. 40: p. 128).

It is possible to argue that all the objects on display at the 'The Holocaust Exhibition' allow us to identify with either victim or perpetrator. However,

36–9
Mario Petrucci,
'Search and Create', *Poetry Places* (1999)
Imperial War Museum, London.
Photographs: Jane Rendell (1999).

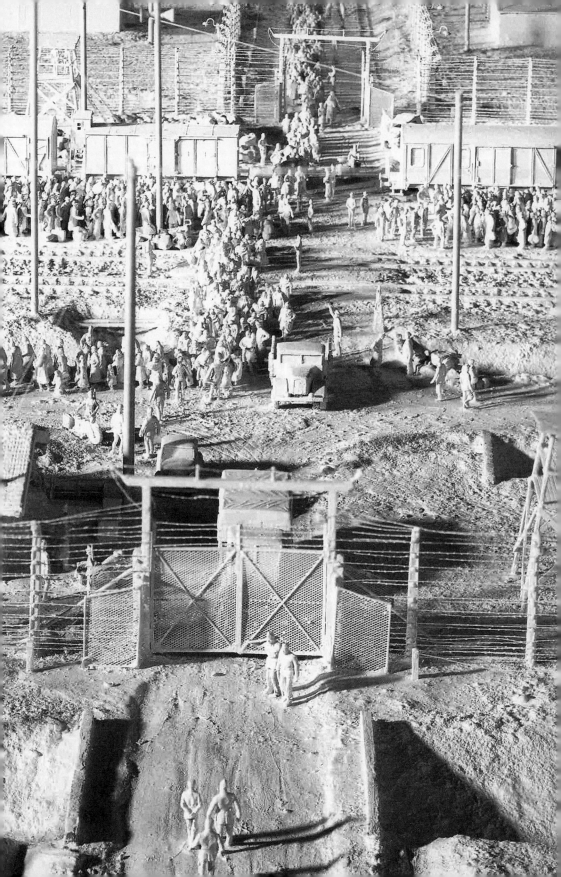

being shown discarded shoes, glasses, combs, all things at one time intimate with their owners, we tend to think of ourselves in the place of the victim. The architectural model of Auschwitz positions us differently. Looking down into the pristine world of a model sprayed power-white, we are shown a fragment of the whole camp, including the railway tracks leading in, the gates, the huts, the gas chambers and the chimneys. The model offers the viewer at least two simultaneous but contradictory positions. Do we identify with the tiny scaled-down replicas of the prisoners or the guards? With the model being placed on a table so that we have to look down into it, we are brought close to a third point of view – the mind of the architect. From this position, if we look up, we can see nearby on the wall of the exhibition some drawings: these are the original blueprints for the design and reinforce the architect's perspective.

For over a decade, from her first public work 'House' (1993), the cast of a Victorian terraced house in east London commissioned by Artangel, artist Rachel Whiteread has been making casts of absence, of what is not there – hollows, gaps and cavities – rather than what is there.[12] In New York, in a work for the Public Art Fund, Whiteread created 'Water Tower' (1998), a transparent resin cast of the inside of a wooden water tower, an object that because of its ordinariness tends to remain invisible on the New York skyline (fig. 41).[13] Made of a transparent rather than opaque material, 'Water Tower' slips in and out of visibility depending on the weather conditions, refunctioning a utilitarian rooftop object as a new kind of ephemeral landmark.

In various projects in different ways Whiteread's work brings the invisible into visibility. Although her mode is not necessarily site-specific, given that the objects she produces allow for metaphorical as well as physical connections to be made with the contexts in which they are positioned, provided with a pertinent ideological and historical location the work can resonate strongly, drawing out meanings buried within the site. Whiteread's winning competition entry for the Holocaust Memorial in the Jüdenplatz, Vienna (1995), a concrete cast of a library that would sit at the northern end of the square on the excavations of a thirteenth-century synagogue, did exactly this.[14] The site had a turbulent history; in the fifteenth century Jews committed mass suicide by going down into the crypt and burning themselves alive.

Whiteread's memorial is a solid and visible historical marker; her response to this particular event in which Jewish people have been made absent, first through acts of persecution and then through acts of historical amnesia, has been to add back what has been subtracted, tracing what has been negated. So, on first glance, her work appears to mark an event that history has denied existed: a gap between lines, a silence between words,

41
Rachel Whiteread,
'Water Tower' (1998)
New York.
Photograph: Jane Rendell (1999).

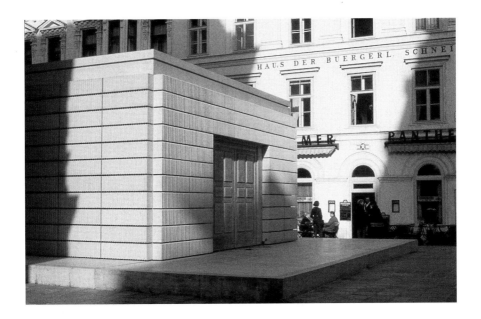

42
Rachel Whiteread,
Holocaust Memorial (1995)
Jüdenplatz, Vienna.
Photograph: Felicitas Konecny (2001).

and a story left untold (fig. 42). However, the work's quiet presence does not simply confirm forgotten facts; rather, on closer examination, it appears that the cast she has constructed is an impossible form. While the double doors at one end and the ceiling rose on the roof are negative inversions, Whiteread has not cast the spines of the books that would line the walls of a library but the inner edges that would normally face the wall. In creating a form that is not simply a cast of what has been made absent but rather a physical and material impossibility, perhaps Whiteread is suggesting that although one might wish to it is not possible to simply 'fill in' the gap that remains as a trace of the negations caused by acts of discrimination.

The Jewish Museum in Berlin is a project that also considers a traumatic aspect of Jewish history, but specifically in this work the effects of the Holocaust in Germany. Architect Daniel Libeskind won the competition to design the museum in 1988–9,[15] and his building is one of the most controversial and conceptual architectural projects of the last decade. The conversations it has generated focus as much on the theoretical concerns at its core as the material manifestation of those ideas:

> *Three basic ideas formed the foundation for the Jewish Museum design: first, the impossibility of understanding the history of Berlin without understanding the enormous intellectual, economic and cultural contribution made by its Jewish citizens; second, the necessity to integrate the meaning of the Holocaust, both physically and spiritually, into the consciousness and memory of the city of Berlin; third, that only through acknowledging and incorporating this erasure and void of Berlin's Jewish life can the history of Berlin and Europe have a human future.*[16]

To enter the building one walks into a baroque Prussian courthouse before descending into the foundations of the new structure. Three underground routes are then offered. The longest one leads up the main stair and into empty rooms with vertical voids made visible through diagonal cuts in the walls. Through windows sliced on the diagonal into the exterior surface it is possible to look back out to the cream plaster of the courthouse and see for the first time the external silver skin of the building in which you are standing (fig. 43). For Libeskind, these rooms represent the continuation of Berlin's history. If you take the second road, you find yourself outdoors, on sloping ground in a grid of tilting columns. This is the E. T. A. Hoffmann Garden that, for the architect, represents the exile and emigration of Jews from Germany (fig. 45). Finally, if you follow the third road you are taken to a cold, dark room at the end of a corridor. As the heavy door clangs shut, you look up to the light coming in high above and realize that you are in a tall, dark tower with no way out.

This architectural project drew on four conceptual concerns. The first, which traced the relationship between Jewish tradition and German culture, involved graphically plotting a matrix of the addresses of Jewish Berliners in such a way as 'to yield' an emblem in the form of a star. This then generated the building plan for Libeskind, 'a compressed and distorted star: the yellow star that was so frequently worn on this very site'.[17] The second conceptual concern was linked to Arnold Schönberg's *Moses and Aaron*, an opera in which the libretto of the third act has no musical accompaniment and in which the voice that calls out for the 'Word' is accompanied by instruments all playing one note. For Libeskind the 'spacing of the music's soundlessness' can be correlated with 'the space of the void in architecture'. It was also important to the architect that the composer, an assimilated Jew and professor of music in Berlin at around the time he wrote the opera, was exiled from the city.[18] Libeskind's third concept involved the use of the *Gedenkbuch*, a document that lists the names, dates of birth, dates of deportation and presumed places where Jewish Berliners were murdered in Riga, the Lodz ghetto and the concentration camps. And, for his fourth, the architect drew inspiration from Walter Benjamin's 'One-Way Street' and used its 60-part structure to inform the number of crossing points for the voids in the building (fig. 44).[19]

Of Libeskind's different conceptual themes, the void is the most spatial and easily translatable into architecture; it communicates through experience rather than as a representation; it shows rather than tells. The voids are organized in a line running through the building and their 60 crossing points form empty and enclosed vertical passages dropping through each floor. Then there is the Holocaust Tower. In Libeskind's words, this is the 'voided void', which he refers to as 'that which can never be exhibited when it comes to Jewish Berlin history', expressed through spatial emptiness in the architecture. For Libeskind, the Holocaust Tower is what it means 'to take emptiness and to materialize it as a building'.[20]

The text that describes the architectural design process reveals a complex set of literary references and spatial concepts that the physical experience of the architecture does not always communicate.[21] For some this has been seen as a failing, but it is possible to get to know a building on a number of levels, by reading about it as well as by walking through it. Architecture might not be a text that can be read like a book, but this does not mean that architectural design should not draw on ideas from literature and philosophy. More fascinating than reflecting on how difficult it is to apply ideas generated through text-based practices to architecture, is a consideration of how materials and spaces hold ideas differently from the words on a page in a book. Libeskind's architecture offers a number of different architectural experiences – intellectual, emotional and physical.

43–5
Daniel Libeskind,
'The Jewish Museum' (1992–9)
Berlin.
Photograph: Jane Rendell (1999).

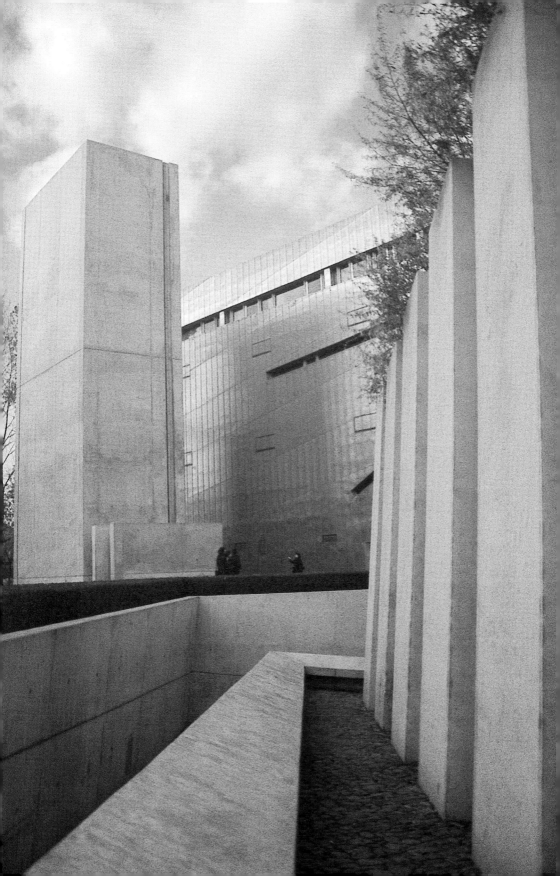

When the museum first opened to the public, it was empty throughout and many visitors, myself included, remarked on how moved they were by this experience. The emptiness of the maze of corridors enhanced the impression of futility – there was nothing to do except walk, think and feel. Absence was presented as the subject matter of the museum. But now that the spaces have been filled with exhibits, the building appears to have lost this power, so that the experience of absence or loss starts to feel rather forced or fabricated. Does this suggest that the design of the exhibition has been misconceived, that for this particular museum to communicate it needs to be empty? Or, is it possible to think about the museum itself as an intervention into the city that questions the way history has been told, that reinserting aspects of the past places emphasis on the presence of absence in history, on the what-has-been in the now?

While museums have provided a context for the spatial development and diversification of dialectical approaches, both allegorical and montage-based, a number of projects operating outside the museum have used similar techniques to draw out repressed aspects of their context, highlighting events that remain 'undercover', or that have been marginalized in the telling of cultural history. In works that take a strongly political role in pointing to the attempted erasure of a particular people, in this case the Eora, or Aboriginal people of Australia, artists Janet Laurence and Fiona Foley, and Paul Carter, have used texts in two recent public art projects connected to new museum designs in Sydney and Melbourne.

'Edge of the Trees' by Laurence and Foley, made in collaboration with architects Denton Corker Marshall, uses a combination of visual imagery and audio components to critique the miscarriages of justice in Australian cultural history.[22] Located outside the main entrance to the Museum of Sydney in the heart of downtown Sydney, the artwork consists of a number of vertical rods of different heights made of various materials – metal, plaster and wood – placed to the side of a plaza that sits in front of a museum, whose purpose is to tell the history of Sydney (fig. 46: opposite page).

This forest of columns is inscribed with words and is resonant with voices. The names of local plant species taken from an archaeological pollen reading on the site are carved into the wood; the names of the members of the First Fleet (the first colonizers of Australia) are inscribed on zinc plates recessed into the wooden poles; and the names of places and Aboriginal men and women who once lived in the region are written in the sandstone. The corten steel columns pick up on the grid of the new museum building, the yellow-block sandstone columns cut out of the ground follow the footings of the first Government House located on

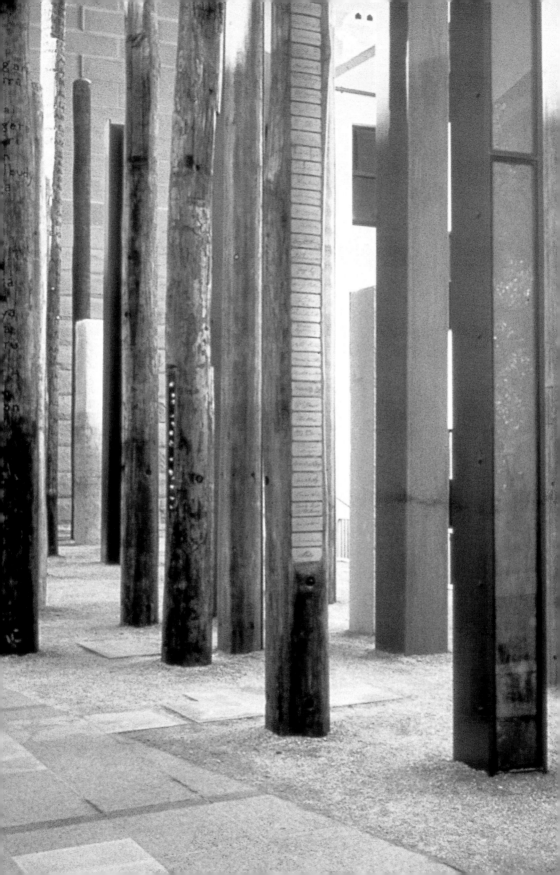

this site at the intersection of two busy streets, and the reclaimed timber columns refer to the cluster of trees that once grew here. Each 'tree' speaks almost inaudibly, saying the words of species named by the Eora. That the term Eora means 'here' or 'from this place', and was used by Aboriginal people to describe to the colonizers the place from which they came, helps point to the significance of place, history and identity in this project. As you enter the space between the columns, the sounds and textures immerse you, transporting you to another place where history is re-imagined.

A point like this at 'the edge of the trees' looking out from the forest towards the seashore has been mythologized as the place where the Aboriginal people first saw those who came to colonize their land. 'Edge of the Trees' plays an important role in remembering an aspect of Australian history that for years has remained buried: 'the discoverers struggling through the surf were met on the beaches by other people looking at them from the edges of the trees. Thus the same landscape perceived by the newcomers as alien, hostile or having no coherent form, was to the indigenous people, their home, a familiar place, the inspiration of dreams.'[23]

Anthropologist James Clifford has suggested that museums are contact zones, places of exchange between cultures.[24] Critical theorist Homi Bhabha draws an important distinction between two different kinds of cultural exchange – cultural diversity and cultural difference. While cultural diversity is understood as the 'recognition of pre-given cultural contents and customs' and connected to liberal notions of multiculturalism, for Bhabha, cultural difference is a more radical concept that allows new positions to arise. In Bhabha's opinion, 'the problem of cultural interaction emerges only at the significatory boundaries of cultures, where meanings and values are misread or signs are misappropriated'.[25]

If the museum can be understood as a contact zone or place of cultural exchange, then the edge of the trees marks this spatial boundary, with significance, as a place in which Bhabha might expect misreadings or misappropriations to occur. It is a pity that in the urban design such a potent spatial configuration was placed to one side of the plaza and to the entrance route into the museum. In my opinion, the grouping of columns would have had a more powerful impact had they been positioned across the front of the building, providing an edge, or moment of recognition of cultural difference, that each visitor would have to pass through to enter the site of the history of colonization. It is interesting to note, then, that the architects, who had always envisioned an empty plaza in front of their building, resisted the artists' original proposition to extend the poles across the plaza to map the 29 Aboriginal clans of the Sydney area.[26] 'Edge of

the Trees' makes clear that, when inserting a fragment of the past into the present, the precise position through which the work is experienced matters. The specificity of the relationship between the 'what-has-been' and the now cannot be underestimated in a dialectical construction.

Similar concerns with place, cultural identity and history are behind the work of artist Paul Carter who, for the redevelopment of Federation Square in Melbourne, was commissioned to make a piece for the main plaza. 'Nearamnew' (2001) is a text-based work developed in collaboration with lab architecture studio. The political concept of federation is the motivation behind the whole project. lab's design for the square, a collection of crystalline structures, described by the architects as a 'tectonic aggregation', interpreted federation as 'a league of parts rather than a central authority'.[27] American political scientist Morton Grodzin's description of the organization of federal systems of government as layers of marble cake provided a key reference for Carter's work. 'Nearamnew' consists of three elements: a whorl pattern manifest throughout the plaza, eight surface figures located along the force lines of the swirl and eight federal texts engraved into the surface figures. Carter likens these to the three layers of federal government – global, regional and local: 'The result is a cryptic encyclopaedia in stone: a ground design that, by harmonizing with the intent of the architectural design, marks Fed Square as a federated space, as a distribution of meeting places, desire lines and accumulating memories.'[28]

'Nearamnew' recognizes the suppression of the aboriginal inhabitants of the land that accompanied Australia's new independent status as a white nation. Derived from a local word, 'narr-m' in pidgin, 'nearamnew' means 'the place where Melbourne now stands'. Pidgin is a language that could be described as Clifford's 'contact zone' or for Bhabha, a contested hybrid space. Carter's interests lie in the relationships between topography and the writing of place, between site-identification and self-identification, and between place-naming and name-placing. His aim for the project was 'to rename, and thereby to bring into being, a new place'.[29] This renaming occurs not by simply positioning a word in a site, but through the readings that activate the body as well as the mind, involving the adoption of particular positions. These different spatial reading experiences are constructed through the use of various fonts, scales and spacings, for example between the federal text written in a cramped 'generic bureau grotesque font' that involves getting up close to decipher the writing and the 'ur-letters' of the larger-scale surface figures that appear more like images and invite one to walk across them to make sense of them.[30] Perhaps in line with anthropologist Michel de Certeau's notion of space as

47
Paul Carter,
'Nearamnew' (1999–2001)
Federation Square, Melbourne.
Photograph: Paul Carter (2005).

a practised place, discussed in Section 1: Chapter 3, Carter treats 'reading as a mobile activity'.

At each scale the reader is offered a different understanding of the site that raises questions concerning the political history of Australian land and government (fig. 47).[31]

Poet, writer and art critic Sue Hubbard has argued that words are not simply individual objects or even images to be used at random, but are connected to one another in formal and complex systems. For Hubbard, poetry is a language with its own rules of composition and she suggests that although the content of a poem can be informed by themes connected to specific places, a poem comes to a location with its own spatial composition.[32] Hubbard's focus on the integrity of poetic composition adds another dimension to our consideration of the insertion of words into locations to bring to the surface past occupations that have been erased through history. Her argument emphasizes how, in positioning words in particular locations, we are bringing together two different and not necessarily compatible signifying structures.

Hubbard's 'Eurydice' (1999) is a large-scale permanent poem composed of a series of three-line stanzas written along the wall of a tunnel on London's South Bank from the Imax Cinema to Victory Arch at Waterloo Station (fig. 48). Commissioned by the British Film Institute, this poem was a response to a brief to improve the underpass and make it feel safe, yet also retain some of the tensions of the site, once the infamous bull-ring occupied by many of London's homeless. Eurydice's journey to the underworld makes reference to the treacherous conditions of the underpass, refusing to allow the benign renovations to obliterate the recent and somewhat darker history of the site.

I am not afraid as I descend,
step by step, leaving behind the salt wind
blowing up the corrugated river,
the damp city streets, their sodium glare
of rush-hour headlights pitted with pearls of rain;
for my eyes still reflect the half-remembered moon.
Already your face recedes beneath the station clock,
a dark smudge among the shadows
mirrored in the train's wet glass.[33]

In this work, associations with the history and current use of the site inform the content of the poem, but what is the relation between the structure of the poem and the form of the underpass? Has the spatial condition of the site informed the structure of the poem? Could a poem of one line that

48
Sue Hubbard,
'Eurydice' (1999)
Waterloo, London.
Photograph: Edward Woodman (1999).

lasts the length of the journey along the underpass exhaust the condition of the written line? And, once inserted, do we experience the underpass, interrupted by the punctuated addition of a series of three-line stanzas, differently, reading while we walk?

The artworks and architectural projects discussed above each involve the insertion of a new layer into an existing context in order to destabilize historical meanings, allowing the slowness of listening, reading and walking to interrupt the more public and instantaneous moment of looking. The new elements draw attention to repressed aspects of the site and its history, bringing the what-has-been into direct relationship with the now, and inviting the viewer to take part in the making of a dialectical construction. Addressing absences in history is a project certainly concerned with loss and sadness but it is also one that provides a strong critique of historical acts of negation. As Howard Caygill suggests of Walter Benjamin's writing, it is not simply the case that as a critic Benjamin was looking to draw out the constructive principle of work, but rather he was 'part of the speculative effort to discover and invent new forms'.[34] It seems to me that in the critical interventions described here there is a desire to 'interrupt' the versions of history told by inserting new voices. But the constructions produced are not necessarily instants in which the thinking stops in shock or astonishment, but moments where the viewer is required to act as critic and to engage in a slower time, a different thinking, one that takes the encounter with the work as integral to the writing of a dialectical image.

Section 3

Between One and Another

Introduction

Listening, Prepositions and Nomadism

Recent disappointments with many of the objects produced and described as 'public art' have resulted in a preference for process-based work. Such disappointments might be characterized as irritations with the often-patronizing effect of many finished works stemming from the intentions of commissioning bodies to use public art to solve problems and simplify issues, as well as the more long-standing aversion to monumental and domineering artefacts built in the service of dominant forces, be they private companies or public bodies. Instead, hope has been placed, often misplaced, in art that is less object-driven, not surprisingly smaller in scale, and frequently engaged in process and interaction with various 'local' user constituencies. Here, in Section 3, I suggest that we should not reject objects outright but rather consider the role they play in tracing and constructing relationships. Objects can certainly be thought of as a material composite of a series of interactions between people, but they can also be more proactive; for example, as props they can encourage play and speculation and as gifts they can challenge capitalist notions of profit and ownership. In mediating between real and imaginary spaces, objects provide possibilities for people to exchange ideas and communicate dreams and desires in material form.

A feature of much contemporary criticism and art practice has been a shift towards understanding art as relational or dialogical. In *Relational Aesthetics*, for example, Nicholas Bourriaud argues that the work of particular artists such as Rirkrit Tiravanija produces open-ended conditions or

'relational aesthetics' that invite the viewer to participate in the construction of the work.[1] In relational art, the work of art operates as a partial object, a vehicle of relation to the other.[2] Bourriaud sets forth the importance of 'forms which do not establish any sort of precedence, *a priori*, of the producer over the beholder ... but rather negotiate open relationships ... which are not resolved beforehand'.[3] In *Conversation Pieces*, Grant H. Kester provides a different way to consider art and the making of relationships through discussions around dialogue.[4] Kester examines both artworks that are based on conversation and dialogue and a theoretical framework for thinking about dialogue from a philosophical point of view and explores how the writings of Emmanuel Levinas on 'face-to-face' encounter have provided an ethical dimension to the debate, in particular through his concept of the figure of the irreducible 'Other'. Kester considers from a critical perspective how the work of literary critic Mikhail Bahktin has been invoked to argue that meaning is constructed between the speaker and the listener, rather than simply given. Tom Finkelpearl, in an earlier contribution, raised the importance of dialogue in public art, and pointed to the work of the Brazilian Paulo Freire, for whom dialogue is not a means to an end but a process, an ongoing project of intersubjective investigation based on a series of ethical decisions.[5]

This recent interest in how relationships between subjects play a central part in thinking about and making art demands that discussions about ethics complement those on aesthetics. There is also a need to situate such an enquiry within psychoanalytic theory, not necessarily to 'explain' the intention of an artist or attempt to unravel the 'unconscious' aspects of a work, but to provide a necessary context in which to understand what is at stake in the making of relationships to produce and interact with art and architecture. Indeed, psychoanalyst Jessica Benjamin suggests that once we start to think in terms of relationships between subjects, or subjectivity, we have no choice but to consider intrapsychic mechanisms of relation, most importantly identifications. 'Once subjectivity is embraced, we have entered into a realm of knowledge based on identifications, hence knowing that is intrapsychically filtered.'[6]

In her book on identity and identification, feminist theorist Diane Fuss focuses on the centrality of relation in processes of identification. Fuss states that identification is 'a question of *relation*, of self to other, subject to object, inside to outside';[7] it is 'the psychical mechanism that produces self-recognition'.[8] Fuss outlines how identification involves the interrelationship of two processes working in different directions: introjection, the internalization of certain aspects of the other through self-representation, and projection, the externalization of unwanted parts of the self onto the other. Visual theorist Kaja Silverman, in exploring the

importance of identification for understanding how subjects relate to one another, has attempted to think through the differences between varying forms of identification, specifically cannibalistic or idiopathic identification where one attempts to absorb and interiorize the other as the self, and heteropathic identification where 'the subject identifies at a distance' and in the process of identification goes outside him/herself.[9]

As Benjamin states, interests in subjectivity and relations have been at the heart of conceptual debates in feminism in philosophy and theory since the late 1960s and early 1970s. 'An intersubjective theory of the self is one that poses the question of how and whether the self can actually achieve a relationship to an outside other without, through identification, assimilating or being assimilated by it. This – how is it possible to recognize an other? – may be taken as another aspect of the problem addressed by much feminist writings.'[10]

Benjamin, for example, has argued that while critical theorist Theodor Adorno's critique of identity allowed negation through self-reflection, his concept of reflection did not allow for negation of the self through the entry of another.[11] Feminist theorist Judith Butler has recently suggested, following Levinas, that it is precisely our relation to the other that negates our identity:

> *For if I am confounded by you, then you are already of me, and I am nowhere without you. I cannot muster the 'we' except by finding the way in which I am tied to 'you', by trying to translate but finding that my own language must break up and yield if I am to know you. You are what I gain through this disorientation and loss. This is how the human being comes into being, again and again, as that which we have yet to know.[12]*

Through psychic processes such as identification, introjection and projection, psychoanalytic theory provides a rich source of conceptual tools for exploring the complex relationships made between subjects and others, and between people, objects and spaces. However, given the limited scope of this book, in Section 3 I do not delve deeply into this specialized field of enquiry, but rather, in accordance with the aims of my project – to place an emphasis on exchanges between subjects and objects in the making and using of art and architecture – I have chosen briefly to introduce three speculative areas of feminist enquiry – dialogue, relation and nomadism – each one of which allows us to focus on a different aspect of the making of relationships in art and architecture.

In her 1991 book, *The Reenchantment of Art,* feminist art critic Suzi Gablik critiqued the modernist aesthetic for encouraging 'distancing and depreciation of the Other' rather than inspiring creative participation or

engagement.[13] Gablik took issue with modes of distanced knowing, the removal of the self from social and moral responsibility, and the stripping away of emotion present in certain works of modernist art.[14] Gablik asked us to consider our relationships to others in terms of listening, her understanding of which was informed by what philosopher David Michael Levin called 'enlightened listening', a listening oriented towards the achievement of shared understandings. The kind of art rooted in a 'listening' self suggested for Gablik a flow-through experience that was not limited by the self but extended into the community through modes of reciprocal empathy. This suggestion still stands and points to the kind of art that is 'listener-centred rather than vision-orientated' and that operates through dialogue and open conversation – where one listens to and includes other voices:[15] 'the boundary between self and Other is fluid rather than fixed: the Other is included within the boundary of selfhood. We are talking about a more intersubjective version of the self that is attuned to the interrelational, ecological and interactive character of reality.'[16]

To focus on 'listening' as an aesthetic act allows us to trace the current interest in conversation and dialogue in art theory back in time to feminist criticism; likewise, in thinking about the role of prepositions as words that link and connect, it is also possible to refigure Bourriaud's notion of 'relational aesthetics' from a feminist perspective. At a talk at the Architectural Association, London, in April 2001, French feminist philosopher Luce Irigaray spoke of her research into language with eight-year-old Italian girls and boys. She described how when given a preposition to use, girls made sentences that linked them to people, whereas boys made sentences that linked them to objects. From her research findings, Irigaray speculated that women's desire to form relationships with others, people rather than objects, could provide the starting point for imagining new forms of relationship between men and women as equal but different subjects:

> *Far from wanting to possess you in linking myself to you, I preserve a 'to', a safeguard of the in-direction between us – I Love to You, and not: I love you. This 'to' safeguards a place of transcendence between us, a place of respect which is both obligated and desired, a place of possible alliance.*[17]

For Irigaray the potential of the insertion of the word 'to' into the phrase 'I love you' making 'I love to you' suggests a new social order of relations between two, where both the 'I' and the 'you' are related as different subjects, rather than as subject and object. Prepositions possess a strong suggestive role, allowing us to think more specifically about how we construct and can change relationships between subjects and objects,

and between people, places and things. As philosopher Michel Serres has observed, for such small words, prepositions have the potential to change everything around them.[18]

Gablik's and Irigaray's positions correspond closely to much other work in postmodern feminism, where new ways of knowing and being have been and continue to be discussed in spatial terms – 'mapping', 'locating', 'situating', 'positioning' and 'boundaries'. Employed as critical tools, spatial metaphors constitute powerful political devices for examining the relationship between identity and place, subjectivity and positionality. *Where* I am makes a difference to what I can know and who I can be. Such feminist theories provide an account of subjects constructed in relation to others, whose knowledges are contingent and partial rather than 'all knowing'.[19] Feminists in visual and spatial culture have drawn extensively on psychoanalytic theory to further understandings of subjectivity in relation to positionality, making connections between the spatial politics of internal psychic figures and external cultural geographies.[20] In particular, Rosi Braidotti's notion of the 'nomadic subject' has provided an important 'theoretical figuration for contemporary subjectivity'.[21] In her writings, the nomad describes an epistemological condition, a kind of knowingness (or unknowingness) that refuses fixity, that allows us to think between or 'as if', to articulate another reality.[22]

In the following chapters I explore how artworks and architectural projects operate as the place of exchanges between subjects – artists and architects, producers and users, viewers and occupiers. In Chapter 1: 'Collaboration' I look at how in collaborations between artists and architects assumptions tend to be made about the role and function of 'subjects' and 'objects' in the two disciplines. I suggest that if processes of identification are key in determining how relationships are made, then central to any collaboration, particularly an interdisciplinary one, is the process of dialogue, which allows us to recognize the positions we take up in relation to one another in order to make and use a work.

In Chapter 2: 'Social Sculpture' I examine how the concept and practice of social sculpture, derived from artist Joseph Beuys, places emphasis on the role that physical objects can play in tracing and prompting relationships between the various people – artists, architects, users and participants – involved in producing a work. I discuss a series of projects that have located their aesthetic concerns in the construction of relationships between people and speculate how, in these cases, it is possible to consider objects as prepositions in their ability to articulate and transform existing connections between people.

Braidotti's concept of 'as if' and her celebration of the nomad as a figure bringing critical possibility and change through new ways of thinking and

moving, is taken up in Chapter 3: 'Walking', with its focus on walking in art and architecture. The popularity of a work like Janet Cardiff's 'The Missing Voice (Case Study B)' (1999), a choreographed walk around the Whitechapel area in London, demonstrates a current interest in artworks that engage us performatively.[23] In Chapter 3 I draw on Braidotti's concept of nomadism to emphasize the conceptual rethinking and political critique that characterize practices that comprise walking, articulating how encounters between people are constructed in and through space. By exploring ongoing and changing spaces of encounter between people, objects and places, walking can play an important role in creating new kinds of relationships between subjects and objects, subjects and others in architectural design, shifting emphasis from the qualities of particular end-products to the aesthetic values of exchanges involved in the processes of investigation.

Chapter 1

Collaboration

The boundary between self and Other is fluid rather than fixed: the Other is included within the boundary of selfhood. We are talking about a more intersubjective version of the self that is attuned to the interrelational, ecological and interactive character of reality.[1]

In this chapter I explore three collaborations between artists and architects, each of which functions in a different way. In the first part I argue that architect Will Alsop celebrates architecture as art and operates in a somewhat old-fashioned mode where the architect admires the artist as unfettered genius. I then go on to discuss the basic tenets of the Royal Society of Arts 'Art for Architecture Award Scheme', where throughout the UK, from 1991 to 2004, artists were financially supported to collaborate with architects. Finally, I investigate some projects by London-based art–architecture collaborative muf, who have created a number of works that use the basic tenets of conceptual art – which we might characterize as a questioning of the terms of engagement – to challenge the roles of artist and architect and definitions of art and architecture.

Known for buildings like the regional government building in Marseilles, the Hamburg ferry terminal and the Cardiff Bay visitors centre, Alsop Architects received the Stirling Prize for Architecture in 2000 for its new media centre and library in Peckham, south London. Will Alsop is also the architect for The Public, a new arts building for West Bromwich, Sandwell, in the West Midlands, due to be completed in 2006.[2]

Originally named c/PLEX, the project was described in 2001 as 'a new
centre for arts, community and technology'. c/PLEX was established in
1998 to develop the work of Jubilee Arts, to regenerate West Bromwich by
supplying employment, training and education, and to provide a landmark
building commissioned to signify 'hope'.[3] This initial brief fits well with
what architect Alsop expressed as his 'essential objective' – 'to make life
better through architecture'.[4] In June 2000 c/PLEX was the centrepiece
in the British Pavilion at the Seventh Venice Architecture Biennale, which
focused on the relationship between ethics and aesthetics.

Since its establishment in 1974, Jubilee Arts has taken a leading role
in developing community arts practice, dealing with such social issues as
drugs awareness ('Buzz'), asthma ('Ease the Wheeze'), rape ('Facts and
Myths') and Aids and HIV ('Sex get Serious').[5] From the initial conception
of c/PLEX, Jubilee Arts and Alsop Architects held consultations with
local groups from the council, schools, retailers and residents to generate
a programme that corresponded to the needs of Sandwell. In 2005 the
client, renamed 'The Public' – a term used to describe the building and the
arts organization that instigated its conception – said of Alsop: 'His way of
working is unorthodox. He has established an architecture whose tenets are
consultation, imagination and the tangible manifestation of civic pride.'[6]

This mode of working fits well with Alsop's image of himself as an
architect interested in social issues. In 2001, he made clear his belief in the
necessity for a strong link between society and creativity

> *It [the Architecture Foundation] must try to demonstrate that there is a
> relationship between new, innovative and creative design, and socially
> responsible action. In the past, the idea of public participation has not sat well
> with cutting-edge architecture. Public consultation was watered down to a series
> of questionnaires that only confirmed past prejudices, as opposed to positing
> new possibilities ... We need our best architects to participate in a more open
> and creative working process – one that addresses the possibilities of design,
> urbanism and architecture.* [7]

When architects primed with the objective of regenerating an area are
asked to create landmark buildings, there is a strong demand for architecture
to operate as a formal gesture signifying cultural regeneration – you only
have to think of Frank Gehry's Guggenheim Museum in Bilbao (1997).
Alsop's observation that 'in the past, the idea of public participation has
not sat well with cutting-edge architecture' is not unfounded.[8] Certainly, it
is not uncommon for architecture practices that wish to experiment to shy
away from dealing with committees and large-scale public participation,

believing that the management of such a process will somehow constrain the creative process.

Alsop is also, however, suspicious of both community and theory for the role he perceives they play in reducing creative potential. He believes that 'community' works against transformation. 'The theory of community states that directly a community recognizes itself it starts to create defences to protect itself, which stultifies and discourages change.'[9] Theory is also problematic to Alsop because he believes it tries to define 'the right way to make architecture'.[10] Typical of many architects of his generation, Alsop apprehends theory from a defensive position, producing a misunderstanding where theory is located as a judgemental and controlling device rather than as a tool for self-reflection and a possible generator of imaginative spatial ideas.

Alsop's idiom, 'form swallows function', attempts to switch the terms of the modernist idiom 'form follows function' and to displace the social agenda of use that he associates with functionalism with a new kind of formalism. Alsop sees architecture as art, but not the sort of art I have been discussing during the course of this book. Alsop is interested in art as the gesture of creative individuals, and in his view both community and theory work against the artistic freedom of the individual. If Alsop could be said to identify with the figure of the artist as sole genius, he would not be the first architect to do so; and, as we saw in Section 1: Chapter 2, the identification can work the other way – artists are not exempt from identifying with architects. And although the ways in which artists identify with architects today, in particular with the control that the figure of the architect represents and the often highly rationalized processes of architectural design, are often accompanied by a certain degree of critical reflection, this has not always been the case.

Architects Hawkins\Brown have been working in CEDA (Central East Dalston Area), Hackney, London, on a number of mixed-use schemes from 1995 to 2005.[11] The site is on the west of Dalston High Street opposite Ridley Road market. Phase one, the main building on Bradbury Street, contains 40 workshops, studios, shops and offices for artists, craftsmen, businesses and community groups. Phase two involved the design of ten market-stall units each with access to a shared store and toilets. These robust 'pods' are rented out for £30 a week and can be used as stalls, lock-ups and small walk-in shops for starter businesses. Instead of turning their backs on a parking lot, the pods face into it, creating the first stage in the transformation of this leftover space towards becoming Gillette Square, a new urban square for Dalston. Hawkins\Brown's redevelopment of the whole square includes a new culture house on the

west side and the renovation of Stanford Works, the building on the north side. Artist Andrew Cross worked with architects Hawkins\Brown at Gillette Square, funded by the 'Art for Architecture Award Scheme', a project that supported collaborations between artists and architects from 1991 to 2004.[12]

For some years Cross has been photographing the mundane and banal architectures of the post-industrial global landscape. His interest is in the non-glamorous environments around the edge of cities, the often overlooked architecture of distribution centres, warehouses, suburban homes, service stations and out-of-town shopping centres, dull and non-descript but vital to the lives of many people. Cross focuses on the details of such places, not in terms of the 'taste' and connoisseurship of high art and culture, but, for example, on the different styles of lettering on delivery vans or the variations of the hedges of suburbia. Following in the tradition of photographers like the Bechers and their fascination with the formal taxonomies of highly functional architectures like water towers, one of Cross's best-known works is a guidebook to the petrol stations of London. The architects chose to work with him because of his interest in infrastructure:

Andrew [Cross] is incredibly interested in infrastructure, but he is also interested in the relationships to spaces that are created as a result of infrastructure. ... What we would like to do here is propose a way in which the people of Hackney can understand the changes that are taking place as a result of the redevelopment of the square and think about how this relates to either their home or the city as a whole. So it is about looking in and looking out at the same time. Two ideas could become very much part of the architecture. One is a camera obscura, or some form of viewing device, so that people can gain an understanding of where the square sits in relationship to the city as a whole. The second is a way of elevating people so they can see where the town-square lies in relationship to where they live. So the project is about helping people understand processes of urban change.[13]

As I suggested in the 'Introduction' to this book, art and architecture are often defined in relation to each other in terms of function, namely that architecture is taken to be functional and art is presumed to have no function. I suggested instead that art's 'function' was its critical role. In this case art's critical role functions through a photo-essay operating as a record of the transformation of this urban space. Cross focused attention on Gillette Square as a site of transition between the existing Dalston and the Dalston the architects imagined it would one day be.

The 'Art for Architecture Award Scheme' aimed to challenge the traditional model of collaborative practice whereby architects invite artists to contribute an artwork near the end of a project when many of the key design decisions have already been made. In such cases an artist's skills tend to be employed in the decoration of a site or a building rather than strategically. Exchanging ideas at an earlier stage in an architectural project increases the possibilities for dialogue and for aspects of existing working procedures and forms of knowledge usually taken for granted to be revealed and possibly questioned. In providing financial support, the award allowed the artist to get involved in the initial stages of a project. According to its director, Jes Fernie, '"Art for Architecture" did something that is almost unheard of in the world of art and architecture funding: it supported conversations, the exchange of ideas and forms of experimentation with no pressure to produce preconceived outcomes.'[14]

However, despite promoting an exchange of views between artists and architects, and enabling the artists to gain more influence in the design of buildings, in the projects supported by the award those involved tended to adopt the already-assumed identities of artist and architect within the context of the built environment, rather than allow a critique and redefinition of roles. Indeed, the title of the award 'Art *for* Architecture' suggests that art is operating in the service of architecture, that art is offering itself to architecture. What would the relationship be like the other way around? What could architecture *for* art be like? This is a question I will go on to explore now in relation to muf, a practice of artists and architects who work collaboratively, and who, by adapting processes from conceptual and critical art practice to challenge assumptions made concerning the role art is assigned in relation to architecture, implicitly address this question.

Described as an architectural practice, muf is frequently criticized for not producing any 'architecture' or buildings, but this is because muf's way of working is itself a critique of architectural design methodologies that emphasize form and object-making. muf's working method highlights the importance of exchange across art and architecture, the participation of users in the design process and the importance of collaborating with other producers. For muf, the architectural design process is not an activity that leads to the making of a product, but is rather the site of the work itself. As one architect member of muf comments in reference to an artist colleague, 'There is a sharp contrast with what Katherine [Clarke] has taught me – that the conclusion is unknown – and the deceptive reassurances of architects who begin by describing a conclusion.'[15]

In *This is what we do: a muf manual*, architectural writer Kath Schonfield, who collaborated with muf on many occasions, describes muf's working

49
muf architecture/art,
'The Pleasure Garden of the Utilities' (1998)
Stoke-on-Trent (casting the bench in the Armitage Shanks Factory).
Photograph: Cathy Hawley (1998).

50
muf architecture/art,
'The Pleasure Garden of the Utilities' (1998)
Stoke-on-Trent (in situ after completion).
Photograph: Cathy Hawley (1998).

process as a movement from micro to macro and back again, focusing on details at the outset, then addressing the urban scale, before returning again to the detail. This is an unusual way to work in architecture, where the starting point is usually strategic, starting with the big picture and working down to smaller scale.

In Hanley, muf won an open competition set up by Stoke City Council with the Public Art Commissioning Agency (1998). muf's brief was to make a lifting barrier to prevent illegal traffic entering Hanley town centre as part of a larger urban regeneration project. In dialogue with the council planner at an initial stage of the project, the brief was opened out to reveal how 'art can contribute to a safer, more social environment'.[16] The proposal was to make, in close collaboration with Armitage Shanks, two ceramic benches from a design generated by muf. The Stoke area has a strong tradition of ceramic production, today branching out into sanitary ware. The benches were patterned with oversized fragments of a dinner plate design particular to the area and positioned among newly planted white birches and roses (figs. 49 and 50). For the first month of the installation a video was projected in the site consisting of portraits of the people with whom muf had worked on the project, including those at the factory. The documentation of the design process through the video piece, in close physical proximity to the benches, underlines the benches' role in tracing the relationships between the various people who produced the work, as well as their position as prompts for future conversations between those who live and work in the area about the site and its culture of ceramic production: 'We wanted to reveal this as the place where the hands of the person you sit next to on a bus or pass in the street are the hands of the person who shaped the plate from which you eat your dinner.'[17]

For 'Wide', a project funded by the London Arts Board and the London Borough of Hackney, muf's role was 'to research a public art strategy integrated with the council's cultural quarters regeneration policy for South Shoreditch'.[18] The strategy that emerged paired a number of artists with council officers from outside the council arts and leisure department. The project questioned how valuable art could be in an 'under-funded and contested public environment'. The neighbourhood contained a mixture of council housing and recently gentrified light industrial buildings. Research revealed the 'invisible infrastructure of memories and personal history' and six artists were commissioned to 'research the hinterland of personal memory'. Katherine Clarke's 'Urban Grazing' asked residents of a tenement block near Pitfield Street where in the world they would most like to live. The answers generated a video. An empty grassy space outside the tenement was 'transformed into a bucolic idyll' with a number of sheep and a series of images glittering in the grass, which on closer inspection

revealed themselves to be video monitors showing, for example, goldfish swimming in blue water in sunny settings. The work functioned as a provocation: it got people out of their homes on a cold Saturday morning to discuss what the sheep were doing on a piece of ground previously unclaimed but which in response to the intervention had become 'their patch'. Later, in the pub on the corner, the views of those who had got involved were recorded and sent to the local council.[19] The project taps into people's cynicism with the claims of public art to date – that it can and will somehow make things better. This work made no such grandiose claims; rather it used art as a 'trigger', a way to get conversations started, to intrigue people and engage them in the possibility of changing their own back gardens, but on their own terms.

More recently muf has been working in St Albans, UK, where its brief was to protect and enclose a Roman mosaic and hypocaust. It was muf's wish to juxtapose what was once the Roman city of Verulamium with the contemporary life of the park. The building is a simple structure with a few key elements: a roof whose underside is tilted upwards with a mirrored soffit reflecting the activities of the park, and that drains into an ancient Roman well filled with pieces of crockery rejected by the archaeological dig. A glazed strip allows the passers-by to see the mosaic but also layers their reflections onto the view of the mosaic within. For muf, the work asks: 'Is this a football game in a Roman city or a mosaic interrupting a football game? Is this building standing in for an attitude, a methodology?'[20]

In architecture, to position a building as a 'methodology' rather than as the end result of the method or process that makes the building is a radical proposition. For muf the methodology occurs through dialogue between artists, architects and various other material fabricators, between those who produce the work and those who use it. In conversations between these people, active listening plays a critical role, for it allows one set of processes to be informed, and in some cases transformed, by others. The provocation then is that architecture can 'stand in' for conversation and perhaps conversely that conversation can 'stand in' for architecture.

Chapter 2

Social Sculpture

This most modern art discipline – Social Sculpture/Social Architecture – will only reach fruition when every living person becomes a creator, sculptor, or architect of the social organism.[1]

As we saw in Section 1: Chapter 1, '7000 Oaks' Joseph Beuys's project for planting 7000 trees, each paired with a basalt column obtained from quarries outside Kassel – began at Documenta 7, Kassel, Germany, in 1982. On a local level the project was integrated with various urban renewal programmes and on a global level it was part of a mission to effect environmental and social change. The tree-planting in Kassel was intended to be the first stage in an ongoing scheme of tree-planting extended throughout the world. Although the concept for the project originates with Beuys, the final form of the work lies beyond his control. The artist set certain coordinates or parameters to determine the work, but the exact unfolding of the project was dependent on the actions of different participants. Who will choose to plant an oak and basalt marker and where will they choose to plant them?

'7000 Oaks' is perhaps the clearest indication of Beuys's concept of 'Social Sculpture' and his statement that 'everybody is an artist'. According to Beuys, '"Everybody is an artist" simply means to point out that the human being is a creative being, that he is a creator, and what's more, that he can be productive in a great many ways. To me, it's irrelevant whether a product comes from a painter, from a sculptor, or from a physicist.'[2]

51
Shelley Sacks,
'Exchange Values: Images of Invisible Lives' (1996–9)
(Exchange Values sheet of skin linked to grower Vitas Emanuelle).

Beuys was a key member of artists' group Fluxus in the 1960s, whose questioning of the traditional separations between art and life, artist and audience, influenced his thinking about art, politics and pedagogy. Deeply committed to education and activism, Beuys called for creative thinking to enter all areas of life, including law and science. He believed that an expanded concept of creativity would result in 'social sculpture': that by participating and becoming part of the creation of a social architecture, people could become artists. For Beuys, it is not so much that life is already art, but that there is something particular to the creative process valued by artists that can transform other areas of life.

Although the notion of social sculpture places emphasis on exchange through discussion, artist Shelley Sacks, herself a one-time pupil of Beuys, reminds us that he never argued for 'the complete abandonment of all object making'. A quote from Beuys emphasizes her point:[3]

It is often maintained that in my class everything is conceptual or political. But I put great value on something coming out of it that is sensuously accessible according to the broad principles of the theory of recognition. ... My main interest here is to begin with speech and to let the materialization follow as a composite of thought and action.[4]

Beuys's work involved making objects that embodied certain processes, psychic and social, in their material forms. He believed that by embodying a threshold between spirit and matter, human beings could develop a sense of self-awareness that would provide the basis for human freedom. Beuys had a great interest in the work of Rudolph Steiner, the Austrian scientist and philosopher who founded anthroposophy or spiritual science, and derived from this a whole educational system. Steiner proposed that through developing an 'enhanced consciousness independent of the senses – composed of intuition, imagination and inspiration – one could regain contact with the spiritual world'.[5] These influences, as well as events in his own history that have taken on an almost mythic value in art history, go some way to explaining why Beuys saw the chemical changes of the body and its secretions as a medium for creativity.[6]

In Sacks's work, matter becomes a vehicle for exchange and transformation. 'Exchange Values: Images of Invisible Lives' is composed of 20 sheets of dried blackened banana skins collected from 20 boxes of Windward Island bananas and sewn together (fig. 51). Fascinated by their colour, texture and smell, Sacks had collected banana skins for years. She used the grower identification number stamped on each box of bananas to trace the skins back to their growers. Once in the Windward Islands, Sacks had conversations with the farmers concerning global trade and

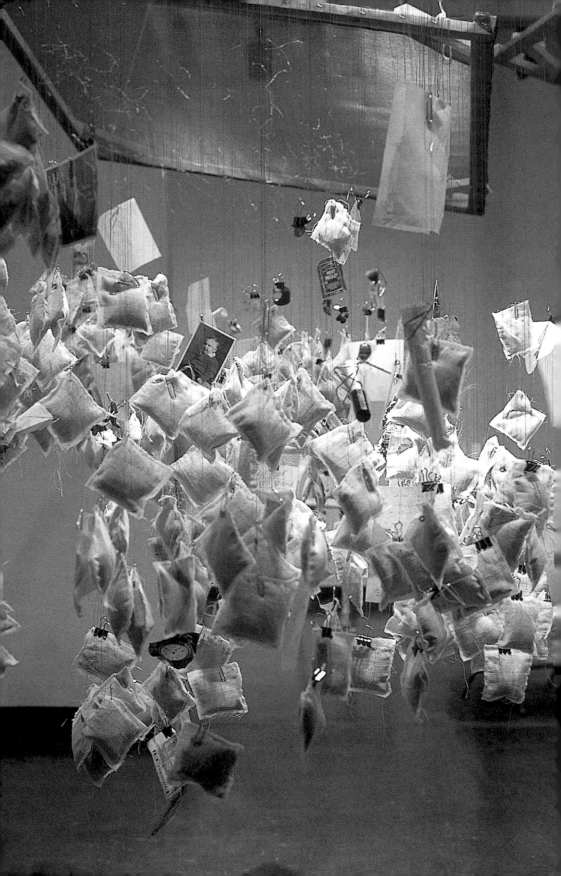

the control of markets by multinationals. The vocal exchanges between Sacks and the farmers were recorded and paired with a corresponding square of skins. In the gallery space, the pairs were ordered in such a way that each viewer or consumer could look at a black square of banana skins while also listening to the farmer or producer speak about the conditions in which the particular bananas under view were grown (fig. 51).[7]

The work succeeds in transforming such an inanimate object as a banana, described paradoxically as 'an easy thing', into one resonant with the injustices of consumer capitalism. To hear the voice of the man who grew this very banana, while enveloped in its sensual and material presence – its colour, texture and smell – provokes the consumer to make a connection, one that is usually and purposefully denied, with another subject, the person who is the producer. But what does the producer get in return?

In Pamela Wells's 'Tea for 2000', a simple act of interaction – an object from a pocket exchanged for a tea bag for a cup of tea – encouraged people to engage with one another to produce a space of conversation. The artist made a decision to initiate a certain kind of exchange, the offering of an item that suggests a particular social use in return for another, and to control her initial inclusion of only one kind of object, the tea bag, but to leave the choice of the other objects open so that the final spatial and material arrangement of the work remained up to the audience (fig. 52: opposite page).

> *sewn tea bags—light muslin stuffed with raspberry leaf and mint.*
> *hung from ceiling panels with golden thread.*
> *scent is overwhelming, fading slowly.*
> *an invitation to take one, putting something else in its place.*
> *(a banana peel, a train-ticket, a photo of her grandson).*
> *hot water, hand-made tea bowls, tables and chairs.*
> *an invitation to share a cup of tea.[8]*

As the artist and I have elaborated elsewhere, these physical things – the tea bags, the train-ticket, the photo of her grandson – like prepositions in language, allow connections to be made between people – I offer tea 'to' you, in return, you offer me something from your pocket. As vehicles for interpersonal exchange, prepositions, in this case the tea bags, provide the potential for transformation; through a simple conversation, by listening to another, there is always the possibility we might change and rethink the position we occupy in the world.[9]

In artist Mierle Laderman Ukeles's now seminal work, 'Manifesto for Maintenance Art' (1969), the role of a physical object as a device for

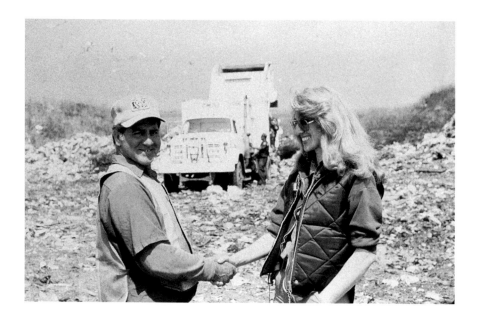

53
Mierle Laderman Ukeles,
'Handshake Ritual' (1978–9)
New York City.
Photograph: Courtesy Ronald Feldman Fine Arts, New York City.

54
Suzanne Lacy and Leslie Labowitz, with Bia Lowe and women from the
Los Angeles Woman's Building,
'In Mourning and in Rage' (1977)
Los Angeles.
Photograph: Maria Karras.

connecting people is absent; here the art exists in making relationships between people through the repetition of an action – a repeated handshake. As an unsalaried artist in residence for the New York City Department of Sanitation from 1976, Ukeles worked with thousands of different employees or 'sanmen' to produce three major projects. 'Touch Sanitation' (1978–84) involved a number of projects including 'Handshake Ritual' (1978–9) where she shook hands with 8500 sanmen in recognition of the importance of their usually overlooked labour (fig. 53).[10] Art critic Patricia C. Phillips has argued of Ukeles's work that 'while the artist serves as an agent, the potential for activism is realized and resides most conclusively in the work's subjects and participants'.[11]

Another artist who is well known for placing importance on the role of relationships in her work is Suzanne Lacy. Rather than understand the artist as a choreographer, someone who controls the actions of participants, or who requires a witness to participate in the work in order to make it art, Jeff Kelley has argued that Lacy uses notions of empathy to connect with others. As Kelley sees it, although the participants involved in Lacy's work 'perform' certain actions, they are not acting roles, but performing these actions as themselves. The connections made between the artist and the participants that constitute the 'public' domain of Lacy's work do not involve the appropriation of another's experience, but in Kelley's view constitute an exploration of identity as the interplay of internal and external perspectives.[12]

On the morning of 13 December 1977, for 'In Mourning and in Rage' (1977), an event staged specifically for the press, a funeral procession of 22 cars filled with women followed a hearse from the Woman's Building to City Hall, Los Angeles, where nine women, seven feet tall with veils angled in the shape of coffins, got out and stood on the steps facing the street. Other women stood behind them holding banners: 'In memory of our Sisters. Women Fight Back.' The first mourner walked to the microphone and said in front of the assembled local press: 'I am here for the ten women who have been raped and strangled between October 18 and November 29.' A chorus spoke the words on the banner. Each one of the nine women then made statements that connected the specific events of the 'Hillside Strangler' murders to the larger issues pertaining to social violence against women. After each individual voice, a chorus came in (fig. 54).

If, in art, exchange – including actions that involve objects – can provide a place between one and another where new relationships between people are constructed, how do such places get configured in architecture? From the 1960s onwards the radical work of socially engaged architects like Ralph Erskine and Lucien Kroll sought in different ways to minimize the role of the architect and to integrate the involvement of the user in

the design process itself. For Erskine, it was by maintaining the role of organizer and manager that the architect was best positioned to offer future occupants a series of different options from which to choose what would then be synthesized into a final design.[13] Kroll was interested in how users might transform the building after completion though occupation, and he attempted to build this potential into the design process.[14]

In recent years, Japanese architect Shigeru Ban has become known for his use of paper tube structures in a number of architectural projects. Ban's explorations in paper stem not simply from a technological interest, but from a desire to provide architectural solutions to certain kinds of social problem, for example the provision of shelters for people made homeless after natural disasters. In 1995, the earthquake that struck Kobe, Japan's main port, left 5471 people dead and thousands injured and homeless. In the two weeks immediately after the earthquake, at the peak of their occupancy, around 250,000 people were housed in approximately 600 evacuation shelters.[15] Rather than focus on building community spaces, as he had originally agreed, Ban designed a paper log house that could be built by anyone, not only those skilled in the design and production of architecture. The foundation was made of sand-filled beer cases, which could be rented from the manufacturers, and walls were constructed of paper tubes 108 millimetres in diameter and four millimetres thick. The tubes could be made on site, easily moved, stored and recycled, and waterproofed by applying self-adhesive waterproof tape to both sides of the space between the tubes. The roof and ceiling were made of tent material, kept open in summer to allow air to circulate and closed in the winter to retain warm air (fig. 55).[16] In this example, the architect's creativity is located in the invention of building materials and design of new systems of production – those that can be cheaply obtained and easily assembled and that will allow the future occupants to take control over the making of their own spaces.

It seems that in places where natural disaster, war or other acts of destruction have occurred, where an immediate lack of shelter, shortage of materials for building and often also a breakdown, temporary or permanent, of the existing social order has been produced, conditions, often forced, are generated where people become 'architects' and invent their own spaces in which to live with whatever they can find around them. So too in locations where industrial capitalism is less developed, users are more likely to be involved in making their own buildings and develop skills of architectural production, whereas in countries and cities where capitalism is highly advanced, building activities tend to be carried out only by specialists whose 'trades' and professional skills are usually protected through legislation. In this latter situation, one is most likely to

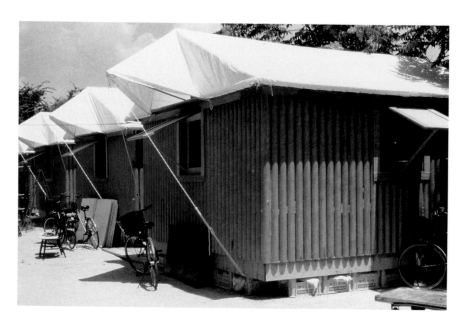

55
Shigeru Ban,
'Paper Log House' (1994)
Kobe.
Photograph: Takanobu Sakuma (1994).

find examples of architecture as social sculpture through the occupiers' alterations, through DIY (do-it-yourself), to an architectural environment that has already been built for them. However, despite users being involved in the production of their own spaces, becoming 'architects', such projects are neither necessarily, and indeed not normally, critiques of the social relations of architectural production, nor do they aspire to create communities that provide alternative scenarios to those operating under globalized capitalism. One would therefore need to be wary of calling them social sculptures in a Beuysian sense. To find examples of social sculpture that operate in this way, we would need to look at sites where users appropriate existing spaces for new and socially radical uses, ones that may work against the intention of the designer.[17]

However, it is worth thinking a little bit more about what is meant by Beuys's definition of social sculpture in which 'every living person becomes a creator, sculptor, or architect of the social organism'. Some might argue that the relationships between architect, builder and user constitute a social organism, others that the social organism cannot be confined to architectural production and that for people to become 'architects' as Beuys intended they would be required to participate in political action. It would seem therefore that the most productive site for social sculpture would be a place or time where architectural and social structures overlap. In most design processes, by the time builders and later users get involved in handling the materials that constitute the architecture, contracts and codes governing and limiting their actions have already been laid down. Rather, it is prior to the start of work on site, or to the physical construction of architecture in the initial consultation period between architect and developer, client and user, in the early stages of writing the brief, that the potential for social sculpture occurs. Certainly, architectural practices that have a social and political commitment to local community participation and are interested in user involvement in architectural design have needed to focus their operations in these early stages of design consultation.[18]

In these works described above, material objects are both the stimulant for social interactions and the trace of exchanges between people. Similar to the potential of the 'to' in Luce Irigaray's 'I love to you', where the 'to' suggests a new order of relations between the sexes, here the 'to' indicates a role for objects in negotiating new terms of engagement between artists and audiences in artworks and architecture. For artists, where the role of objects as facilitators of exchange is of key importance, the aesthetic dimension of the work can be located in the conceptualization of the construction of social exchanges, manifest less in the material qualities of the individual objects and more in the patterns produced through their

distribution and the kinds of relationships they allow people to make with one another.

It is possible to recognize in the works described above the construction of relationships that, though inspired by a desire to operate through what Kaja Silverman calls 'heteropathic identification' – where the subject, in this case the artist or architect, goes outside him or herself to identify with the other – seem to demonstrate characteristics of Silverman's 'cannibalistic identification' where one assimilates the other. How, against all the best intentions, can we prevent the artist's and architect's other, his or her collaborator, whether tree planter, banana grower, tea drinker, sanman or home builder, from being assimilated, from becoming invisible? I argue that it is such a concern that drives the final project to be discussed in this chapter, which starts to rethink such a question, suggesting that it is not only that the role of the other, as viewer, user or collaborator, requires articulation in the process of defining the artist's intentions or the architect's brief for a work, but also that the later descriptions of the work, 'after the event', by the artist and architect can reveal or conceal the role of collaborators in the work, leaving the critic with the task of locating the position of the other in the work.

For their residency at the Serpentine Gallery, London, public works – comprising artist Katrin Böhm and architect Andreas Lang – engaged closely in 'Park Products' (2004) with a number of different individuals who used Kensington Gardens, the royal park in which the gallery is located.[19] Such engagements developed understandings of the park that went beyond its physical characteristics to consider the cultural activities and social occupations that produce it as a space. 'Park Products' took the spatial practices already at large in the place of the park, such as grass-planting, compost-making, dog-walking and litter-collecting, as the starting point for initiating and inventing new relationships between the different park users. Through sustained conversations and shared design processes, the expressions of need or desire that operate through these existing practices were transformed into the functions of a new collection of products. In turn, these products acted as props or prompts, for new acts of exchange determined by their makers, creating an alternative economy of places and encounters.

Central to the 'Park Products' and an ongoing trend in Böhm's work (see Section 1: Chapter 2) is an interest in the responsibility to satisfy users' needs and functional requirements that designers take very seriously. However, many of the products invent actions, and even when they do respond to existing needs it is often in ways that parody the need itself. 'The Man with the Compost Arm', for example, responds to a perceived

need but, by exaggerating the purpose of the product, the relationship between form and function is pushed to a bizarre extreme. In many of the products, what appears to be a minimalist or at least modernist approach to the 'solving of problems' turns out to be far more baroque and excessive. Perhaps the architects' term programme discussed previously (see Section 2: Chapter 1) is more appropriate here than function, for it suggests a less deterministic view of use, one where imaginative narratives and differing experiences allow for a more diverse and contested understanding of what an object or space can allow a user 'to do'.

On display for exchange in the roving 'stall' they designed, the products play a proactive role in encouraging people to engage with one another by negotiating specific forms of object exchange. Although public works made certain decisions governing these exchanges, such as the prohibition of the use of money, the time-frame and the design of the stall, the exact terms of engagement were left up the designers and users of the products; for example, lawn seed can be obtained for tree-stroking and a certain amount of time spent weeding gets you a fence tool (figs. 56–8).

The products suggest new economies, ones whose exchange rates do not rely on the common currency of money. The value of one product can only be decided in specific relation to another. Although barter might not quite hold the utopian appeal of the gift economy as a critique of commodity capitalism – the promise of giving something for nothing – the potential of gift giving can be held back by the expectation of return, something that is often not fully acknowledged. In 'Park Products' the proposition of mutual consent as the principle governing the exchange of objects is a refreshingly radical one, especially given contemporary deceptions around consumer choice.

If the raw materials of the park are transformed into products through new kinds of interaction between artist, architect and other park users, where is the aesthetic value of the work to be located? In the products themselves or in the emotional, intellectual and social relations established by those people involved? And if we were not involved directly either in making or exchanging the products, are we to connect with these relationships through the traces they have left in the objects themselves?

The products are residues of the processes that produced them but they also point to the future. Their material forms suggest activities and influence the kinds of exchanges people choose to make with one another, and in this way they 'trigger' the final form of the project; for example, the final manifestation of 'Park Products' is not predictable in advance and depends entirely on the actions of the users of the park. If we consider the aesthetic qualities of the work through the practices of production and consumption initiated by the various users, as makers and exchangers,

56–7
public works,
'Park Products' (2004)
The Serpentine Gallery, London.
Photographs: public works (2004).

58
public works,
'Park Products' (2004)
The Serpentine Gallery, London.
Photograph: David Bebber (2004).

how important then are artists' and architects' conceptualizations of these relationships?

I asked public works if they had choreographed 'Park Products' – preselected the user groups and instigated certain rules of conduct – or had they let things emerge more organically? Both Böhm and Lang were emphatic: it was the latter. This made me reconsider my own position. Rather than press forward to try to uncover the processes I felt sure had been used conceptually to structure the project, it seemed to me that this situation asked for a different approach. To choose to relinquish control over the final work and hand the decision-making process over to others marks the surfacing of a different creative consciousness, which in turn asks for a new form of critical engagement: not a holding down, but a letting go.[20]

Chapter 3

Walking

The nomad is my own figuration of a situated, postmodern, culturally differentiated understanding of the subject in general and of the feminist subject in particular. ... The nomadic subject is a myth, that is to say political fiction, that allows me to think through and move across established categories and levels of experience: blurring boundaries without burning bridges.[1]

Walking, along with discussion, performance and publication, forms the core of the work of PLATFORM, an interdisciplinary group of environmental and politically engaged artists for whom practice and research are intrinsically connected.[2] Over several years PLATFORM has been researching the Fleet and refining this knowledge by walking the course of this river through London, from its springing-point in Hampstead, down through Camden, King's Cross and St Pancras, on then to Clerkenwell and along the Farringdon Road to the point where the tributary enters the Thames near Blackfriar's Bridge. The odd thing is that the walk does not follow a silver line of water cutting through the urban terrain, but instead traverses the tarmac and concrete of north London. The walk, which I joined in May 2001, is a meditation upon the course of this buried river.

It is spring in London. Across the tender green of Hampstead Heath I see a cluster of people; a wedding is taking place outdoors (fig. 59: opposite page). But I am being asked to look down, at the earth; beneath my feet

new life is emerging. The river Thames is oozing through the soil, in the form of the Fleet, one of its many tributaries.

Before we leave Hampstead, we pause for reflection in the ponds at the Vale of Health. We learn that they are possibly artificial and consider the distinction between what is natural and what is man-made. PLATFORM comments on the trees and plants around us; some are indigenous, others are, or at one point were, strange to this land. At what point does a newcomer become an old friend?

After Hampstead, the Fleet runs underground. When a river is buried, canalized, contained and arched over, what does it become – a flood drain, a sewer? Is it still a river? We note remnants of the impact the river once had when it cut channels through the surface of the city. Road names recall watercress beds; there are laundries and swimming pools, pubs that grew up around springs. In Camden, we stop a while to watch the reeds in the slow-moving canal – a complex microbiology that cleans up the water. We hear how the babbling brook and the dialogue of the reeds in the wind taught humans to speak.

An interesting conversation starts up in St Pancras churchyard about the poet Aidan Andrew Dunn whose recent epic, *Vale Royal,* recalls the history of the Fleet in this part of London, in a manner not dissimilar to a twentieth-century Blake.[3] The churchyard has some strange memorials – Sir John Soane's mausoleum designed by his wife, Thomas Hardy's grave – as well as some fascinating stories about the dust heap that used to shadow this site. Like the river, this portion of London was a dumping-ground for all kinds of waste: rubble from the brick-making industries, blood and entrails from the tanneries, as well as human effluent. As far back as the thirteenth century, the foul-smelling Fleet was a source of complaint. At one point it was described as a 'cocktail of effluent', and Ben Jonson claimed that it outdid the four rivers of Hades in its vile stench. Anxieties about the river's filthy condition and fears of flood damage were among the reasons given for its burial. The bottom reaches were covered over in the seventeenth century and the upper reaches later, at the end of the nineteenth century. Today the Fleet is a sewer.

What does it mean to bury a river? At the outset of the walk, this did not seem to me such a big deal. But during the day, as I walked the Fleet, my views shifted. PLATFORM told us about a school group they had been working with as part of their campaign to uncover the buried rivers of London. When the children were told that a river lay beneath them underground, they were bewildered. How? How, they had asked, do you bury a river? And, technicalities aside, why? Why would anyone do such a thing? Why indeed would anyone want to bury a river?

Nearby, also underground, apparently under platform nine at King's Cross station, is the body of Boudicca, defeated and buried after Battlebridge. This part of north London remains still the site of conflict, though today it is over the regeneration of King's Cross. Are there any links to be made between the buried body of this ancient British queen and the burying of the river Fleet? Our present culture is one that attempts to deny the natural in so many ways; medical knowledge and technological expertise seek control of wayward human flesh as we turn a blind eye to the terrifying indications of global warming and environmental disaster around us.

As evening falls we reach the lower stretch of the Farringdon Road; with the Thames now in sight we come to a grim halt by some bolted iron doors under Blackfriar's Bridge. This is where the Fleet ends its journey into the city, behind this set of metal grilles. They pass around a postcard of an oil painting made by Samuel Scott in the seventeenth century – 'Mouth of the River Fleet'. It shows a grand scene, London as Venice, in the style of Canaletto, with a turquoise Fleet glorious, proudly joining the Thames.

It is hard to reconcile this magnificent image with the rather bleak view before me. All along the river, ancient tributaries are falling apart, removing a special way of experiencing London. I learn so much that day, not just facts about the Thames, but a new way of relating to this city. Walking to the Thames along the Fleet offers a particular sense of 'being in the world', an ecological view that connects me to an environment that is both natural and cultural. Unlike reading a book or watching television, I walk the river as I find out about it. Ley lines, song lines, story lines, some lines only speak as you walk them. The stories I was told that day are intimately connected with the places in which I first heard them.

PLATFORM ask us to imagine what London would be like with majestic rivers flowing down its valleys into the Thames. 'Imagination is the root of all change,' they say.[4]

PLATFORM's walk reminds me of another artist's walk I participated in a year or so earlier. In 1999, in autumn this time, I followed Marysia Lewandowska's 'Detour' through the Paddington basin in west London. The project, funded by the Public Arts Development Trust, took the form of a route through the city, but this artist chose to adopt an anonymous role. Following months spent researching the area, Lewandowska devised several walks. The knowledge she gained was imparted to a number of professional tour guides who, along with workers and residents of the area, took us on 'Detour'.

We went to some strange places – 'strange', that is, for a conventional 'tour'. We spent a good hour in a storage warehouse for a major Oxford

Street retailer hearing the site manager give a full and detailed account of his day's activities, the organization, moving and storage of various-sized cardboard boxes. We visited the place where penicillin was invented (quite by accident), rummaged through an antiques market and squashed into a tiny council flat to hear the inhabitant talk about life on the estate (figs. 60–1).

Lewandowska's research into the history of this part of London focused on aspects of exchange – production, consumption and waste. As in many of her projects, most of them conducted with Neil Cummings, Lewandowska's passion for investigations of material culture and aspects of the 'everyday' is a driving force.[5] Via tour guides, she brought to our attention neither historical facts and dates nor famous monuments or sites of architectural interest in the area, but rather the sort of stuff that is all around us but so ordinary that it remains ignored and invisible. I was left pondering on the huge number of objects we acquire, only to get rid of them again.

Tim Brennan is another artist who has reworked the guided tour as an art form but, unlike Lewandowska, he prefers to remain physically present, positioning his work across visual and performing arts. In 1999 Brennan produced 'Mole Gap Trail', a three- to four-hour walk in the Surrey Hills linking Leatherhead, Boxhill and Dorking railway stations through the historic landscape of Norbury Park.[6] Brennan has also produced a series of walks and written texts in east London, 'A Rising', 'A Cut' and 'A Weave' (1999).[7] Informed by his background in public history, Brennan intersperses periods of private archive research with public input gathered on journeys and guided tours. Brennan's walks operate as forms of 'discursive performance' that aim to construct performing and reading subjects.[8]

But perhaps the most influential artist's walk in recent years has been Janet Cardiff's 'The Missing Voice (Case Study B)' (1999), a work commissioned by Artangel in Whitechapel, London, in which the artist took on the role of story-teller. Cardiff created a soundtrack layered with historical narratives about Jack the Ripper's activities in the area in the late nineteenth century, fictional detective stories and more recent descriptions of this part of London made by the artist. A CD-ROM obtained from Whitechapel's public lending library led the listener, wearing headphones, on a choreographed route through the city. On the walk your emotional state shifts between empowerment and fear; at one moment you are encouraged to take the role of a detective following clues, the next you are a victim being followed. Sometimes the voice you hear describes what you see; at other times the two do not coincide.[9] Cardiff articulates aspects of site, which exist as much in our imagination as in material form, highlighting our existence in a world that is simultaneously internal and external.

It is not the first time artists have been interested in walking; one only has to look back at the work of Hamish Fulton or Richard Long in the 1960s and 1970s, or further back to the history of pilgrimages and trade routes.[10] Today there certainly seems to be a fascination with walking among artists, as a way perhaps of engaging with concepts and experiences of place, space and site. By relating one location to another in a particular sequence, walking provides a way of practising space through time and time through space. As a critical spatial practice, walking operates in a similar mode to much of the work discussed in Section 1 – rethinking place as unfixed and site as performed. Importantly, as an activity, walking temporarily positions the subject in motion between a series of scenes that at times might resemble dialectical images; depending on the histories of a precise combination of objects at a particular location, these scenes might be constellations where the thinking stops, allegorical compositions or montage constructions.

This interest in walking explored through theory and current art practice can open new possibilities for architecture. The design of buildings based on predetermined routes has a strong precedent in architecture, from the axial route through Egyptian burial complexes to the carefully sequenced promenades through picturesque parklands and baroque opera houses. Recent designs, arguably led by the early work of Rem Koolhaas and OMA, merge plan and section by creating a ground plane that winds its way up through the building. UN-Studio takes things one stage further in its concrete and glass 'Möbius House'.[11] The Möbius strip is a twisted figure of eight where one side becomes the other. It is a diagrammatic form or a topological model derived from Jacques Lacan's psychoanalytic theory that allows us to describe the interrelation of inner and outer spaces.[12] According to the architects, 'The Möbius strip model has the advantage of showing that there can be a relation between two "things" – mind and body – which presumes neither their identity nor their radical disjunction, a model which shows that while there are disparate "things" being related, they have the capacity to twist one into the other.'[13]

The commission for the 'Möbius House', located in the Netherlands, came from a couple who both worked from home during the day and wanted a house where they could have 'complete individual privacy, but also the possibility of instantaneous connection to one another'.[14] The Möbius strip provided a spatial diagram of how connection and separation could be achieved at the same time. The house is designed around a flexible programme, where activities of sleeping, eating and working can take place at any point on either of the two routes. Gentle ramps or 'stramps' and sliding screens are employed as connecting and separating elements (figs. 62 and 3).

60–1
Marysia Lewandowska,
'Detour' (1999)
London.
Photographs: Jane Rendell (1999).

Walking provides a way of understanding sites in flux in a manner that questions the logic of measuring, surveying and drawing a location from a series of fixed and static viewpoints. When we walk we encounter sites in motion and in relationship to one another, suggesting that things seem different depending on whether we are 'coming to' or 'going from'. Rather than proceed from the observational, to the analytic, to the propositional, by intervening and moving though a site, walking proposes a design method that enables one to imagine beyond the present condition without freezing possibility into form.

The group of Roman architects called Stalker (Laboratory for Urban Interventions) – their name was inspired by Tarkovsky's film *Stalker* (1979) – reclaim land by moving through it and take this occupation as a starting point for architectural design. Stalker use walking as a way of getting to know the city: not only their hometown Rome, but also Naples, Turin, Paris and Berlin. For Stalker, walking allows one to link up neglected parts of the city, locations that may be physically proximate but have been separated by walls and fences to make way for roads or other urban redevelopments. Stalker are particularly interested in parts of the city that have become what they call *terrains vagues* – areas that have been abandoned or are undergoing slow transformations. Stalker's project is to transgress, to go where they should not, to cut through barriers, to climb up and over obstacles in unusual ways. Such actions heighten awareness by rendering familiar places 'strange'.[15]

Stalker call their mode of operation architectural practice, precisely the kind of practice that extends and critiques definitions of what architecture might be. Stalker's methodology consists of a three-part process accompanying their walks. First, 'preparation of the terrain', the collection of historical surveys and maps of the area to be walked; second, 'spot visit', a visit to the site to prepare the itinerary, to select a track for making a walk, often following abandoned rights of way and other infrastructural lines; and third, the production of an exhibition following the walk, including documentation of the walk in photographs, video and writing, as well as suggestions on how the city might reuse abandoned areas.

There is a kind of thinking that corresponds to walking, one that follows an itinerary, keeps up a certain pace and remains in constant motion, moving from one thing to another, engaging only in passing; the external world operates as a series of prompts for more philosophical musings. The spatial story acts as a theoretical device that allows us to understand the urban fabric in terms of narrative relationships between spaces, times and subjects. The notion of 'spatial stories' can be connected to surrealist wanderings, to the situationist dérive as well as to more recent theoretical ideas about nomadology. Feminist philosopher Rosi Braidotti's

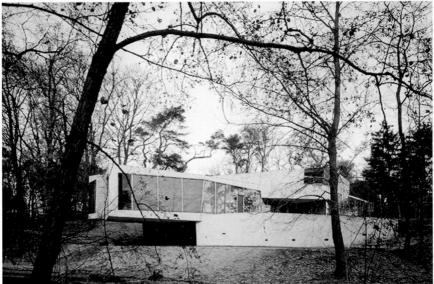

62-3
UN-Studio (Ben van Berkel with Aad Krom, Jen Alkema, Matthias Blass, Remco
Bruggink, Marc Dijkman, Casper le Fevre, Rob Hootsmans, Tycho Soffree,
Giovanni Tedesco, Harm Wassink), 'Möbius House' (1993–98) 't Gooi, The
Netherlands, UN Studio ©.
Photographs: Christian Richters (1998).

interest in nomadism does not so much describe the nomadic subject as the person who moves from place to place; rather, she is inspired by nomadism as a way of knowing that refuses to be pinned down by existing conditions. For those concerned with issues of identity and the oppression of minorities, the kind of thinking engendered through walking is important for emancipatory politics since it provides a way of imagining a beyond, an 'as if'.[16] As Braidotti states:

> *Political fictions may be more effective, here and now, than theoretical systems. The choice of an iconoclastic, mythic figure such as the nomadic subject is consequently a move against the settled and conventional nature of theoretical and especially philosophical thinking. ... It is the subversion of set conventions that defines the nomadic state, not the literal act of traveling.[17]*

Through the act of walking new connections are made and remade, physically and conceptually, over time and through space. Public concerns and private fantasies, past events and future imaginings, are brought into the here and now, into a relationship that is both sequential and simultaneous. Walking is a way of at once discovering and transforming the city; it is an activity that takes place through the heart and mind as much as through the feet.

Conclusion

Criticism as
Critical Spatial Practice

The architect's only option is to find a course for revolutionary praxis outside the traditional boundaries of his field.[1]

If architectural theorist Joan Ockman is correct in her assertion, quoted above, then it is exactly this 'course' that I have explored throughout *Art and Architecture*, suggesting that to develop as a critical practice architecture must look to art, and move outside the traditional boundaries of its field and into a place between disciplines. As a mode of cultural production that enjoys a greater degree of separation from economic and social concerns, art can offer architecture a chance for critical reflection and action. There is much gallery-based art that provides cultural and political critique, but once outside the gallery, as 'public art', art is better positioned to initiate critical spatial practices that can inform the activity of architectural design and the occupation of buildings.

For example, in Section 1: 'Between Here and There' debates about site-specificity in current art practice allowed discussions in architecture on context to be rethought in terms of processes that locate a building in relation to its sites of production and dissemination and the various practices that take place in them. In Section 2: 'Between Now and Then' explorations of the time of viewing produced through various critical interventions into public places showed how in architecture the intentionality of the

so-called function of a work can be understood differently in terms of the more experiential 'programme' or event produced. The concept of social sculpture in fine art practice, examined in Section 3: 'Between One and Another', shifted the emphasis in architecture from product – defined as object, form or representation – to the aesthetic qualities of the social relationships through which architecture is produced, encountered and engaged with in day-to-day life.

In the 'Introduction' I suggested that understandings of the interactions of two disciplinary modes of practice required certain kinds of critical spatial theory. I explained how, for me, theoretical concepts provided the impetus to think of practice in this way, and produced the 'starting points for considering the relationship between art and architecture'. Throughout *Art and Architecture* I have discussed how the potential of specific concepts elaborated through critical spatial theory makes it possible to discuss particular projects as critical spatial practices.

I have also argued that understandings, informed by critical spatial theory, of the place between art and architecture in terms of the spatial, the temporal and the social, allow terms like site, insertion and relationships to be reconfigured at the intersection between disciplines. For example, in Section 1: 'Between Here and There' it is the ongoing redefinitions of space and place in cultural geography that open up discussions of the differences between such terms as site and context in art and architecture. Explorations of the distinctions between past and present through allegorical, montage and dialectical techniques in the work of Benjamin suggest in Section 2: 'Between Now and Then' the importance of the temporal experience of viewers and users of new insertions in existing locations. And in Section 3: 'Between One and Another', theories of relationships between subjects, objects and spaces emphasise the importance of interaction between people, things and locations in the production and use of art and architecture.

In 1999, in their introduction to *Rewriting Conceptual Art*, Michael Newman and Jon Bird stated: 'An essential part of the project of Conceptual art was to demolish the distinctions between art practice, theory and criticism.'[2] If their assertion is correct, and we agree that the projects of conceptual art was to 'demolish' the boundaries between art practice, theory and criticism, has this project succeeded and, if so, are these three terms distinguishable today? I would argue that it depends on where you look. While certain kinds of art practice informed by conceptualism have taken on the role of theorizing and criticizing, the influence of this work in theory and criticism has been slower to take effect. Although increasingly theorists discuss their work as a form of practice, the tendency has been less marked in criticism. Is it because there is more at stake in the distinction

between art practice as criticism and criticism as art practice than between art practice as theory and theory as art practice?

In my previous work in architectural history, I turned to feminist critical theory to elucidate and inform my practice as an architectural historian – my choice of 'object of study' and interpretative stance.[3] And again, in this book, theoretical concepts have informed my choice of artworks and architectural projects to study as well as offered ways of understanding the relationship between certain kinds of practice, both inside and across disciplinary constraints. I have drawn on theoretical models to inform how I practice criticism, in other words, how I write about practice – art and architecture. So, for me, the distinctions have not been demolished, at least not yet. In *Art and Architecture*, theory, criticism and practice all continue to play different roles. However, even if the lasting legacy of conceptual art has not been to completely demolish disciplinary boundaries, the emphasis conceptualism has placed on the need for practice to be self-aware and to critique its own terms of engagement has been highly influential. To 'practice' after conceptualism is to think more carefully about procedures – about what we are doing and how we are doing it – and the questions this attention to methodology raises.

It is certainly possible to think of criticism in terms of a situated practice and indeed I have begun to do so.[4] In moving between art, architecture and theory, I occupy particular and changing positions in relation to the texts, objects and situations I discuss. Perhaps it is my background in architectural design that has had this spatial effect on how I think and write about art and architecture, but I consider criticism to be a spatial investigation and production of the various intersections between theory and practice, art and architecture. I wish to conclude *Art and Architecture* by arguing just this: that criticism can itself be considered a mode of critical spatial practice. This is not to say that criticism as a written text takes the place of an artistic or architectural form of critical spatial practice or that writing communicates theoretical concepts and imaginative ideas in the same way as art or architecture; rather, I suggest that it is through writing as a critical spatial practice that I, as a critic, understand and produce particular 'places between' theory and practice, art and architecture. I write spatially; many architects do. My subject matter is spatial and so too are my processes. When I write I work between a number of points, laying theoretical ideas alongside artworks and architectural projects, creating constellations and correspondences, connections and separations between them. For me, this writing process has constructed as well as traced 'a place between.'

Endnotes

Introduction: A Place Between

[1] Edward Soja, *Thirdspace: Expanding the Geographical Imagination* (Oxford: Blackwell, 1996); and Edward Soja, *Postmodern Geographies: The Reassertion of Space in Social Theory* (London: Verso, 1989).

[2] I borrow and develop the term 'expanded' from Rosalind Krauss, 'Sculpture in the expanded field', in Hal Foster (ed.) *Postmodern Culture* (London: Pluto Press, 1985) pp. 31–42. This essay was originally published in *October* 8 (Spring 1979).

[3] For a discussion that parallels this opinion, see Johanne Lamoureux, 'Architecture recharged by art', in Cynthia C. Davidson (ed.) *Anyplace* (Cambridge, MA: MIT Press, 1995) p. 130.

[4] Maya Lin, 'Round table discussion', in Richard Roth and Susan Roth King (eds) *Beauty is Nowhere: Ethical Issues in Art and Design* (Amsterdam: G+B Arts International, 1998) p. 67.

[5] Suzanne Lacy (ed.) *Mapping the Terrain: New Genre Public Art* (Seattle: Bay Press, 1995).

[6] Nina Felshin (ed.) *But is it Art? The Spirit of Art as Activism* (Seattle: Bay Press, 1995) and Tom Finkelpearl, *Dialogues in Public Art* (Cambridge, MA: MIT Press, 2000).

[7] David Harding (ed.) *Decadent: Public Art – Contentious Term and Contested Practice* (Glasgow: Glasgow School of Art, 1997).

[8] Malcolm Miles, *Art, Space and the City* (London: Routledge, 1997).

[9] Chris Burden, quoted in Suzi Gablik, *The Reenchantment of Art* (London: Thames and Hudson, 1991) pp. 79–80.

[10] Patricia C. Phillips argues that art should be designated as public not because of its accessibility but 'because of the kinds of questions it chooses to ask'. See Patricia C. Phillips, 'Temporality and public art', in Harriet F. Senie and Sally Webster (eds) *Critical Issues in Public Art, Content, Context and Controversy* (New York: Harper Collins, 1992), p. 298.

[11] Rosalyn Deutsche, *Evictions: Art and Spatial Politics* (Cambridge, MA: MIT Press, 1996) p. 269.

[12] See Chantal Mouffe, *The Return of the Political* (London: Verso, 1993). See also Ernesto Laclau and Chantal Mouffe *Hegemony and Socialist Strategy: Toward a Radical Democratic Politics*, translated by Winston Moore and Paul Cammack (London: Verso, 1985).

[13] Judith Squires, 'Private lives, secluded places: privacy as political possibility', *Environment and Planning D: Society and Space*, vol. 12 (1994) pp. 387–410.

[14] Jane Rendell, 'Public art: between public and private', in Sarah Bennett and John Butler (eds) *Locality, Regeneration and Diver(c)ities* (Bristol: Intellect Books, 2000), pp. 19–26; Jane Rendell, 'Foreword', in Judith Rugg and Dan Hincliffe (eds) *Recoveries and Reclamations* (Bristol: Intellect Books, 2002), pp. 7–9. See also Jane Rendell (ed.) 'A Place Between', Special Issue of *Public Art Journal*, October 1999.

[15] Victor Burgin, *The End of Art Theory: Criticism and Postmodernity* (Basingstoke: Macmillan, 1986) p. 204.

[16] Brian McHale, 'What ever happened to descriptive poetics?' in Mieke Bal and Inge E. Boer (eds) *The Point of Theory: Practices of Cultural Analysis* (New York: Continuum, 1994) pp. 57, 59.

[17] Kate Nesbitt (ed.) *Theorizing a New Agenda for Architecture: An Anthology of Architectural Theory 1965–1995* (New York: Princeton Architectural Press, 1996) p. 16.

[18] Michael K. Hays (ed.) *Architecture Theory since 1968* (Cambridge, MA: MIT Press, 2000) p. v.

[19] Neil Leach (ed.) *Rethinking Architecture* (London: Routledge, 1997); Iain Borden and Jane Rendell (eds) *InterSections: Architectural History and Critical Theory* (London: Routledge, 2000).

[20] Raymond Geuss, *The Idea of Critical Theory: Habermas and the Frankfurt School* (Cambridge: Cambridge University Press, 1981) p. 2.

[21] For a detailed discussion of the various possibilities opened up by critical theory for exploring the relationship between theory and practice, see Jane Rendell, 'Between two: theory and practice', in Jonathan Hill (ed.) 'Opposites Attract: Research by Design', Special Issue of *Journal of Architecture* vol. 8, no. 2 (Summer 2003) pp. 221–38.

[22] Theodor W. Adorno, *Critical Models: Interventions and Catchwords*, translated by Henry W. Pickford (New York: Routledge, 1998) p. 276 argues that the relationship between theory and practice is one of discontinuity.

[23] See, for example, Jacques Derrida, *Of Grammatology*, translated by Gayatri Chakravorty Spivak (Baltimore: Johns Hopkins University Press, 1976) especially pp. 6–26. See also Jacques Derrida, *Dissemination*, translated by Barbara Johnson (London: Athlone Press, 1981) for an attempt to perform rather than describe deconstruction. See also Christopher Norris, *Deconstruction: Theory and Practice* (London: Routledge, 1991).

[24] Derrida's aim is not to destroy the categories but to 'destabilize, challenge, subvert, reverse or overturn some of the hierarchical binary oppositions (including those implicating sex and gender) of Western culture'. See Elizabeth Grosz, *Sexual Subversions* (London: Taylor & Francis, 1989) p. xv.

[25] Diane Elam, *Feminism and Deconstruction: Ms. En Abyme* (London: Routledge, 1994) p. 83.

[26] According to Elizabeth Grosz, Derrida uses the term deconstruction to describe a threefold intervention that destabilizes the metaphysical structures of binary oppositions. Following Grosz's reading of Derrida, the first step in the process of

deconstruction is the strategic reversal of binary terms, so that the term occupying the negative position in a binary pair is placed in the positive position and the positive term is placed in the negative position. The second is the movement of displacement in which the negative term is displaced from its dependent position and located as the very condition of the positive term. The third and most important strategy of deconstruction is the creation or discovery of a new term that is undecidable within a binary logic. Such a term operates simultaneously as both and neither of the binary terms; it may include both and yet exceed their scope. See Grosz, *Sexual Subversions*, p. xv.

[27] Michel Foucault and Gilles Deleuze, 'Intellectuals and power: a conversation between Michel Foucault and Gilles Deleuze', in Donald F. Bouchard (ed.) *Language, Counter-memory, Practice: Selected Essays and Interviews* (New York: Ithaca, 1977) p. 205.

[28] Foucault and Deleuze, 'Intellectuals and power', p. 206.

[29] Foucault and Deleuze, 'Intellectuals and power', p. 208.

[30] Foucault and Deleuze, 'Intellectuals and power', p. 206.

[31] Foucault and Deleuze, 'Intellectuals and power', p. 206.

[32] Mieke Bal and Inge E. Boer (eds) *The Point of Theory: Practices of Cultural Analysis* (New York: Continuum, 1994) pp. 8–9.

[33] Bal and Boer, *The Point of Theory*, p. 8.

[34] Julia Kristeva, 'Institutional interdisciplinarity in theory and practice: an interview', in Alex Coles and Alexia Defert (eds) *The Anxiety of Interdisciplinarity, De-, Dis-, Ex-*, vol. 2 (London: Black Dog Publishing, 1998) pp. 5–6.

Section 1: Between Here and There
Introduction: Space, Place and Site

[1] See Nick Kaye, *Site-Specific Art: Performance, Place and Documentation* (London: Routledge, 2000); Alex Coles (ed.) *Site Specificity: The Ethnographic Turn* (London: Black Dog Publishing, 2000). See also Julie H. Reiss, *From Margin to Center: The Spaces of Installation Art* (Cambridge MA: MIT Press, 1999). Reiss argues that site-specificity is one of the key characteristics of installation art.

[2] Hal Foster, *Design and Crime (and Other Diatribes)* (London: Verso, 2002) p. 91.

[3] Miwon Kwon, *One Place After Another: Site Specific Art and Locational Identity* (Cambridge, MA: MIT Press, 2002) p. 1.

[4] Kwon, *One Place After Another*, p. 166.

[5] James Clifford, 'An ethnographer in the field', interview by Alex Coles, in Alex Coles (ed.) *Site Specificity: The Ethnographic Turn* (London: Black Dog Publishing, 2000) pp. 52–73.

[6] Krauss, 'Sculpture in the expanded field'. This essay was originally published in *October* 8 (Spring 1979).

[7] Edward Soja, *Postmodern Geographies: The Reassertion of Space in Social Theory* (London: Verso, 1989).

[8] See David Harvey, *The Condition of Postmodernity* (Oxford: Blackwell, 1989); and Doreen Massey, *Space, Place and Gender* (Cambridge: Polity Press, 1994).

[9] Henri Lefebvre, *The Production of Space* (Oxford: Basil Blackwell, 1991) p. 8. This quote from Henri Lefebvre emphasized by David Harvey is discussed in Soja, *Postmodern Geographies*, p. 81. See footnote 4.

[10] Lefebvre, *Production of Space*, p. 81.

[11] See the ground-breaking work produced in the mid 1990s by Liz Bondi, Linda McDowell, Doreen Massey and Gillian Rose. See, for example, Liz Bondi, 'Gender Symbols and Urban Landscapes', *Progress in Human Geography* vol. 16, no. 2 (1992) pp. 157–70; Liz Bondi, 'Gender and Geography: Crossing Boundaries', *Progress in Human Geography*, vol. 17, no. 2 (1993) pp. 241–6; Linda McDowell, 'Space, place and gender relations', *Progress in Human Geography*, Part 1, vol. 17, no. 2 (1993) pp. 157–79, and Part 2, vol. 17, no. 3 (1993) pp. 305–18; Doreen Massey, *Space, Place, and Gender* (Cambridge: Polity Press, 1994); and Gillian Rose, *Feminism and Geography: The Limits of Geographical Knowledge* (Cambridge: Polity Press, 1993).

[12] A number of feminist critiques of Harvey and Soja's work appeared in 1990–91. See Rosalyn Deutsche, 'Men in space', *Strategies*, no. 3 (1990) pp. 130–7; Rosalyn Deutsche, 'Boys town', *Environment and Planning D: Society and Space*, vol. 9 (1991) pp. 5–30; Doreen Massey, 'Flexible Sexism', *Environment and Planning D: Society and Space*, vol. 9 (1991) pp. 31–57; and Gillian Rose's reviews of Edward Soja's *Postmodern Geographies* and David Harvey's *The Condition of Postmodernity* in *Journal of Historical Geography*, vol. 17, no. 1 (January, 1993) pp. 118–21.

[13] Michael Keith and Steve Pile (eds) *Place and the Politics of Identity* (London: Routledge, 1993).

[14] Keith and Pile, *Politics of Identity*, p. 5.

[15] Mike Crang and Nigel Thrift (eds) *Thinking Space* (London: Routledge, 2000).

[16] See Crang and Thrift's 'Introduction' to *Thinking Space*, pp. 1–30, especially pp. 19–24.

[17] Michel de Certeau, *The Practice of Everyday Life* (Berkeley: University of California Press, 1988). See Michel de Certeau, Luce Giard and Pierre Mayol, *The Practice of Everyday Life*, vol. 2, *Living and Cooking*, translated by Timothy J. Tomasik (Minneapolis: University of Minnesota Press, 1998).

[18] De Certeau, *Practice of Everyday Life*, p. 117.

[19] De Certeau, *Practice of Everyday Life*, p. 118.

[20] De Certeau, *Practice of Everyday Life*, p. 117.

[21] Massey, *Space, Place and Gender*, pp. 4–5.

[22] Harvey, *Condition of Postmodernity*, p. 296.

[23] Marc Augé, *Non-Places: Introduction to an Anthropology of Supermodernity*, translated by John Howe (London: Verso, 1995).

[24] See Gaston Bachelard, *The Poetics of Space*, translated by Maria Jolas (Boston: Beacon Press, 1969); and Yi-Fu Tuan, *Topophilia: A Study of the Environmental Perception, Attitudes, and Values* (Englewood Cliffs, NJ: Prentice Hall, 1974). See also Paul C. Adams, Steven Hoelscher and Karen E. Till (eds) *Textures of Place: Exploring Humanist Geographies* (Minneapolis: University of Minnesota Press, 2001) pp. xix.

[25] See, for example, Christian Norberg-Schulz, *Genius Loci: Towards a Phenomenology of Architecture* (New York: Rizzoli, 1980).

Chapter 1: Site, Non-Site, Off-Site

[1] '"Earth" (1969) symposium at White Museum, Cornell University', in Jack Flam (ed.) *Robert Smithson: The Collected Writings* (Los Angeles: University of California Press, 1996) p. 178.

[2] 'Land art: the enigma of Robert Smithson's "Spiral Jetty"', Tate Britain, London (23 March 2001).

[3] Suzaan Boettger, *Earthworks: Art and the Landscape of the Sixties* (Los Angeles: University of California Press, 2002) p. 202.

[4] Robert Smithson, 'The spiral jetty' (1972), in Flam, *Robert Smithson*, pp. 143–53.

[5] Boettger, *Earthworks*, pp. 55–8. See Robert Smithson, 'Towards the development of an air terminal site' (1967), in Flam, *Robert Smithson*, p. 291.

[6] '"Earth" (1969) symposium at White Museum, Cornell University' in Flam, *Robert Smithson*, p. 178.

[7] See Robert Smithson, 'Entropy and new monuments' (1966), in Flam, *Robert Smithson*, pp. 10–23; and Robert Smithson, 'A tour of the monuments of Passaic, New Jersey' (1967), in Flam, *Robert Smithson*, pp. 68–74.

[8] Discussions with Heizer, Oppenheim and Smithson/Liza Bear and Willoughby Sharp, in Flam, *Robert Smithson*, p. 244. This discussion was first published in *Avalanche Magazine*, Fall 1970, p. 3.

[9] Boettger, *Earthworks*, p. 67.

[10] Germano Celant, *Dennis Oppenheim* (Milan: Charta, 1997) pp. 28–9. See also Germano Celant, *Dennis Oppenheim: Explorations* (Milan: Charta, 2001) pp. 9–27.

[11] Alanna Heiss and Thomas McEvilley, *Dennis Oppenheim, Selected Work 1967–90: And the Mind Grew Fingers* (New York: Harry N. Abrams Inc, 1992) p. 10.

[12] Flam, *Robert Smithson*, p. 244.

[13] Smithson, 'The spiral jetty' (1972), in Flam, *Robert Smithson*, pp. 152–3.

[14] Boettger, *Earthworks*, pp. 111–15, 215.

[15] Walter de Maria, quoted in Michael Archer, Nicolas de Oliveira, Nicola Oxley and Michael Petri, *Installation Art* (London: Thames & Hudson, 1994) p. 34.

[16] Robert Morris, 'Earthworks: land reclamation as sculpture', in Harriet F. Senie and Sally Webster (eds) *Critical Issues in Public Art: Content, Context and Controversy* (New York: Harper Collins) p. 251.

[17] The original patronage of Philippa de Menil and Heiner Friedrich founded the Dia Foundation in 1974. Their interest was in commissioning and funding exceptional projects, such as 'The Lightning Field' by Walter de Maria and works by Judd, Heizer, Turrell and Beuys among others. The Lone Star Foundation, set up in 1976, had a different objective – to make a collection. In 1987 Dia opened an exhibition space in Chelsea in Manhattan whose exhibition programme included the commissioning of new works by artists who came to maturity in the 1960s as well as younger and mid-career artists. The premise was long-term single artist projects. Some of these works have entered the collection, for example works by Irwin and Bridget Riley. In May 2003 a new space, Dia:Beacon, opened in upstate New York to put more of this permanent collection on display, to provide long-term and in-depth presentations of works by single artists. The building was renovated in consultation with American artist Robert Irwin and the architectural team Open Office. Artists were consulted regarding the choice of gallery space and disposition of their works. These comments are based on a discussion with the curator of the Dia Art Foundation, Lynne Cooke, in February 2003. See also www.diacenter.org (accessed 14 March 2006).

[18] Walter de Maria, quoted in Archer et al., *Installation Art*, p. 34.

[19] Rosalyn Deutsche, 'Alternative space', in Brian Wallis (ed.) *If You Lived Here: The City in Art, Theory and Social Activism – A Project by Martha Rosler* (Seattle: Bay Press, 1991) p. 55.

[20] The project, supported substantially by Dia, was managed through the Free International University (FIU). See Fernando Groener and Rose-Marie Kandler (eds) *Joseph Beuys: 7000 Eichen* (Cologne: Walter König, 1987).

[21] The park includes a pavilion designed by the artist Dan Graham in collaboration with architects Moji Baratloo and Clifton Balch and a video salon with a coffee bar showing work selected by the artist. See leaflet published by Dia, Dan Graham, 'Rooftop Urban Park Project', long-term installation, consisting of Dan Graham 'Two-Way Mirror Cylinder Inside Cube' (1981–91) and Design Collaboration, Baratloo-Balch Architects, 'Video Salon'. See also Dan Graham, *Pavilions* (Munich: Kunstverein München, 1988).

[22] This programme included Anna Best's 'MECCA', State Mecca Bingo Hall; Felix Gonzalez-Torres's 'Untitled' (America) (1994–5); Maurice O'Connell's 'On Finchley Road'; and Orla Barry's 'Across an Open Space'. Others artists worked with participants at Swiss Cottage library and the Royal Free NHS Trust.

[23] See Adam Chodzko, *Plans and Spells* (London: Film & Video Umbrella, 2002) pp. 40–1; also Adam Chodzko, 'Out of place', in John Carson and Susannah Silver (eds) *Out of the Bubble: Approaches to Contextual Practice within Fine Art Education* (London: London Institute, 2000) pp. 31–6.

[24] Chodzko, *Plans and Spells*, pp. 40–1.

[25] See Tania Kovat, in collaboration with Levitt Bernstein Associates, New Ikon Gallery, Birmingham, *Frontiers: Artists and Architects, Architectural Design* (London) no. 128 (1997) pp. 94–5.

[26] See *As It Is*, off-site exhibition by Ikon Gallery, Birmingham (2000); also Claire Doherty (ed.) *Out of Here: Creative Collaborations beyond the Gallery* (Birmingham: Ikon Gallery, 1998).

[27] *As It Is*, p. 66.

[28] *As It Is*, pp. 70–3. See also Tadashi Kawamata, *Field Work* (Ostfildern: Reihe Cantz, 1998).

[29] *Public Art Journal*, vol. 1, no. 1 (March 1999) p. 14.

[30] See Anita Berrizbeitia and Linda Pollak, *Inside Outside: Between Architecture and Landscape* (Gloucester, MA: Rockport Publishers, 1999) p. 49.

[31] Benedetta Tagliabue (ed.) *Enric Miralles: Mixed Talks, Architectural Monographs*, no. 40 (London: Academy Editions, 1995).

[32] See, for example, Peter Latz's landscaping of the former Saarbrucken coal dock (1985–89); the rock garden of Hafeninsel Saarbrucken is based on an archaeological dig and is produced by sorting rubble. See Udo Weilacher, *Between Landscape Architecture and Land Art* (Basel: Birkhäuser, 1999) pp. 121–4 which looks at projects that defy definition as either land art or landscape architecture.

[33] Morris, *Earthworks*.

[34] Thomas Hirschhorn, Anthony Spira and Craig Martin (eds) *Material: Public Works – The Bridge 2000* (London: Whitechapel Art Gallery, 2000).

[35] Juan Cruz, *Application for a Planning Permit: Proposal to Build a Metaphor* (Melbourne: Melbourne Festival, 2001).

[36] See, for example, Jonathan Hill, *The Illegal Architect* (London: Black Dog Publishing, 1998).

Chapter 2: The Expanded Field

[1] Krauss, 'Sculpture in the expanded field', p. 40. This essay was originally published in *October* 8 (Spring 1979).

[2] Krauss, 'Sculpture in the expanded field'. For an extended discussion of Krauss's use of the semiotic square in this essay, see Jane Rendell, 'Space, place, site: critical spatial practice', in Cameron Cartière and Shelly Willis (eds) *RE/Placing Public Art* (Minneapolis: University of Minnesota Press, forthcoming).

[3] Krauss, 'Sculpture in the expanded field', pp. 36–8.

[4] Krauss, 'Sculpture in the expanded field', p. 33.

[5] Krauss, 'Sculpture in the expanded field', p. 43. See footnote 1 for Krauss's discussion of the technique of the semiotic square.

[6] Fredric Jameson, 'Foreword', in Algirdas Julien Greimas, *On Meaning: Selected Writings on Semiotic Theory*, translated by Paul J. Perron and Frank H. Collins (Minneapolis: University of Minnesota Press, 1987) p. vi.

[7] Foster, *Design and Crime*, p. 126.

[8] See Nigel Prince and Gavin Wade (eds) *In the Midst of Things* (London: August Media, 2000). See also Gavin Wade (ed.) *Curating in the 21st Century* (Walsall: New Art Gallery/University of Wolverhampton, 2000).

[9] Prince and Wade, *In the Midst of Things*, p. 12.

[10] Prince and Wade, *In the Midst of Things*, pp. 116–19.

[11] Prince and Wade, *In the Midst of Things*, p. 65.

[12] See for example, Alex Coles, *DesignArt*, (London: Tate Publishing, 2005). Coles has coined the term 'designart' to describe practices that cross art and design.

[13] See for example, Neil Leach, 'Architecture or revolution?' in Neil Leach (ed.) *Architecture and Revolution* (London: Routledge, 1999) p. 112.

[14] Prince and Wade, *In the Midst of Things*, pp. 88–91.

[15] Prince and Wade, *In the Midst of Things*, pp. 112–15.

[16] Robert Morris, 'Notes on sculpture 1–3', in Charles Harrison and Paul Wood (eds) *Art in Theory 1900–1990: An Anthology of Changing Ideas* (Oxford: Blackwell, 1992) p. 814. Part 1 was first published in *Artforum*, February 1966, pp. 42–4.

[17] See David Antin, 'Art and Information, 1, Grey Paint, Robert Morris', *Art News*, 65, no. 2 (April 1966) pp. 24–6 referenced in Boettger, *Earthworks*, p. 211.

[18] David Bourdon, 'The razed sites of Carl Andre', in Gregory Battcock (ed.) *Minimalism: A Critical Anthology* (Berkeley/Los Angeles: University of California Press, 1995) pp. 103–8. Reprinted from *Artforum*, October 1966, pp. 103–4.

[19] Morris, 'Notes on sculpture 1–3', p. 816. Part 2 was first published in *Artforum*, October 1966, pp. 20–3.

[20] Robert Smithson, 'Interview with Robert Smithson for the archives of American Art/Smithsonian Institution' (1972), in Flam, *Robert Smithson*, p. 296.

[21] Celant, *Dennis Oppenheim*, p. 29.

[22] Prince and Wade, *In the Midst of Things*, pp. 72–3.

[23] Prince and Wade, *In the Midst of Things*, pp. 50–3.

[24] Prince and Wade, *In the Midst of Things*, pp. 60–3.

[25] Prince and Wade, *In the Midst of Things*, pp. 84–7.

[26] Prince and Wade, *In the Midst of Things*, pp. 58–9.

[27] Hal Foster, *The Return of the Real: The Avant-Garde at the End of the Century* (Cambridge, MA: MIT Press, 2001) p. 38.

[28] Foster, *Return of the Real*, p. 43.

29 Luca Galofaro, *Artscapes: Art as an Approach to Contemporary Landscape* (Barcelona: Editorial Gustavo Gili, 2003) p. 27.

30 Galofaro, *Artscapes*, p. 91.

31 Galofaro, *Artscapes*, p. 151.

32 Urs Staub (ed.) *Décosterd & Rahm: Physiological Architecture* (Basel: Birkhäuser Staub, 2003).

33 Staub, *Décosterd & Rahm*, p. 317.

34 Staub, *Décosterd & Rahm*, p. 322.

35 Staub, *Décosterd & Rahm*, p. 292.

36 Staub, *Décosterd & Rahm*, p. 292.

37 Aaron Betsky, 'Swiss cheese: disappearing down the holes of modernism with Décosterd & Rahm', in Staub, *Décosterd & Rahm*, p. 50.

Chapter 3: Space as Practised Place

1 De Certeau, *Practice of Everyday Life*, p. 117.

2 Michael Landy, 'Breakdown' (2001), C&A Store at Marble Arch, 499–523 Oxford Street, London, W1. See Gerrie van Noord (ed.) *Off Limits: 40 Artangel Projects* (London: Artangel, 2002) pp. 162–7; and Michael Landy, *Breakdown* (London: Artangel, 2001).

3 See, for example, Dave Beech's review of Michael Landy, 'Breakdown', *Art Monthly*, March 2001, pp. 30–1.

4 Walter Benjamin, 'Theses on the philosophy of history' (completed in 1940 and translated by Harry Zohn), in Hannah Arendt (ed.) *Illuminations* (London: Fontana, 1992) p. 247. Walter Benjamin, who quotes the positivist historian Leopold von Ranke, argues that such an endeavour is impossible for a critical historian to achieve.

5 See van Noord, *Off Limits*, pp. 190–5; and Jeremy Deller, *The Battle of Orgreave* (London: Artangel, 2002). See also Dave Beech's review of Jeremy Deller, 'The Battle of Orgreave', *Art Monthly*, July/August 2001, pp. 38–9.

6 Benjamin, 'Theses on the philosophy of history', p. 248.

7 Artangel has been commissioning artworks since the early 1990s when the company was set up by James Lingwood and Michael Morris, both of whom had previously worked at the ICA (Institute of Contemporary Arts) in London. See van Noord, *Off Limits*; and www.artangel.org.uk (accessed 14 March 2006).

8 For work commissioned by Public Art Development Trust in London, see www.padt. org.uk (accessed 14 March 2006) and the series of publications, *PADT Documentary Notes*.

9 Discussion with Sandra Percival, October 2001. It is also worth looking at other agencies that commission art in the UK. For the work of Locus +, a commissioning agency based in Sunderland, see Julian Stallabrass, Pauline van Mourik Broekman and Niru Ratnam (eds) *Locus Solus: Site, Identity and Technology in Contemporary Art* (London: Black Dog Publishing, 2001). For Bulkhead, a commissioning agency based in Glasgow from 1999 to 2001, see www.bulkhead.org.uk (accessed 2003).

10 See *PADT Documentary Notes: Henry Bond and Angela Bulloch* (London: Public Art Development Trust, 2000).

11 Henry Bond, *Deep Dark Water* (London: Public Art Development Trust, 1994).

12 In May 1999 the 'Fourth Wall' programme was divided into 'Waiting', 'Plotting', 'Believing' and 'Ending'. The concept was to look at the idea of an invisible wall

lying both between the stage and the audience, and between the city and the stage. See http://www.padt.org.uk/4thwall/4thwall.html (accessed 14 March 2006).

[13] Here Sandra Percival and Diane Shamash collaborated as curators. See www. minettabrook.org (accessed 14 March 2006); and Miwon Kwon (ed.) *Watershed* (Journal no. 1) *The Hudson Valley Art Project* (New York: Minetta Brook, 2002).

[14] See also Marie José Burki, *Time After, Time Along, The River* (Paris: Galerie Nelson, 2002).

[15] Roni Horn, *Another Water (The River Thames, for Example)* (New York: Scalo Publishers, 2000).

[16] In New York the Public Art Fund has been operating for 25 years to support emerging and established artists' projects, installations and exhibitions in alternative venues throughout New York City. PAF is a non-profit arts organization; financial support comes from a combination of donations from individuals, foundations and corporations, and as public funds from the New York State Council on the Arts and the New York City Department of Cultural Affairs. See the Public Art Fund Journal, *In Process, Public Art Fund Publications* and www.publicartfund.org (accessed 14 March 2006).

[17] See *In Process*, Fall/Winter 2000, pp. 3–4, 9 and *In Process*, Winter/Spring 2002, p. 9.

[18] See *Public Art Fund Publications*, no. 3. (New York, 2001) p. 4.

[19] OMA, Rem Koolhaas and Bruce Mau, *S, M, L, XL* (New York: Monacelli Press, 1995).

[20] Foster, *Design and Crime*, p. 54. See also Chuihua Judy Chung, Jeffrey Inaba, Rem Koolhaas and Sze Tsung Leong (eds) *Harvard Design School Guide to Shopping* (Cologne: Taschen, 2001).

[21] Alejandro Zaera Polo, 'Conceptual evolution of the work of Rem Koolhaas', in Rem Koolhaas, *Urban Projects (1985–1990)* (Barcelona: Editorial Gustavo Gili, 1991) p. 56.

[22] Foster, *Design and Crime*, p. 60.

[23] Foster, *Design and Crime*, p. 61.

[24] Foster, *Design and Crime*, p. 61.

[25] MVRDV, *Meta City Data Town* (Rotterdam: 010 Publishers, 1999).

[26] Bart Lootsma, 'Architecture in the second modernity', in Frédéric Migayrou and Marie-Ange Brayer (eds) *Archilab: Radical Experiments in Global Architecture* (London: Thames & Hudson, 2001) pp. 26–7.

[27] Foreign Office Architects, '1996–2003: complexity and consistency', *El Croquis*, 115/116 (2003) p. 15.

[28] Foreign Office Architects, '1996–2003', p. 14.

[29] Foreign Office Architects, *Phylogenesis: FOA, Foreign Office Architects* (Barcelona: Actar, 2004) pp. 7–8.

[30] Foreign Office Architects, 'Yokohama International Port Terminal', *Foreign Office Architects, 2G International Architecture Review*, no. 16 (2000) p. 88.

[31] Foreign Office Architects, *Phylogenesis*, pp. 228–30.

[32] This is the phrase used by Japanese architect Toyo Ito, one of the judges of the design when it was entered in the competition. See Toyo Ito, 'Yokohama International Port Terminal', in *Foreign Office Architects, 2G International Architecture Review*, no. 16 (2000) p. 86. See also Foreign Office Architects, '1996–2003', p. 42.

[33] Foreign Office Architects, 'Yokohama International Port Terminal', p. 93.

[34] Michael Speak, 'Two stories for the avant-garde', in Migayrou and Brayer, *Archilab: Radical Experiments in Global Architecture*, p. 21.

[35] Lootsma, 'Architecture in the second modernity', p. 25.

[36] Fredric Jameson, 'Is space political?' in Cynthia C. Davidson (ed.) *Any Place* (Cambridge, MA: MIT Press, 1995) p. 196.

Section 2: Between Now and Then
Introduction: Allegory, Montage and Dialectical Image

[1] George Steiner, 'Introduction', in Walter Benjamin, *The Origin of German Tragic Drama*, translated by John Osborne (London: Verso, 1977) pp. 16–8.

[2] Benjamin, *Origin of German Tragic Drama*, p. 178.

[3] Benjamin, *Origin of German Tragic Drama*, p. 223.

[4] Benjamin, *Origin of German Tragic Drama*, p. 140. See also Susan Buck-Morss, *The Dialectics of Seeing: Walter Benjamin and the Arcades Project* (Cambridge, MA: MIT Press, 1991) p. 170.

[5] Benjamin, *Origin of German Tragic Drama*, pp. 165–6.

[6] Buck-Morss, *Dialectics of Seeing*, pp. 166–8.

[7] Benjamin, *Origin of German Tragic Drama*, pp. 176–7.

[8] Jennifer Bloomer, *Architecture and the Text: The (S)crypts of Joyce and Piranesi* (New Haven: Yale University Press, 1993) p. 21.

[9] Peter Bürger, *Theory of the Avant-Garde* (Minneapolis: University of Minnesota Press, 1984) p. 69.

[10] See Walter Benjamin, *The Arcades Project (1927–39)*, translated by Howard Eiland and Kevin McLaughlin (Cambridge, MA: Harvard University Press, 1999).

[11] Rolf Tiedemann, 'Dialectics at a standstill: approaches to the passagen-werk', in Benjamin, *The Arcades Project*, p. 932.

[12] Walter Benjamin, 'Materials for the exposé of 1935', in *The Arcades Project*, p. 910.

[13] Walter Benjamin, 'Paris: the capital of the nineteenth century' (completed in 1935 and translated by Quintin Hoare), in *Charles Baudelaire: A Lyric Poet in the Era of High Capitalism*, translated by Harry Zohn (London, New Left Books, 1997) p. 176.

[14] Susan Buck-Morss, *The Origin of Negative Dialectics: Theodor W. Adorno, Walter Benjamin, and the Frankfurt Institute* (Hassocks: Harvester, 1977) p. 106.

[15] Benjamin, 'Materials for the exposé of 1935', in *The Arcades Project*, p. 911.

[16] Benjamin, *The Arcades Project*, p. 462.

[17] Buck-Morss, *Dialectics of Seeing*, p. 219.

[18] Benjamin, 'Theses on the philosophy of history', p. 254.

[19] Buck-Morss, *Dialectics of Seeing*, pp. 60–2.

[20] Walter Benjamin, 'The work of art in the age of mechanical reproduction', completed in 1936 and translated by Harry Zohn, in Hannah Arendt (ed.) *Illuminations* (London: Fontana, 1992) p. 231.

[21] Buck-Morss, *Dialectics of Seeing*, pp. 67, 77.

[22] Bürger, *Theory of the Avant-Garde*, p. 79. In this respect, Bürger follows Theodor Adorno.

[23] Bürger, *Theory of the Avant-Garde*, pp. 80–1. It is important to note that Bürger is referring to artworks where 'reality fragments' have been inserted into 'the work of art' such that the work is transformed. See *Theory of the Avant-Garde*, p. 78.

[24] Benjamin, 'The work of art', p. 233.

[25] Benjamin, 'The work of art', pp. 233–4.

26 Benjamin, 'The work of art', p. 235.

27 Benjamin, *The Arcades Project*, p. 460.

28 Benjamin, *The Arcades Project*, p. 461.

29 'One-Way Street' is dedicated to Asja Lacis, a Bolshevik actress and director active in post-revolutionary Russia, who saw her own work as integral to the revolutionary transformation of society. Benjamin met Lacis in 1924 and they collaborated on the first of Benjamin's city portraits, the 'Naples' essay published in 1925 (see Walter Benjamin, 'Naples', translated by Edmund Jephcott, in Marcus Bullock and Michael W. Jennings (eds) *Walter Benjamin: Selected Writings* vol. 1, *1913–26* (Cambridge MA: Harvard University Press, 2004) pp. 414–21. For a longer discussion, see Jane Rendell, 'Thresholds, passages and surfaces: touching, passing and seeing in the Burlington Arcade', in Alex Cole (ed.) *The Optics of Walter Benjamin* (London: Black Dog Press, 1999) pp. 168–91.

30 Walter Benjamin, 'One-Way Street', first published in 1928 and translated by Edmund Jephcott, in Marcus Bullock and Michael W. Jennings (eds) *Walter Benjamin: Selected Writings* vol. 1, *1913–26* (Cambridge, MA: Harvard University Press, 2004) pp. 444–88. See also Steve Pile, 'Between city and dream', in Jane Rendell (ed.) 'A Place Between', Special Issue of *Public Art Journal*, October 1999, pp. 10–11.

31 Buck-Morss, *Origin of Negative Dialectics*, p. 103.

32 Buck-Morss, *Origin of Negative Dialectics*, p. 103.

33 Sigrid Weigel, *Body- and Image-Space: Re-Reading Walter Benjamin* (London: Routledge, 1996) p. 51.

34 Weigel, *Body- and Image-Space*, p. 51.

35 Weigel, *Body- and Image-Space*, p. 52.

36 Weigel, *Body- and Image-Space*, pp. 55–7. See also Gershom Scholem, 'Walter Benjamin and his angel' (1972), in Gary Smith (ed.) *On Walter Benjamin: Critical Essays and Recollections* (Cambridge, MA: MIT Press, 1991) p. 62.

37 Benjamin, 'Theses on the philosophy of history', p. 249.

38 Weigel, *Body- and Image-Space*, p. 55.

39 Howard Caygill, *The Colour of Experience* (London: Routledge, 1998) pp. 74–5.

40 Caygill, *Colour of Experience*, p. 79.

41 Scholem, 'Walter Benjamin and his angel', pp. 51–89.

42 Buck-Morss, *Dialectics of Seeing*, p. 241.

43 Max Pensky, *Melancholy Dialectics: Walter Benjamin and the Play of Mourning* (Amherst: University of Massachusetts Press, 1993) p. 236.

44 Benjamin, 'Paris', p. 172.

45 Buck-Morss, *Dialectics of Seeing*, p. 170.

46 Pensky, *Melancholy Dialectics*, pp. 220–1.

47 Pensky, *Melancholy Dialectics*, p. 16.

48 Bürger, *Theory of the Avant-Garde*, p. 73.

49 I want to note the similarities here between my suggestions and those of art critic Craig Owens, who in 1979 drew on Benjamin's notion of the allegory to discuss the radical social potential of the fragment and the ruin in a number of contemporary artworks. I discovered this essay on completion of my own research and was amazed by the resonances between our approaches to considering allegory in relation to contemporary art. See Craig Owens, 'The allegorical impulse: toward a theory of postmodern', *October*, no. 12 (Spring 1980) pp. 67–84 and no. 13 (Summer 1980) pp. 59–80.

50 Fredric Jameson, *Marxism and Form: Twentieth-Century Dialectical Theories of Literature* (Princeton: Princeton University Press, 1971) p. 82.

Chapter 1: Ruin as Allegory

[1] Benjamin, 'Paris', p. 178.
[2] Clarrie Wallis, 'Introduction', *Tacita Dean* (London: Tate Britain exhibition catalogue, 2001) p. 13.
[3] Benjamin, 'The work of art', pp. 231–2.
[4] See, for example, *Jane & Louise Wilson* (London: Serpentine Gallery, 1999).
[5] See Rut Blees Luxemburg, *London – A Modern Project* (London: Black Dog Publishing, 1997).
[6] Ralph Rugoff, *Scene of the Crime* (Cambridge, MA: MIT Press, 1997).
[7] Ilka Ruby and Andreas Ruby, 'Naive architecture: notes on the work of Lacaton & Vassal', in *Lacaton & Vassal, 2G International Architecture Review*, no. 21 (2001) p. 19.
[8] *Lacaton & Vassal, 2G International Architecture Review*, no. 21 (2001) p. 113.
[9] 'A conversation with Patrice Goulet', in *Lacaton & Vassal, 2G International Architecture Review*, p. 142.
[10] *Lacaton & Vassal, 2G International Architecture Review*, p. 31.
[11] *Lacaton & Vassal, 2G International Architecture Review*, p. 112.
[12] Robin Wilson, 'Beyond the fringe', *The Architects' Journal*, 3 October 2002, pp. 32–3.
[13] Jane Rendell, 'Conductor: a tribute to the angels', catalogue essay in *Jane Prophet, 'Conductor'*, (London: The Wapping Project, December 2000).
[14] See Nick Barley (ed.) *Leaving Tracks: Artranspennine98, an International Contemporary Visual Art Exhibition Recorded* (London: August Media in association with Art Transpennine, 1999) pp. 98–101.
[15] Anya Gallaccio, *Anya Gallaccio: Chasing Rainbows* (Tramway/Locus +, 1999).
[16] Gallaccio, *Chasing Rainbows*, p. 60.
[17] Galofaro, *Artscapes*, p. 152.
[18] Richard Scofidio and Elizabeth Diller, *Blur: The Making of Nothing* (New York: Abrams, 2002) p. 195.
[19] Scofidio and Diller, *Blur*, p. 44.
[20] Scofidio and Diller, *Blur*, pp. 324–5.

Chapter 2: Insertion as Montage

[1] Benjamin, quoted in Buck-Morss, *Dialectics of Seeing*, p. 67. See also p. 77.
[2] Peter Osbourne has distinguished between the 'abstract negation' of Duchamp's ready-made as 'this is art?' and Joseph Kosuth's 'determinate negation' as 'this *is* art'. See Peter Osbourne, 'Conceptual art and/as philosophy', in Michael Newman and John Bird (eds) *Rewriting Conceptual Art* (London: Reaktion Books, 1999) p. 57.
[3] Benjamin H. D. Buchloh identifies the work of Marcel Broodthaers, Hans Haacke and Daniel Buren after 1966 as 'institutional critique'. See Benjamin H. D. Buchloh, 'Conceptual art 1962–1969: from the aesthetic of administration to the critique of institutions', *October*, Winter 1990, p. 528.
[4] See, for example, Hans Haacke, 'Museums: managers of consciousness', in *Hans Haacke*, vol. 2 (London: Tate Gallery and Eindhoven: Van Abbemuseum, 1984) pp. 105–9.

5 See, for example, Benjamin H. D. Buchloh (ed.) *Michael Asher, Writings 1973–1983 on Works 1969–1979* (Novia Scotia College of Art and Design and Museum of Contemporary Art Los Angeles, 1984) pp. 76–81.

6 Victor Burgin, 'Photographic practice and art theory', in Victor Burgin (ed.) *Thinking Photography* (London: Macmillan, 1982) p. 72.

7 Victor Burgin, 'Art, common sense and photography', in Jessica Evans and Stuart Hall (eds) *Visual Culture: The Reader* (London: Sage, 1999) p. 48.

8 See, for example, Peter Wollen, 'Barthes, Burgin, Vertigo', in Peter Wollen, *Victor Burgin* (Barcelona: Fundacio Antoni Tapies, 2001) p. 12.

9 Victor Burgin's 'Photopath' (1967) and 'When attitudes become form' (1969) at the Institute of Contemporary Art, London. See, for example, Joelle Pijaudier, *Victor Burgin: Passages*, translated by Anne Ortiz-Talvaz (Lille, Villeneuve d'Ascq, Ville de Blois: Musée d'Art Moderne, 1992) p. 20.

10 See for example, Victor Burgin, *Between* (Oxford: Blackwell, 1986).

11 Victor Burgin quoted in Pijaudier, *Passages*, p. 24.

12 Tatsurou Bashi, catalogue for *Tatsurou Bashi alias Taxro Niscino* (Wolfsburg, 2002).

13 Cornford & Cross, 'Live adventures', in Iain Borden, Joe Kerr and Jane Rendell (eds) with Alicia Pivaro, *The Unknown City: Contesting Architecture and Social Space* (Cambridge, MA: The MIT Press, 2001) pp. 328–39, pp. 334–6.

14 Ruby and Ruby, 'Naive architecture', p. 7.

15 Sarah Wigglesworth and Jeremy Till, *9/10 Stock Orchard Street: A Guidebook* (London: Bank of Ideas, 2001).

16 See http://www.swarch.co.uk/medium-straw-twol.html (accessed November 2003).

17 See Peter Davey, 'The slick and the hairy', *Architectural Review*. January 2002, pp. 64–8.

18 Krzysztof Wodiczko, *Critical Vehicles: Writings, Projects, Interviews* (Cambridge MA: The MIT Press, 1999) pp. 57–8.

19 Wodiczko, *Critical Vehicles*, pp. 64–73.

20 Wodiczko, *Critical Vehicles*, p. 64.

21 Wodiczko, *Critical Vehicles*, p. 65.

22 Wodiczko, *Critical Vehicles*, p. 70.

23 Wodiczko, *Critical Vehicles*, p. 65.

24 The dig at Whitefriars in Canterbury is referred to as 'The Big Dig' on the website. See http://www.canterburytrust.co.uk/archive/bigdig01.html (accessed May 2005).

25 http://www.harrismatrix.com/history.htm (accessed May 2005). See also Jane Rendell, 'Seeing Time/Writing Place', in *Janet Hodgson, 'The Pits'*, (Canterbury: Whitefriars Art Programme, 2005), pp. 28–36.

26 Emma Beadsmoore, Duncan Garrow and Mark Knight, 'Neolithic spaces and the material temporality of occupation', paper presented at Connected Space conference, McDonald Institute, Cambridge (14–15 May 2005).

27 fat (1999) 'Art attack!', in Jane Rendell (ed.) *A Place Between*, p. 37.

28 fat (2001) 'Projects and tactics', in Borden et al. *The Unknown City*, p. 348.

29 Bernard Tschumi, *Architecture and Disjunction* (Cambridge, MA: The MIT Press, 1996) p. 205.

30 Tschumi, *Architecture and Disjunction*, pp. 191–2. See also Kaye, *Site-Specific Art*, pp. 41–52.

31 Bernard Tschumi, 'Interview with Bernard Tschumi: architecture and the city', in Borden et al., *The Unknown City*, pp. 370–85.

[32] Jacques Derrida, 'Point de folie: maintenant l'architecture', *Forum*, May 1988, pp. 11–25.
[33] Tschumi, *Architecture and Disjunction*, p. 378.
[34] Tschumi, *Architecture and Disjunction*, p. 378.
[35] Tschumi, *Architecture and Disjunction*, p. 378.
[36] Tschumi, *Architecture and Disjunction*, p. 378.
[37] Caygill, *Colour of Experience*, p. 79.

Chapter 3: The 'What-has-been' and the Now

[1] Benjamin, *Arcades Project*, p. 462.
[2] Sophie Calle, *Appointment: Sophie Calle and Sigmund Freud* (London: Violette Editions, 2002).
[3] Erica Davies, the director of the Freud Museum, has facilitated the work of a number of artists in response to the museum over the past few years. See also Susan Hiller, *After the Freud Museum* (London: Bookworks, 1995).
[4] Sophie Calle, 'The Birthday Ceremony', Tate Britain, London (1998). See, for example, Tracey Emin interviewed by Mark Gisbourne, 'Life into Art', *Contemporary Visual Arts*, issue 20, (1998) pp. 28–34.
[5] http://www.jamesputnam.org.uk/inv_exhibition_07.html (accessed 6 October 2005).
[6] Mario Petrucci, 'Anaesthesia or synaesthesia: between artefact and poem', in Jane Rendell, 'A Place Between', p. 15. See also Mario Petrucci, *Shrapnel and Sheets* (Liverpool: Headland, 1996).
[7] In the First World War London buses were sometimes pressed into service in France.
[8] Buck-Morss, *Origin of Negative Dialectics*, p. 106.
[9] See http://mariopetrucci.port5.com for Petrucci's commentary on his own method.
[10] PLATFORM's ongoing project, 'Killing Us Softly' (2000–) provides a detailed account of this history. See http://www.platformlondon.org/kus.htm (accessed 6 October 2005).
[11] See http://london.iwm.org.uk/server/show/nav.00b005 (accessed 6 October 2005).
[12] See James Lingwood (ed.) *Rachel Whiteread: House* (London: Phaidon Press, 1995); Rachel Whiteread, *Rachel Whiteread: Shedding Life* (Liverpool: Tate Gallery exhibition catalogue, 1996); and van Noord, *Off Limits*, pp. 78–83.
[13] Louise Neri (ed.) *Looking Up: Rachel Whiteread's Water Tower* (New York: Scalo, 2000).
[14] Rachel Whiteread, 'Holocaust Memorial' (1995) Jüdenplatz, Vienna. See British Council, *Rachel Whiteread: British Pavilion XLVII Venice Biennale 1997* (London: British Council, 1997) p. 31.
[15] See for example, Daniel Libeskind, *Jewish Museum* (Berlin: 1999); and Bernhard Schneider, *Daniel Libeskind: Jewish Museum, Berlin* (Munich: Prestal, 1999).
[16] Libeskind, *Jewish Museum*, p. 10.
[17] http://www.daniel-libeskind.com/projects/pro.html?ID=2 (accessed 5 October 2005).

[18] Libeskind, *Jewish Museum*, p. 24.

[19] Libeskind, *Jewish Museum*, pp. 24–5.

[20] Libeskind, *Jewish Museum*, p. 30.

[21] See for example, Libeskind, *Jewish Museum*; and Schneider, *Daniel Libeskind*. Also http://www.daniel-libeskind.com/projects/pro.html?ID=2 (accessed 5 October 2005).

[22] Paul McGillick, 'The art of Janet Laurence', *Monument*, December/January 1999–2000, p. 74.

[23] Rhys Jones, 'Ordering the landscape', in Ian Donaldson and Tamsin Donaldson (eds) *Seeing the First Australians* (Sydney: Allen & Unwin, 1985) p. 185 quoted in Dinah Dysart (ed.) *Edge of the Trees: A Sculptural Installation by Janet Laurence and Fiona Foley* (Sydney: Historic Houses Trust of New South Wales, 2000) p. 28. See also Marsha Meskimmon, *Women Making Art: History, Subjectivity, Aesthetics* (London: Routledge, 2003) pp. 171–8.

[24] Clifford, 'An ethnographer in the field', pp. 56–7.

[25] Homi K. Bhabha, *The Location of Culture* (London: Routledge, 1994) p. 34.

[26] See Dysart, *Edge of the Trees*, p. 10.

[27] Kim Dovey with Iain Woodcock, 'Insinuations', lecture at the Bartlett School of Architecture, UCL, London, October 2003.

[28] Paul Carter, Peter Davidson, lab architecture studio, Vanessa Walker, Federation Square Public Art Program, *Making Tracks: 'Nearamnew' at the NGV, Proposal for an Exhibition*. See also Andrew Mackenzie, 'Blasted geometry', *Contemporary*, April 2002, pp. 58–63.

[29] See Paul Carter, 'Arcadian writing: two text into landscape proposals', *Studies in the History of Gardens and Designed Landscapes*, vol. 21, no. 2 (April–June 2001) p. 138.

[30] Carter, 'Arcadian writing', p. 144.

[31] Carter, 'Arcadian writing', p. 137.

[32] Sue Hubbard, 'Between poem and writing', in Rendell, 'A Place Between', pp. 18–19.

[33] Extract from Sue Hubbard's 'Eurydice' in Sue Hubbard, *Ghost Station* (Great Wilbraham, Cambridge: Salt Publishing, 2004) p. 7.

[34] Caygill, *Colour of Experience*, pp. 74–5.

Section 3: Between One and Another
Introduction: Listening, Prepositions and Nomadism

[1] Nicholas Bourriaud, *Relational Aesthetics*, translated by Simon Pleasance and Fronza Woods (Dijon: Presses du reel, 2002).

[2] Bourriaud, *Relational Aesthetics*, pp. 47, 99.

[3] Bourriaud, *Relational Aesthetics*, p. 58.

[4] Grant H. Kester, *Conversation Pieces: Community and Communication in Modern Art* (Berkeley: University of California Press, 2004) pp. 118–23.

[5] Finkelpearl, *Dialogues in Public Art*, p. 283.

[6] Jessica Benjamin, *Shadow of the Other: Intersubjectivity and Gender in Psychoanalysis* (London: Routledge, 1998) p. 25.

[7] Diane Fuss, *Identification Papers* (London: Routledge, 1995) p. 3.

[8] Fuss, *Identification Papers*, p. 2.

[9] Kaja Silverman, *The Threshold of the Visible World* (London: Routledge, 1996) pp. 23–4.

[10] Benjamin, *Shadow of the Other*, p. 80.

[11] Benjamin, *Shadow of the Other*, pp. 92–3.

[12] Judith Butler, *Precarious Life: The Powers of Mourning and Violence* (London: Verso, 2004) p. 49.

[13] Suzi Gablik, 'Connective aesthetics: art after individualism', in Suzanne Lacy (ed.) *Mapping the Terrain: New Genre Public Art* (Seattle: Bay Press, 1995) p. 80. See also Gablik, *Reenchantment of Art*, pp. 96–114.

[14] Gablik, 'Connective aesthetics', p. 84.

[15] Gablik, 'Connective aesthetics', pp. 80–3.

[16] Gablik, 'Connective aesthetics', p. 84.

[17] Luce Irigaray, *To Be Two* translated by Monique M.Rhodes and Marco F.Cocito-Mouoc (London: Athlone Press, 2000) p. 19.

[18] Michel Serres, *Angels: A Modern Myth* (Paris: Flammarion, 1995) pp. 140–7.

[19] See, for example, Donna Haraway, 'Situated knowledges: the science question in feminism and the privilege of partial knowledge', *Feminist Studies*, vol. 14, no. 3 (Fall 1988) pp. 575–603; and Elspeth Probyn, 'Travels in the postmodern: making sense of the local', in Linda Nicholson (ed.) *Feminism/Postmodernism* (London: Routledge, 1990) p. 178.

[20] See, for example, Susan Stanford Friedman, *Mappings: Feminism and the Cultural Geographies of Encounter* (Princeton: Princeton University Press, 1998); Fuss, *Identification Papers*; Elizabeth Grosz, *Volatile Bodies: Towards a Corporeal Feminism* (Indianapolis: Indiana University Press, 1994); Irit Rogoff, *Terra Infirma: Geography's Visual Culture* (London: Routledge, 2000); and Silverman, *Threshold of the Visible World*.

[21] Rosi Braidotti, *Nomadic Subjects* (New York: Columbia University Press, 1994) p. 1.

[22] Braidotti, *Nomadic Subjects*, pp. 5–7.

[23] Janet Cardiff, *The Missing Voice (Case Study B)* (London: Artangel, 1999).

Chapter 1: Collaboration

[1] Gablik, 'Connective aesthetics', p. 84.

[2] http://www.thepublic.com/building-willalsop.asp (accessed 16 December 2005).

[3] Leaflet: Jubilee Arts c/PLEX Project: Project Information December 2001.

[4] Leaflet: Jubilee Arts c/PLEX Project: Architecture.

[5] Leaflet: Jubilee Arts c/PLEX Project: Jubilee Arts – a brief history.

[6] http://www.thepublic.com/building-willalsop.asp (accessed 16 December 2005).

[7] Will Alsop, 'Creative interrogation should flourish in the AF's next decade', *The Architects' Journal*, 22 November 2001, p. 20.

[8] Alsop, 'Creative interrogation should flourish in the AF's next decade', p. 20.

[9] Will Alsop, 'Departments without walls', *Blueprint*, June 2001, pp. 38–43, p. 41.

[10] Alsop, 'Departments without walls', p. 41.

[11] Hawkins\Brown, *&\Also* (London: Black Dog, 2003) pp. 74–91.

[12] The 'Art for Architecture Award Scheme', at the Royal Society of Arts (RSA) London, ran for 13 years and in that time awarded almost one million pounds in grants for 160 artists to work with architects on 135 projects across the UK. See http://www.rsa.org.uk/afanew/home/index/index.htm (accessed 27 July 2005).

[13] See Jane Rendell, 'Architecture as the traces of the relationships people make with one another', in Hawkins\Brown, *&\Also*, pp. 30–9.

[14] Jes Fernie, outgoing director of RSA Art for Architecture, http://www.rsa.org.uk/afanew/home/index/index.htm (accessed 19 October 2005).

[15] muf, *This is What we Do: A muf Manual* (London: Ellipsis, 2001) p. 25.

[16] muf, *This is What we Do*, p. 92.

[17] muf, *This is What we Do*, p. 92.

[18] muf, *This is What we Do*, p. 34.

[19] Katherine Clarke of muf (1999) 'How to: a description of what it takes to make a relationship to make a thing', in Rendell, 'A Place Between', pp. 42–3.

[20] muf, *This is What we Do*, p. 151.

Chapter 2: Social Sculpture

[1] Joseph Beuys, 'I am searching for a field character' (completed in 1974 and translated by Caroline Tisdall), in Charles Harrison and Paul Wood (eds) *Art in Theory 1900–1990: An Anthology of Changing Ideas* (Oxford: Blackwell, 1992) p. 903. This article was originally published in the exhibition catalogue *Art into Society, Society into Art* (London: Institute of Contemporary Art, 1974).

[2] Joseph Beuys (1970) quoted by Peter Schata, 'Social sculpture (soziale plastik) every human being is an artist', in Shelley Sacks (ed.) *Social Sculpture Colloquium: A Collaboration 9–12 November 1995* (Oxford Brookes University and the Goethe-Institut, Glasgow, in collaboration with The Free International University, 1995) pp. 11–12.

[3] Shelley Sacks, 'A gift from Joseph Beuys', in Sacks, *Social Sculpture Colloquium*, p. 106.

[4] Joseph Beuys, 'Not just a few are called, but everyone' (completed in 1972), in Charles Harrison and Paul Wood (eds) *Art in Theory 1900–1990: An Anthology of Changing Ideas* (Oxford: Blackwell, 1992) p. 890. Interview with Georg Jappe (translated by John Wheelwright) originally published in *Studio International* vol. 184, no. 950 (December 1972) pp. 226–8.

[5] Victor Toso, 'Joseph Beuys as spritual scientist', in *Joseph Beuys: Multiples* (Walker Art Centre, September 1998).

[6] According to Beuys, two traumatic events had a great affect on him. The first was his near death in a wartime air crash. He was found and cared for by nomads in the Crimea who wrapped his frozen body in animal fat and felt. The second was his realization while recovering on a friend's farm in a cow barn, that in drawing comfort from the smell of the cow's breath, manure, milk and straw, he was connected to a material world from which he felt the war had separated him.

[7] Shelley Sacks, 'A banana is not an easy thing', *Exchange Values: Images of Invisible Lives* (The New Arts Symposium, 1996) pp. 4–8. A 'social sculpture' project by Shelley Sacks in association with the Free International University Social Sculpture Forum and St Lucian banana producers and representative organizations of Windward Islands banana producers.

[8] Jane Rendell with Pamela Wells, 'The place of prepositions: a place inhabited by angels', in Jonathan Hill (ed.) *Architecture: The Subject is Matter* (London: Routledge, 2001) pp. 144–5.

[9] Rendell with Wells, 'The place of prepositions', pp. 130–58.

[10] See for example, Patricia C. Phillips, 'Maintenance activity: creating a climate for change', in Nina Felshin (ed.) *But is it Art: The Spirit of Art as Activism* (Seattle: Bay Press, 1995) pp. 180–1.

[11] Phillips, *But is it Art*, p. 178.

[12] Jeff Kelley, 'The body politics of Suzanne Lacy', in Nina Felshin (ed.) *But is it Art: The Spirit of Art as Activism* (Seattle: Bay Press, 1995) p. 326.

[13] Peter Collymore, *The Architecture of Ralph Erskine* (London: Granada, 1982) p. 12.

[14] See, for example, the Medical Faculty, Woluwé-Saint Lambert, La Mémé, Brussels, in Lucien Kroll, *Lucien Kroll: Buildings and Projects* (London: Thames & Hudson, 1988). This building complex is also known as the paramedical Faculty Buildings Complex, Catholic University of Louvain 1969–77. See also Lucien Kroll, *The Architecture of Complexity* (London: BT Batsford Ltd, 1986).

[15] See http://www.city.kobe.jp/cityoffice/15/020/quake/saiken/uk/chapter1.html (accessed 15 November 2005).

[16] Shigeru Ban, *GG Portfolio* (Barcelona, Editorial Gustavo Gili, 1997) pp. 44–5; and Shigeru Ban, *Shigeru Ban* (London: Laurence King, 2001) pp. 106–9.

[17] Jonathan Hill (ed.) *Occupying Architecture* (London: Routledge, 1998).

[18] For recent discussions of such practice see, for example, Malcolm Miles, *Urban Avant-Gardes: Art, Architecture and Change* (London: Routledge, 2004) pp. 187–191 and also Jeremy Till, Peter Blundell Jones and Doina Petrescu (eds), *Architecture and Participation*, (London: Routledge, 2005).

[19] Andreas Lang and Kathrin Böhm, *Park Products* (London: Serpentine Gallery, 2004).

[20] For the full version of this essay, see Jane Rendell, 'Letting Go', in Lang and Böhm, *Park Products* (London: Serpentine Gallery, 2004).

Chapter 3: Walking

[1] Braidotti, *Nomadic Subjects*, p. 4.

[2] PLATFORM's core members are Jane Trowell, Dan Gretton and James Marriott. Current projects include 'Killing Us Softly', '100% Crude' and 'Still Waters'. See http://www.platformlondon.org/kus.htm (accessed 14 March 2006).

[3] Aidan Andrew Dunn, *Vale Royal* (Uppingham: Goldmark, 1995).

[4] See Jane Rendell, 'Imagination is the root of all change', in Lucy Blakstad, *Bridge: The Architecture of Connection* (London: August Birkhauser, 2001) pp. 30–7.

[5] See for example, Neil Cummings and Marysia Lewandowska, *Errata* (Louisiana Museum of Modern Art, Denmark (1996); Neil Cummings and Marysia Lewandowska, *The Value of Things* (London, Tate Gallery Publishing, 2000); and Neil Cummings and Marysia Lewandowska, *Capital: Gift* (London, Tate Gallery Publishing, 2001). See also www.chanceprojects.com (accessed 14 March 2006).

[6] Tim Brennan, *Prospectus: A Manoeuvre* (Norbury Park: Art and Landscape Project, 1999). See also John Gange (ed.) *Monograph: Tim Brennan* (York, 2002); and Dave Beech, 'Tim Brennan: the A–Z of nowhere', *Art Monthly*, March 2003, pp. 18–9.

[7] Tim Brennan, *Guidebook: Three Manoeuvres by Tim Brennan in London E1/E2* (London: Camerawork, 1999).

[8] Brennan, *Guidebook*, p. 8.

[9] Cardiff, *The Missing Voice*. See also van Noord, *Off Limits*, pp. 114–17; Tony Godfrey, 'Walks with Mnemosyne: recent Artangel Projects', *Contemporary Visual Arts*, Issue 25,

(1999) pp. 40–5; and David Pinder, 'Ghostly footsteps: voices, memories and walks in the city', *Ecumene: Journal of Cultural Geographies*, vol. 8, no. 1 (2001) pp. 1–19.

[10] See for example Rebecca Solnit, *Wanderlust: A History of Walking* (London: Verso, 2001).

[11] Raymund Ryan, 'Catwalk architecture', *Blueprint*, June 1999, pp. 30–4.

[12] Grosz, *Volatile Bodies*, pp. 34–5, 209–10.

[13] Grosz, *Volatile Bodies*, pp. 209–10.

[14] Ryan, 'Catwalk architecture', p. 32.

[15] Lorenzo Romito, 'Stalker', in Peter Lang and Tam Miller (eds) *Suburban Discipline* (New York: Princeton Architectural Press, 1997) pp. 128–41.

[16] Braidotti, *Nomadic Subjects*, pp. 5–7.

[17] Braidotti, *Nomadic Subjects*, pp. 4–5.

Conclusion: Criticism as Critical Spatial Practice

[1] Joan Ockman (ed.) *Architecture, Criticism, Ideology* (Princeton: Princeton Architectural Press, 1995) pp. 10–11.

[2] Michael Newman and John Bird (eds) *Rewriting Conceptual Art* (London: Reaktion Books, 1999) p. 2.

[3] Jane Rendell, *The Pursuit of Pleasure: Gender, Space and Architecture in Regency London* (London: Athlone Press, 2002).

[4] Elsewhere I have called this form of criticism – criticism as critical spatial practice – 'architecture-writing' and 'site-writing'. See, for example, Jane Rendell, 'Architecture-writing', in Jane Rendell (ed.) 'Critical Architecture', Special Issue of *The Journal of Architecture*, vol. 10, no. 3 (June 2005) pp. 255–64; and Jane Rendell, 'Site-writing', in Sharon Kivland, Jaspar Joseph-Lester and Emma Cocker (eds) *Transmission: Speaking and Listening*, vol. 4 (Sheffield: Sheffield Hallam University, 2005) pp. 180–94.

Bibliography

Adams, Paul C., Steven Hoelscher and Karen E. Till (eds) (2001) *Textures of Place: Exploring Humanist Geographies* (Minneapolis: University of Minnesota Press).

Adorno, Theodor W. (1998) *Critical Models: Interventions and Catchwords*, translated by Henry W. Pickford (New York: Routledge).

Alsop, Will (2001) ' Departments without walls', *Blueprint*, June, pp. 38–43.

Alsop, Will (2001) ' Creative interrogation should flourish in the AF's next decade', *The Architects' Journal*, 22 November, p. 20.

Antin, David (1966) 'Art and Information, 1, Grey Paint, Robert Morris' *Art News*, 65, no. 2 (April) pp. 24–6.

Archer, Michael, Nicolas de Oliveira, Nicola Oxley and Michael Petri (1994) *Installation Art* (London: Thames & Hudson).

As It Is (2000) off-site exhibition catalogue by Ikon Gallery, Birmingham.

Augé, Marc (1995) *Non-Places: Introduction to an Anthropology of Supermodernity*, translated by John Howe (London: Verso).

Bachelard, Gaston (1969) *The Poetics of Space*, translated by Maria Jolas (Boston: Beacon Press, first published 1958).

Bal, Mieke and Inge E. Boer (eds) (1994) *The Point of Theory: Practices of Cultural Analysis* (New York: Continuum).

Ban, Shigeru (1997) *GG Portfolio* (Barcelona, Editorial Gustavo Gili).

Ban, Shigeru (2001) *Shigeru Ban* (London: Laurence King).

Barley, Nick (ed.) (1999) *Leaving Tracks: Artranspennine98, an International Contemporary Visual Art Exhibition Recorded* (London: August Media with Art Transpennine).

Bashi, Tatsurou (2002) catalogue for *Tatsurou Bashi alias Taxro Niscino* (Wolfsburg).

Beadsmoore, Emma, Duncan Garrow and Mark Knight (2005) 'Neolithic spaces and the material temporality of occupation', paper presented at *Connected Space* conference, McDonald Institute, Cambridge, 14–15 May.

Beech, Dave (2001) review of Michael Landy, 'Breakdown', *Art Monthly*, March, pp. 30–1.

Beech, Dave (2001) review of Jeremy Deller, 'The Battle of Orgreave', *Art Monthly*, July/August, pp. 38–9.

Beech, Dave (2003) 'Tim Brennan: the A–Z of nowhere', *Art Monthly*, March, pp. 18–9.

Benjamin, Jessica (1998) *Shadow of the Other: Intersubjectivity and Gender in Psychoanalysis* (London: Routledge).

Benjamin, Walter (1977) *The Origin of German Tragic Drama*, translated by John Osborne (London: Verso, first published 1925).

Benjamin, Walter (1992) 'The work of art in the age of mechanical reproduction' (completed in 1936 and translated by Harry Zohn), in Hannah Arendt (ed.) *Illuminations* (London: Fontana) pp. 211–44.

Benjamin, Walter (1992) 'Theses on the philosophy of history' (completed in 1940 and translated by Harry Zohn), in Hannah Arendt (ed.) *Illuminations* (London: Fontana) pp. 245–55.

Benjamin, Walter (1997) 'Paris: the capital of the nineteenth century' (completed in 1935 and translated by Quintin Hoare), in *Charles Baudelaire: A Lyric Poet in the Era of High Capitalism*, translated by Harry Zohn (London: New Left Books) pp. 155–76.

Benjamin, Walter (1999) *The Arcades Project (1927–39)* translated by Howard Eiland and Kevin McLaughlin (Cambridge, MA: Harvard University Press).

Benjamin, Walter (2004) 'Naples' (first published in 1925 and translated by Edmund Jephcott), in Marcus Bullock and Michael W. Jennings (eds) *Walter Benjamin: Selected Writings vol. 1, 1913–26* (Cambridge MA: Harvard University Press) pp. 414–21.

Benjamin, Walter (2004) 'One-Way Street' (first published in 1928 and translated by Edmund Jephcott), in Marcus Bullock and Michael W. Jennings (eds) *Walter Benjamin: Selected Writings vol. 1, 1913–26* (Cambridge, MA: Harvard University Press) pp. 444–88.

Bennett, Sarah and John Butler (eds) (2000) *Locality, Regeneration and Divers(c)ities* (Bristol: Intellectual Books).

Benveniste, Emile (1971) *Problems in General Linguistics* [1966], translated by Mark Elizabeth Meek (Coral Gables: University of Miami Press).

Berrizbeitia, Anita and Linda Pollak (1999) *Inside Outside: Between Architecture and Landscape* (Gloucester, MA: Rockport Publishers).

Betsky, Aaron (2003) 'Swiss cheese: disappearing down the holes of modernism with Décosterd & Rahm', in Urs Staub (ed.) *Décosterd & Rahm: Physiological Architecture* (Basel: Birkhäuser) pp. 50–5.

Beuys, Joseph (1992) 'Not just a few are called, but everyone' (completed in 1972), in Charles Harrison and Paul Wood (eds) *Art in Theory 1900–1990: An Anthology of Changing Ideas* (Oxford: Blackwell) pp. 890–2.

Beuys, Joseph (1992) 'I am searching for a field character' (completed in 1974 and translated by Caroline Tisdall), in Charles Harrison and Paul Wood (eds) *Art in Theory 1900–1990: An Anthology of Changing Ideas* (Oxford: Blackwell) pp. 902–4.

Bhabha, Homi K. (1994) *The Location of Culture* (London: Routledge).

Bloomer, Jennifer (1993) *Architecture and the Text: The (S)crypts of Joyce and Piranesi* (New Haven: Yale University Press).

Boettger, Suzaan (2002) *Earthworks: Art and the Landscape of the Sixties* (Los Angeles: University of California Press).

Bond, Henry (1994) *Deep Dark Water* (London: Public Art Development Trust).

Borden, Iain and Jane Rendell (eds) (2000) *InterSections: Architectural History and Critical Theory* (London: Routledge).

Borden, Iain, Joe Kerr, Jane Rendell and Alicia Pivaro (eds) (1996) *Strangely Familiar: Narratives of Architecture in the City* (London: Routledge).

Borden, Iain, Joe Kerr and Jane Rendell (eds) with Alicia Pivaro (2001) *The Unknown City: Contesting Architecture and Social Space* (Cambridge, MA: The MIT Press).

Bourdon, David (1995) 'The razed sites of Carl Andre', in Gregory Battcock (ed.) *Minimalism: A Critical Anthology* (Berkeley/Los Angeles: University of California Press) pp. 103–8.

Bourriaud, Nicholas (2002) *Relational Aesthetics*, translated by Simon Pleasance and Fronza Woods (Dijon: Presses du réel).

Braidotti, Rosi (1994) *Nomadic Subjects* (New York: Columbia University Press).

Brennan, Tim (1999) *Guidebook: Three Manoeuvres by Tim Brennan in London E1/E2* (London: Camerawork).

Brennan, Tim (1999) *Prospectus: A Manoeuvre* (Norbury Park: Art and Landscape Project).

British Council (1997) *Rachel Whiteread: British Pavilion XLVII Venice Bienalle 1997* (London: British Council).

Bryson, Norman (2001) 'Introduction: art and intersubjectivity', in Mieke Bal (ed.) *Looking In: The Art of Viewing* (Amsterdam: G & B Arts International) pp. 1–39.

Buchanan, Ian (2000) *Deleuzism: A Metacommentary* (Edinburgh: Edinburgh University Press).

Buchloh, Benjamin H. D. (ed.) (1984) *Michael Asher, Writings 1973–1983 on Works 1969–1979* (Novia Scotia College of Art and Design and Museum of Contemporary Art Los Angeles).

Buchloh, Benjamin H. D. (1990) 'Conceptual art 1962–1969: from the aesthetic of administration to the critique of institutions', *October* Winter, pp. 514–37.

Buck-Morss, Susan (1977) *The Origin of Negative Dialectics: Theodor W. Adorno, Walter Benjamin, and the Frankfurt Institute* (Hassocks: Harvester).

Buck-Morss, Susan (1991) *The Dialectics of Seeing: Walter Benjamin and the Arcades Project* (Cambridge, MA: MIT Press).

Bürger, Peter (1984) *Theory of the Avant-Garde* (Minneapolis: University of Minnesota Press).

Burgin, Victor (1982) 'Photographic practice and art theory', in Victor Burgin (ed.) *Thinking Photography* (London: Macmillan) pp. 39–83.

Burgin, Victor (1986) *Between* (Oxford: Blackwell).

Burgin, Victor (1986) *The End of Art Theory: Criticism and Postmodernity* (Basingstoke: Macmillan).

Burgin, Victor (1999) 'Art, common sense and photography', in Jessica Evans and Stuart Hall (eds) *Visual Culture: The Reader* (London: Sage) pp. 41–50.

Burki, Marie José (2002) *Time After, Time Along, The River* (Paris: Galerie Nelson).

Butler, Judith (2004) *Precarious Life: The Powers of Mourning and Violence* (London: Verso).

Calle, Sophie (2002) *Appointment: Sophie Calle and Sigmund Freud* (London: Violette Editions).

Cardiff, Janet (1999) *The Missing Voice (Case Study B)* (London: Artangel).

Carter, Paul (2001) 'Arcadian writing: two text into landscape proposals', *Studies in the History of Gardens and Designed Landscapes*, vol. 21, no. 2 (April–June) pp. 137–47.

Caygill, Howard (1998) *The Colour of Experience* (London: Routledge).

Celant, Germano (1997) *Dennis Oppenheim* (Milan: Charta).

Celant, Germano (2001) *Dennis Oppenheim: Explorations* (Milan: Charta) pp. 9–27.

Chodzko, Adam (2000) 'Out of place', in John Carson and Susannah Silver (eds) *Out of the Bubble: Approaches to Contextual Practice within Fine Art Education* (London: London Institute) pp. 31–6.

Chodzko, Adam (2002) *Plans and Spells* (London: Film & Video Umbrella).

Chung, Chuihua Judy, Jeffrey Inaba, Rem Koolhaas and Sze Tsung Leong (eds) (2001) *Harvard Design School Guide to Shopping* (Cologne: Taschen).

Clarke, Katherine of muf (1999) 'How to: a description of what it takes to make a relationship to make a thing', in Jane Rendell (ed.) 'A Place Between', Special Issue of *Public Art Journal*, October, pp. 42–3.

Clifford, James (2000) 'An ethnographer in the field', interview by Alex Coles, in Alex Coles (ed.) *Site Specificity: The Ethnographic Turn* (London: Black Dog Publishing) pp. 52–73.

Coles, Alex (ed.) (2000) *Site Specificity: The Ethnographic Turn* (London: Black Dog Publishing).

Coles, Alex (2005) *DesignArt* (London: Tate Publishing).

Coles, Alex and Alexia Defert (eds) (1998) *The Anxiety of Interdisciplinarity, De-, Dis-, Ex-*, vol. 2 (London: Black Dog Publishing).

Collymore, Peter (1982) *The Architecture of Ralph Erskine* (London: Granada).

Cornford & Cross (2001) 'Live adventures', in Iain Borden, Joe Kerr and Jane Rendell (eds) with Alicia Pivaro, *The Unknown City: Contesting Architecture and Social Space* (Cambridge, MA: The MIT Press, pp. 328–39.

Cornford & Cross (2002) 'Where is the work?' in Sharon Kivland, Jaspar Joseph-Lester and Emma Cocker (eds) *Transmission: Speaking and Listening*, vol. 4 (Sheffield: Sheffield Hallam University) pp. 48–55.

Crang, Mike and Nigel Thrift (eds) (2000) *Thinking Space* (London: Routledge).

Cruz, Juan (2001) *Application for a Planning Permit: Proposal to Build a Metaphor* (Melbourne: Melbourne Festival).

Cummings, Neil and Marysia Lewandowska (1996) *Errata* (Louisiana Museum of Modern Art, Denmark).

Cummings, Neil and Marysia Lewandowska (2000) *The Value of Things* (London: Tate Gallery Publishing).

Cummings, Neil and Marysia Lewandowska (2001) *Capital: Gift* (London: Tate Gallery Publishing).

Davey, Peter (2002) 'The slick and the hairy', *Architectural Review*, January, pp. 64–8.

De Certeau, Michel (1988) *The Practice of Everyday Life* (Berkeley: University of California Press).

De Certeau, Michel, Luce Giard and Pierre Mayol (1998) *The Practice of Everyday Life*, vol 2, *Living and Cooking*, translated by Timothy J. Tomasik (Minneapolis: University of Minnesota Press).

Deleuze, Gilles and Felix Guattari (1988) *A Thousand Plateaus: Capitalism and Schizophrenia* (London: Athlone Press).

Deller, Jeremy (2002) *The Battle of Orgreave* (London: Artangel).

Derrida, Jacques (1976) *Of Grammatology*, translated by Gayatri Chakravorty Spivak (Baltimore: Johns Hopkins University Press, first published 1967).

Derrida, Jacques (1981) *Dissemination*, translated by Barbara Johnson (London: Athlone Press, first published 1972).

Derrida, Jacques (1988) 'Point de folie: maintenant l'architecture', *Forum*, 'May' pp. 11–25.

Deutsche, Rosalyn (1990) 'Men in space', *Strategies*, no. 3, pp. 130–7.

Deutsche, Rosalyn (1991) 'Boys town', *Environment and Planning D: Society and Space*, vol. 9, pp. 5–30.

Deutsche, Rosalyn (1991) 'Alternative space', in Brian Wallis (ed.) *If You Lived Here: The City in Art, Theory and Social Activism – A Project by Martha Rosler* (Seattle) pp. 45–66.

Deutsche, Rosalyn (1996) *Evictions: Art and Spatial Politics* (Cambridge, MA: MIT Press).

Doherty, Claire (ed.) (1998) *Out of Here: Creative Collaborations beyond the Gallery* (Birmingham: Ikon Gallery).

Dovey, Kim with Iain Woodcock (2003) 'Insinuations', lecture at the Bartlett School of Architecture, UCL, London, October.

Dunn, Aidan Andrew (1995) *Vale Royal* (Uppingham: Goldmark).

Dysart, Dinah (ed.) (2000) *Edge of the Trees: A Sculptural Installation by Janet Laurence and Fiona Foley* (Sydney: Historic Houses Trust of New South Wales).

Elam, Diane (1994) *Feminism and Deconstruction: Ms. En Abyme* (London: Routledge).

Emin, Tracey (1998) interviewed by Mark Gisbourne, 'Life into Art', *Contemporary Visual Arts*, issue 20, pp. 28–34.

Evans, Jessica and Stuart Hall (eds) (1999) *Visual Culture: The Reader* (London: Sage).

FAT (1999) 'Art attack!', in Jane Rendell (ed.) 'A Place Between', Special Issue of *Public Art Journal*, October, pp. 36–8.

FAT (2001) 'Projects and tactics', in Iain Borden, Joe Kerr and Jane Rendell (eds) with Alicia Pivaro, *The Unknown City: Contesting Architecture and Social Space* (Cambridge, MA: The MIT Press) pp. 340–55.

Felshin, Nina (ed.) (1995) *But is it Art? The Spirit of Art as Activism* (Seattle: Bay Press).

Finkelpearl, Tom (2000) *Dialogues in Public Art* (Cambridge, MA: MIT Press).

Flam, Jack (ed.) (1996) *Robert Smithson: The Collected Writings* (Los Angeles: University of California Press), pp. 177–87.

Foreign Office Architects (2000) 'Yokohama International Port Terminal', *2G International Architecture Review: Foreign Office Architects*, no. 16, pp. 88–105.

Foreign Office Architects (2003) '1996–2003: complexity and consistency', *El Croquis*, 115–16.

Foreign Office Architects (2004) *Phylogenesis: FOA, Foreign Office Architects* (Barcelona: Actar).

Foster, Hal (2001) *The Return of the Real: The Avant-Garde at the End of the Century* (Cambridge, MA: MIT Press).

Foster, Hal (2002) *Design and Crime (and Other Diatribes)* (London: Verso).

Foucault, Michel and Gilles Deleuze (1977) 'Intellectuals and power: a conversation between Michel Foucault and Gilles Deleuze' (1972), in Donald F. Bouchard (ed.) *Language, Counter-memory, Practice: Selected Essays and Interviews* (New York: Ithaca) pp. 205–17.

Fuss, Diane (1995) *Identification Papers* (London: Routledge).

Gablik, Suzi (1991) *The Reenchantment of Art* (London: Thames and Hudson).

Gablik, Suzi (1995) 'Connective aesthetics: art after individualism', in Suzanne Lacy (ed.) *Mapping the Terrain: New Genre Public Art* (Seattle: Bay Press) pp. 74–87.

Gallaccio, Anya (1999) *Anya Gallaccio: Chasing Rainbows* (Glasgow and Newcastle: Tramway/Locus +).

Galofaro, Luca (2003) *Artscapes: Art as an Approach to Contemporary Landscape* (Barcelona: Editorial Gustavo Gili).

Gange, John (ed.) (2002) *Monograph: Tim Brennan* (York).

Geuss, Raymond (1981) *The Idea of Critical Theory: Habermas and the Frankfurt School* (Cambridge: Cambridge University Press).

Godfrey, Tony (1999) 'Walks with Mnemosyne: recent Artangel Projects', *Contemporary Visual Arts*, Issue 25, pp. 40–5.

Graham, Dan (1988) *Pavilions* (Munich: Kunstverein München).

Groener, Fernando and Rose-Maria Kandler (eds) (1987) *7000 Eichen: Joseph Beuys* (Cologne: Walter König).

Grosz, Elizabeth (1989) *Sexual Subversions* (London: Taylor & Francis).

Grosz, Elizabeth (1994) *Volatile Bodies: Towards a Corporeal Feminism* (Indianapolis: Indiana University Press).

Haacke, Hans (1984) 'Museums: managers of consciousness', in *Hans Haacke*, vol. 2 (London: Tate Gallery and Eindhoven: Van Abbemuseum) pp. 105–9.

Haraway, Donna (1988) 'Situated knowledges: the science question in feminism and the privilege of partial knowledge', *Feminist Studies,* vol. 14, no. 3 (Fall) pp. 575–603.

Harding, David (ed.) (1997) *Decadent: Public Art – Contentious Term and Contested Practice* (Glasgow: Glasgow School of Art).

Harvey, David (1989) *The Condition of Postmodernity* (Oxford: Blackwell).

Hawkins\Brown (2003) *&\Also* (London: Black Dog Publishing).

Hays, Michael K. (ed.) (2000) *Architecture Theory since 1968* (Cambridge, MA: MIT Press).

Heiss, Alanna and Thomas McEvilley (1992) *Dennis Oppenheim, Selected Work 1967–90: And the Mind Grew Fingers* (New York: Harry N. Abrams Inc.).

Henry, Rex (1999) 'Between image and construction', in Jane Rendell (ed.) 'A Place Between', Special Issue of *Public Art Journal*, October, pp. 12–14.

Hill, Jonathan (1998) *The Illegal Architect* (London: Black Dog Publishing).

Hill, Jonathan (ed.) (1998) *Occupying Architecture* (London: Routledge).

Hill, Jonathan (ed.) (2001) *Architecture: The Subject is Matter* (London: Routledge).

Hill, Jonathan (2003) *Actions of Architecture: Architects and Creative Users* (London: Routledge).

Hiller, Susan (1995) *After the Freud Museum* (London: Bookworks).

Hirschhorn, Thomas, Anthony Spira and Craig Martin (eds) (2000) *Material: Public Works – The Bridge 2000* (London: Whitechapel Art Gallery).

Horn, Roni (2000) *Another Water (The River Thames, for Example)* (New York: Scalo Publishers).

Hubbard, Sue (1999) 'Between poem and writing', in Jane Rendell (ed.) 'A Place Between', Special Issue of *Public Art Journal*, October, pp. 18–19.

Hubbard, Sue (2004) *Ghost Station* (Great Wilbraham, Cambridge: Salt Publishing).

Irigaray, Luce (1996) *I Love To You: Sketch of a possible felicity in history* translated by Alison Martin (London: Routledge).

Irigaray, Luce (2000) *To Be Two* translated by Monique M.Rhodes and Marco F.Cocito-Mouoc (London: Athlone Press).

Ito, Toyo (2000) 'Yokohama International Port Terminal', in *Foreign Office Architects: 2G International Architecture Review*, no. 16, pp. 84–7.

Jameson, Fredric (1971) *Marxism and Form: Twentieth-Century Dialectical Theories of Literature* (Princeton: Princeton University Press).

Jameson, Fredric (1987) 'Foreword', in Algirdas Julien Greimas, *On Meaning: Selected Writings on Semiotic Theory*, translated by Paul J. Perron and Frank H. Collin (Minneapolis: University of Minnesota Press) pp. xiv–vi.

Jameson, Fredric (1995) 'Is space political?' in Cynthia C. Davidson (ed.) *Any Place* (Cambridge, MA: MIT Press) pp. 192–205.

Jones, Rhys (1985) 'Ordering the landscape', in Ian Donaldson and Tamsin Donaldson (eds) *Seeing the First Australians* (Sydney: Allen & Unwin).

Kawamata, Tadashi (1998) *Field Work* (Ostfildern: Reihe Cantz).

Kaye, Nick (2000) *Site-Specific Art: Performance, Place and Documentation* (London: Routledge).

Kearney, Richard (2002) 'Levinas and the ethics of imagining', in Dorota Glowacka and Stephen Boos (eds) *Between Ethics and Aesthetics: Crossing the Boundaries* (Albany: State University of New York Press) pp. 85–96.

Keith, Michael and Steve Pile (eds) (1993) *Place and the Politics of Identity* (London: Routledge).

Kelley, Jeff (1995) 'The body politics of Suzanne Lacy', in Nina Felshin (ed.) *But is it Art: The Spirit of Art as Activism* (Seattle: Bay Press) pp. 221–49.

Kester, Grant H. (2004) *Conversation Pieces: Community and Communication in Modern Art* (Berkeley: University of California Press).

Kovats, Tania in collaboration with Levitt Bernstein Associates, New Ikon Gallery, Birmingham (1997) *Frontiers: Artists and Architects, Architectural Design* (London) no. 128.

Krauss, Rosalind (1985) 'Sculpture in the expanded field', in Hal Foster (ed.) *Postmodern Culture* (London: Pluto Press) pp. 31–42.

Kristeva, Julia (1998) 'Institutional interdisciplinarity in theory and practice: an interview', in Alex Coles and Alexia Defert (eds) *The Anxiety of Interdisciplinarity, De-, Dis-, Ex-*, vol. 2 (London: Black Dog Publishing) pp. 3–21.

Kroll, Lucien (1986) *The Architecture of Complexity* (London: BT Batsford Ltd).

Kroll, Lucien (1988) *Lucien Kroll: Buildings and Projects* (London: Thames & Hudson).

Kwon, Miwon (2002) *One Place After Another: Site Specific Art and Locational Identity* (Cambridge, MA: MIT Press).

Kwon, Miwon (ed.) (2002) *Watershed* (Journal no. 1) *The Hudson Valley Art Project* (New York: Minetta Brook).

Lamoureux, Johanne (1995) 'Architecture recharged by art', in Cynthia C. Davidson (ed.) *Anyplace* (Cambridge, MA: MIT Press) pp. 124–40.

Lacaton & Vassal (2001) *International Architecture Review, Lacation & Vassal: 2G* (Barcelona) no. 21.

Laclau, Ernesto and Chantal Mouffe (1985) *Hegemony and Socialist Strategy: Toward a Radical Democratic Politics*, translated by Winston Mooore and Paul Cammack (London: Verso).

Lacy, Suzanne (ed.) (1995) *Mapping the Terrain: New Genre Public Art* (Seattle: Bay Press).

Landy, Michael (2001) *Breakdown* (London: Artangel).

Lang, Andreas and Kathrin Böhm (2004) *Park Products* (London: Serpentine Gallery).

Leach, Neil (ed.) (1997) *Rethinking Architecture* (London: Routledge).

Leach, Neil (1999) 'Architecture or revolution?' in Neil Leach (ed.) *Architecture and Revolution* (London: Routledge) pp. 112–23.

Lefebvre, Henri (1991) *The Production of Space* (Oxford: Basil Blackwell).

Libeskind, Daniel (1999) *Jewish Museum* (Berlin).

Lin, Maya (1998) 'Round table discussion', in Richard Roth and Susan Roth King (eds) *Beauty is Nowhere: Ethical Issues in Art and Design* (Amsterdam: G+B Arts International).

Lingwood, James (ed.) (1995) *Rachel Whiteread: House* (London: Phaidon Press).

Lootsma, Bart (2001) 'Architecture in the second modernity', in Frédéric Migayrou and Marie-Ange Brayer (eds) *Archilab: Radical Experiments in Global Architecture* (London: Thames & Hudson) pp. 23–7.

Luxemburg, Rut Blees (1997) *London: A Modern Project* (London: Black Dog Publishing).

McDowell, Linda (1993) 'Space, place and gender relations', *Progress in Human Geography*, Part 1 in vol. 17, no. 2, pp. 157–79, and Part 2 in vol. 17, no. 3, pp. 305–18.

McGillick, Paul (1999–2000) 'The art of Janet Laurence', *Monument*, December/January, pp. 73–5.

McHale, Brian (1994) 'What ever happened to descriptive poetics?' in Mieke Bal and Inge E. Boer (eds) *The Point of Theory: Practices of Cultural Analysis* (New York: Continuum) pp. 56–65.

Mackenzie, Andrew (2002) 'Blasted geometry', *Contemporary*, April, pp. 58–63.

Massey, Doreen (1991) 'Flexible Sexism', *Environment and Planning D: Society and Space*, vol. 9, pp. 31–57.

Massey, Doreen (1994) *Space, Place and Gender* (Cambridge: Polity Press).

Meskimmon, Marsha (2003) *Women Making Art: History, Subjectivity, Aesthetics* (London: Routledge).

Miles, Malcolm (1997) *Art, Space and the City* (London: Routledge).

Miles, Malcolm (2004) *Urban Avant-Gardes: Art, Architecture and Change*, (London: Routledge).

Moos, David and Gail Trechsel (eds) (2003) *Samuel Mockbee and the Rural Studio: Community Architecture* (Birmingham, AL: Birmingham Museum of Art).

Morris, Robert (1992) 'Earthworks: land reclamation as sculpture', in Harriet F. Senie and Sally Webster (eds) *Critical Issues in Public Art: Content, Context and Controversy* (New York: Harper Collins) pp. 250–60.

Morris, Robert (1992) 'Notes on sculpture 1–3', in Charles Harrison and Paul Wood (eds) *Art in Theory 1900–1990: An Anthology of Changing Ideas* (Oxford: Blackwell) pp. 813–22.

Mouffe, Chantal (1993) *The Return of the Political* (London: Verso).

muf (2001) *This is What we Do: A muf Manual* (London: Ellipsis).

MVRDV (1999) *Meta City Data Town* (Rotterdam: 010 Publishers).

Neri, Louise (ed.) (2000) *Looking Up: Rachel Whiteread's Water Tower* (New York: Scalo).

Nesbitt, Kate (ed.) (1996) *Theorizing a New Agenda for Architecture: An Anthology of Architectural Theory 1965–1995* (New York: Princeton Architectural Press).

Newman, Michael and John Bird (eds) (1999) *Rewriting Conceptual Art* (London: Reaktion Books).

Norberg-Schulz, Christian (1980) *Genius Loci: Towards a Phenomenology of Architecture* (New York: Rizzoli).

Noord, Gerrie van (ed.) (2002) *Off Limits: 40 Artangel Projects* (London: Artangel).

Norris, Christopher (1991) *Deconstruction: Theory and Practice* (London: Routledge).

Ockman, Joan (ed.) (1995) *Architecture, Criticism, Ideology* (Princeton: Princeton Architectural Press).

O'Doherty, Brian (1986) *Inside the White Cube: The Ideology of the Gallery Space*, expanded edition (San Francisco: Lapis Press).

OMA, Rem Koolhaas (1978) *Delirious New York* (New York: The Monacelli Press).

OMA, Rem Koolhaas and Bruce Mau (1995) *S, M, L, XL* (New York: Monacelli Press).

Osbourne, Peter (1999) 'Conceptual art and/as philosophy', in Michael Newman and John Bird (eds) *Rewriting Conceptual Art* (London: Reaktion Books) pp. 47–65.

Owens, Craig (1980) 'The allegorical impulse: toward a theory of postmodern', *October*, no. 12 (Spring) pp. 67–84 and no. 13 (Summer) pp. 59–80.

PADT (2000) *Documentary Notes: Henry Bond and Angela Bulloch* (London: Public Art Development Trust).

Park Products (2004) *Park Products: A Serpentine Gallery Special Education Project*, artists' residency throughout 2004 (London: Serpentine Gallery).

Pensky, Max (1993) *Melancholy Dialectics: Walter Benjamin and the Play of Mourning* (Amherst: University of Massachusetts Press).

Petrucci, Mario (1996) *Shrapnel and Sheets* (Liverpool: Headland).

Petrucci, Mario (1999) 'Anaesthesia or synaesthesia: between artefact and poem', in Jane Rendell (ed.) 'A Place Between', Special Issue of *Public Art Journal*, October, pp. 15–17.

Phillips, Patricia C. (1992) 'Temporality and public art', in Harriet F. Senie and Sally Webster (eds) *Critical Issues in Public Art, Content, Context and Controversy* (New York: Harper Collins) pp. 295–304.

Phillips, Patricia C. (1995) 'Maintenance activity: creating a climate for change', in Nina Felshin (ed.) *But is it Art: The Spirit of Art as Activism* (Seattle: Bay Press) pp. 165–93.

Pijaudier, Joelle (1992) *Victor Burgin: Passages*, translated by Anne Ortiz-Talvaz (Lille, Villeneuve d'Ascq, Ville de Blois: Musée d'Art Moderne).

Pile, Steve (1999) 'Between city and dream', in Jane Rendell (ed.) 'A Place Between', Special Issue of *Public Art Journal*, October, pp. 10–11.

Pinder, David (2001) 'Ghostly footsteps: voices, memories and walks in the city', *Ecumene: Journal of Cultural Geographies*, vol. 8, no. 1, pp. 1–19.

Prince, Nigel and Gavin Wade (eds) (2000) *In the Midst of Things* (London: August Media).

Probyn, Elspeth (1990) 'Travels in the postmodern: making sense of the local', in Linda Nicholson (ed.) *Feminism/Postmodernism* (London: Routledge) pp. 176–89.

Reiss, Julie H. (1999) *From Margin to Center: The Spaces of Installation Art* (Cambridge MA: MIT Press).

Rendell, Jane (ed.) (1999) 'A Place Between', Special Issue of *Public Art Journal*, October.

Rendell, Jane (1999) 'Thresholds, passages and surfaces: touching, passing and seeing in the Burlington Arcade', in Alex Cole (ed.) *The Optics of Walter Benjamin* (London: Black Dog Press), pp. 168–91.

Rendell, Jane (2000) 'Conductor: a tribute to the angels', catalogue essay (in *Jane Prophet, Conductor*) (London: The Wapping Project).

Rendell, Jane (2000) 'Public art: between public and private', in Sarah Bennett and John Butler (eds) *Locality, Regeneration and Diver[c}ities* (Bristol: Intellect Books), pp. 19–26.

Rendell, Jane (2001) 'Imagination is the root of all change', in Lucy Blakstad, *Bridge: The Architecture of Connection* (London: August Birkhauser) pp. 30–7.

Rendell, Jane (2002) 'Foreword', in Judith Rugg and Dan Hincliffe (eds) *Recoveries and Reclamations* (Bristol: Intellect Books), pp. 7–9.

Rendell, Jane (2002) *The Pursuit of Pleasure: Gender, Space and Architecture in Regency London* (London: Athlone Press).

Rendell, Jane (2003) 'Architecture as the traces of the relationships people make with one another', Hawkins\Brown, *&\Also* (London: Black Dog) pp. 30–9.

Rendell, Jane (2003) 'Between two: theory and practice', in Jonathan Hill (ed.) 'Opposites Attract: Research by Design', Special Issue of *Journal of Architecture*, vol. 8, no. 2 (Summer) pp. 221–38.

Rendell, Jane (2004) 'Letting Go', in Andreas Lang and Kathrin Böhm, *Park Products* (London: Serpentine Gallery).

Rendell, Jane (2005) 'Architecture-writing', in Jane Rendell (ed.) 'Critical Architecture', Special Issue of *The Journal of Architecture*, vol. 10, no. 3 (June) pp. 255–64.

Rendell, Jane (2005) 'Seeing Time/Writing Place', in Janet Hodgson, 'The Pits', (Canterbury: Whitefriars Art Programme), pp. 28-36.

Rendell, Jane (2005) 'Site-writing', in Sharon Kivland, Jaspar Joseph-Lester and Emma Cocker (eds) *Transmission: Speaking and Listening*, vol. 4 (Sheffield: Sheffield Hallam University) pp. 180–94.

Rendell, Jane (forthcoming) 'Space, place, site: critical spatial practice', in Cameron Cartière and Shelly Willis (eds) *RE/Placing Public Art* (Minneapolis: University of Minnesota Press).

Rendell, Jane with Pamela Wells (2001) 'The place of prepositions: a place inhabited by angels', in Jonathan Hill (ed.) *Architecture: The Subject is Matter* (London: Routledge) pp. 130–58.

Rogoff, Irit (2000) *Terra Infirma: Geography's Visual Culture* (London: Routledge).

Romito, Lorenzo (1997) 'Stalker', in Peter Lang and Tam Miller (eds) *Suburban Discipline* (New York: Princeton Architectural Press) pp. 128–41.

Rose, Gillian (1991) 'Review of Edward Soja, *Postmodern Geographies* and David Harvey, *The Condition of Postmodernity*', *Journal of Historical Geography*, vol. 17, no. 1 (January) pp. 118–21.

Rose, Gillian (1993) *Feminism and Geography: The Limits of Geographical Knowledge* (Cambridge: Polity Press).

Ruby, Ilka and Andreas Ruby (2001) 'Naive architecture: notes on the work of Lacaton & Vassal', in Lacaton & Vassal, *International Architecture Review, 2G* (Barcelona), no. 21, pp. 4–19.

Rugg, Judith and Dan Hinchcliffe (eds) (2002) *Recoveries and Reclamations* (Bristol: Intellect Books).

Rugoff, Ralph (1997) *Scene of the Crime* (Cambridge, MA: MIT Press).

Ryan, Raymund (1999) 'Catwalk architecture', *Blueprint* (June) pp. 30–4.

Sacks, Shelley (1995) 'Afterword', in Shelley Sacks (ed.) *Social Sculpture Colloquium: A Collaboration 9–12 November 1995* (Oxford Brookes University and the Goethe-Insitut Glasgow, in collaboration with The Free International University) pp. 112–13.

Sacks, Shelley (1995) 'A gift from Joseph Beuys', in Shelley Sacks (ed.) *Social Sculpture Colloquium: A Collaboration 9–12 November 1995* (Oxford Brookes University and the Goethe-Insitut Glasgow, in collaboration with The Free International University) pp. 105–8.

Sacks, Shelley (1995) 'PLATFORM', in Shelley Sacks (ed.) *Social Sculpture Colloquium: A Collaboration 9–12 November 1995* (Oxford Brookes University and the Goethe-Insitut Glasgow, in collaboration with The Free International University) pp. 102–4.

Sacks, Shelley (ed.) (1995) *Social Sculpture Colloquium: A Collaboration 9–12 November 1995* (Oxford Brookes University and the Goethe-Institut, Glasgow, in collaboration with The Free International University).

Sacks, Shelley (1996) 'A banana is not an easy thing', *Exchange Values: Images of Invisible Lives* (The New Arts Symposium), pp. 4–8.

Schata, Peter (1995) 'Social sculpture (soziale plastik) every human being is an artist', in Shelley Sacks (ed.) *Social Sculpture Colloquium: A Collaboration 9–12 November 1995* (Oxford Brookes University and the Goethe-Institut, Glasgow, in collaboration with The Free International University) pp. 11–17.

Scholem, Gershom (1991) 'Walter Benjamin and his angel' (1972), in Gary Smith (ed.) *On Walter Benjamin: Critical Essays and Recollections* (Cambridge, MA: MIT Press) pp. 51–89.

Schneider, Bernhard (1999) *Daniel Libeskind: Jewish Museum, Berlin* (Munich: Prestal).

Schrift, Alan D. (ed.) (1997) *The Logic of the Gift: Toward an Ethic of Generosity* (London: Routledge).

Scofidio, Richard and Elizabeth Diller (2002) *Blur: The Making of Nothing* (New York: Abrams).

Senie, Harriet F. and Sally Webster (eds) (1992) *Critical Issues in Public Art: Content, Context and Controversy* (New York: Harper Collins).

Serres, Michel (1995) *Angels: A Modern Myth* (Paris: Flammarion).

Silverman, Kaja (1996) *The Threshold of the Visible World* (London: Routledge).

Smithson, Robert (1996) '"Earth" (1969), Symposium at the White Museum, Cornell University', in Jack Flam (ed.) *Robert Smithson: The Collected Writings* (Los Angeles: University of California Press) pp. 177–87.

Smithson, Robert (1996) 'Entropy and new monuments' (1966), in Jack Flam (ed.) *Robert Smithson: The Collected Writings* (Los Angeles: University of California Press) pp. 10–23.

Smithson, Robert (1996) 'Interview with Robert Smithson for the archives of American Art/Smithsonian Institution' (1972), in Jack Flam (ed.) *Robert Smithson: The Collected Writings* (Los Angeles: University of California Press) pp. 270–96.

Smithson, Robert (1996) 'The spiral jetty' (1972), in Jack Flam (ed.) *Robert Smithson: The Collected Writings* (Los Angeles: University of California Press) pp. 143–53.

Smithson, Robert (1996) 'A tour of the monuments of Passaic, New Jersey' (1967), in Jack Flam (ed.) *Robert Smithson: The Collected Writings* (Los Angeles: University of California Press) pp. 68–74.

Smithson, Robert (1996) 'Towards the development of an air terminal site' (1967), in Jack Flam (ed.) *Robert Smithson: The Collected Writings* (Los Angeles: University of California Press) pp. 52–60.

Solnit, Rebecca (2001) *Wanderlust: A History of Walking* (London: Verso).

Soja, Edward (1989) *Postmodern Geographies: The Reassertion of Space in Social Theory* (London: Verso).

Soja, Edward (1996) *Thirdspace: Expanding the Geographical Imagination* (Oxford: Blackwell).

Speak, Michael (2001) 'Two stories for the avant-garde', in Frédéric Migayrou and Marie-Ange Brayer (eds) *Archilab: Radical Experiments in Global Architecture* (London: Thames & Hudson) pp. 20–2.

Squires, Judith (1994) 'Private lives, secluded places: privacy as political possibility', *Environment and Planning D: Society and Space*, vol. 12, pp. 387–410.

Stallabrass, Julian, Pauline van Mourik Broekman and Niru Ratnam (eds) (2001) *Locus Solus: Site, Identity and Technology in Contemporary Art* (London: Black Dog Publishing).

Stanford Friedman, Susan (1998) *Mappings: Feminism and the Cultural Geographies of Encounter* (Princeton: Princeton University Press).

Staub, Urs (ed.) (2003) *Décosterd & Rahm: Physiological Architecture* (Basel: Birkhäuser).

Steiner, George, (1977) 'Introduction', in Walter Benjamin, *The Origin of German Tragic Drama*, translated by John Osborne (London: Verso, 1977) pp. 7–24.

Tafuri, Manfredo (1980) *Architecture and Utopia: Design and Capitalist Development*, translated by Barbara Luigia La Penta (Cambridge, MA: The MIT Press).

Tagliabue, Benedetta (ed.) (1995) *Enric Miralles: Mixed Talks, Architectural Monographs*, no. 40 (London: Academy Editions).

Tiedemann, Rolf (1999) 'Dialectics at a standstill: approaches to the passagen-werk', in Walter Benjamin, *The Arcades Project (1927–39)* translated by Howard Eiland and Kevin McLaughlin (Cambridge, MA: Harvard University Press) 929–45.

Till, Jeremy, Peter Blundell Jones and Doina Petrescu (eds) (2005) *Architecture and Participation* (London: Routledge).

Toso, Victor (1998) 'Joseph Beuys as spritual scientist', in *Joseph Beuys: Multiples* Walker Art Centre (September).

Tschumi, Bernard (1996) *Architecture and Disjunction* (Cambridge, MA: The MIT Press).

Tschumi, Bernard (2001) 'Interview with Bernard Tschumi: architecture and the city', in Iain Borden, Joe Kerr and Jane Rendell (eds) with Alicia Pivaro, *The Unknown City: Contesting Architecture and Social Space* (Cambridge, MA: The MIT Press) pp. 370–85.

Tuan, Yi-Fu (1974) *Topophilia: A Study of Environmental Perception, Attitudes, and Values* (Englewood Cliffs, NJ: Prentice Hall).

Wade, Gavin (ed.) (2000) *Curating in the 21st Century* (Walsall: New Art Gallery/ University of Wolverhampton).

Wallis, Clarrie (2001) 'Introduction', *Tacita Dean* (London: Tate Britain exhibition catalogue).

Weigel, Sigrid (1996) *Body- and Image-Space: Re-Reading Walter Benjamin* (London: Routledge).

Weilacher, Udo (1999) *Between Landscape Architecture and Land Art* (Basel: Birkhäuser).

Whiteread, Rachel (1996) *Rachel Whiteread: Shedding Life* (Liverpool: Tate Gallery exhibition catalogue) with essays by Rosalind Krauss et al.

Whiteread, Rachel (1997) *Rachel Whiteread: British Pavilion XLVII Venice Biennale 1997* (London: British Council).

Wigglesworth, Sarah and Jeremy Till (2001) *9/10 Stock Orchard Street: A Guidebook* (London: Bank of Ideas).

Wilson, Jane and Louise Wilson (1999) *Jane & Louise Wilson: Serpentine Gallery, London,* (London: Serpentine Gallery).

Wilson, Robin (2002) 'Beyond the fringe', *The Architects' Journal*, 3 October.

Wodiczko, Krzysztof (1999) *Critical Vehicles: Writings, Projects, Interviews* (Cambridge MA: The MIT Press).

Wollen, Peter (2001) 'Barthes, Burgin, Vertigo', in Peter Wollen, *Victor Burgin* (Barcelona: Fundacio Antoni Tapies) pp. 10–25.

Zaera Polo, Alejandro (1991) 'Conceptual evolution of the work of Rem Koolhaas', in Rem Koolhaas, *Urban Projects (1985–1990)* (Barcelona: Editorial Gustavo Gili) pp. 52–63.

Index